BEING BEDOUIN AROUND PETRA

BEING BEDOUIN AROUND PETRA

Life at a World Heritage Site in the Twenty-First Century

Mikkel Bille

berghahn
NEW YORK · OXFORD
www.berghahnbooks.com

First published in 2019 by
Berghahn Books
www.berghahnbooks.com

© 2019, 2023 Mikkel Bille
First paperback edition published in 2023

Library of Congress Cataloging-in-Publication Data

A C.I.P. cataloging record is available from the Library of Congress

British Library Cataloguing in Publication Data

A catalogue record for this book is available from the British Library

ISBN 978-1-78920-120-8 hardback
ISBN 978-1-80073-914-7 paperback
ISBN 978-1-78920-121-5 ebook

https://doi.org/10.3167/9781789201208

✎◉ Contents

❧ Figures

✆☉ Acknowledgements

Doing fieldwork among the Bedouin means meeting thousands of people. There are hence too many people to be thanked for space here to allow. Among all the people who have shaped the data and analysis, there are nonetheless those without whom this work would not have been the same or even possible, particularly the late Sheikh Salame ʿEid of the Hamid branch of the Ammarin tribe and all members of his family. The oldest son Mohammed is particularly thanked for his friendship and help. Likewise, thanks are due to the family of Hamad Abu Lafi from the Jummaīn branch, and the help and friendship from their second son Talal have been indispensable. His company and eager help are greatly missed. Mtiʿa Umm Suleiman has been a great personal inspiration and source of information. I also owe Sheikh Ibrahim and mayor ʿEid Shtiyyan many thanks. Their generosity, hospitality and friendship will never be forgotten, and will serve as reminders of the privilege of doing fieldwork with the Ammarin.

In Wadi Mousa, I thank Waleed al-Hassanat, Suleiman Farajat, Saʿad Rawajfeh, Hani al-Falahat, Zeyad al-Salameen, Erin Addison, Ismael from the Wastewater plant, and Wendy from Petra Moon Tourism Services. From around Jordan, the late Sheikh Suleiman Abu Adef Ammarin, Aysar Akrawi from PNT, Ziad Hamze, Rami Sajdi, Nicholas Seeley, Department of Statistics in Jordan, and the Royal Geographical Institute have all been helpful at various stages. The staff at the Council of British Research in the Levant deserves special thanks, particularly Bill Finlayson and Nadia Qaisi who made my fieldwork easier and my time in Amman much more comfortable. At the German Institute, I thank Nadia Shuqair for interview transcriptions. Geraldine Chatelard from the French Institute has offered indispensable help in discussing UNESCO procedures.

Special thanks are due to Victor Buchli and Chris Tilley at UCL, and Esther Fihl, Lars Højer, Miriam Zeitzen, Michael Ulfstjerne, Stine Puri and Regnar Kristensen from the Centre for Comparative Culture Studies at University of Copenhagen who have also offered much inspiration

and critical reading. Also, my thanks go to Lynn Meskell, David Wengrow, Bo Dahl Hermansen, Stephen Lumsden, Rodney Reynolds, Anna Hoare, and in particular Andreas Bandak and Tim Flohr Sørensen who have been central to my thinking about the issues raised in this book. Also acknowledged are the four reviewers of earlier versions of this manuscript. And finally, I offer my thanks for support from family and friends, with special thanks to my wife Sofie for her immense support, and for accepting the conditions of fieldwork which she took part in. The funding was provided by the Danish Research School of Cultural Heritage Studies, represented by Carl Gustav Johannsen, and the Danish Research Council. Elli and Peter Ove Christensen's fund prompted my initial pursuit of an academic education at UCL.

Chapter 3 builds upon and extends M. Bille, 2012, 'Assembling Heritage: Investigating the UNESCO proclamation of Bedouin intangible heritage in Jordan', *International Journal of Heritage Studies*, 18(2), 107–123. Chapters 4 and 5 were previously published in altered versions in M. Bille, 2013a, 'The Samer, the Saint and the Shaman: Ordering Bedouin Heritage in Jordan', in A. Bandak and M. Bille, (eds), *Politics of Worship in Contemporary Middle East: Sainthood in Fragile States* (Leiden: Brill Publishers), pp. 101–126; and M. Bille, 2013b, 'Dealing with Dead Saints', in D.R. Christensen and R. Willerslev (eds), *Taming Time, Timing Death: Social Technologies and Ritual* (Surrey, UK: Ashgate), pp. 137–155. Parts of chapters 6 and 7 were published in M. Bille, 2010, 'Seeking Providence Through Things: The Words of God versus Black Cumin', in M. Bille, F. Hastrup and T.F. Sørensen (eds), *An Anthropology of Absence: Materializations of Transcendence and Loss* (New York: Springer Press), pp. 167–184.

I have used the English spelling for common names, places and words. To the best of my knowledge, I have otherwise adhered to the Deutsche Morgenländische Gesellschaft standard of Arabic transliteration while also seeking to recognise the varied local pronunciation. My thanks go to Naja Bjørnsson for her guidance on Arabic transliteration, while all mistakes, of course, remain my own.

Mikkel Bille, Copenhagen, Autumn 2015

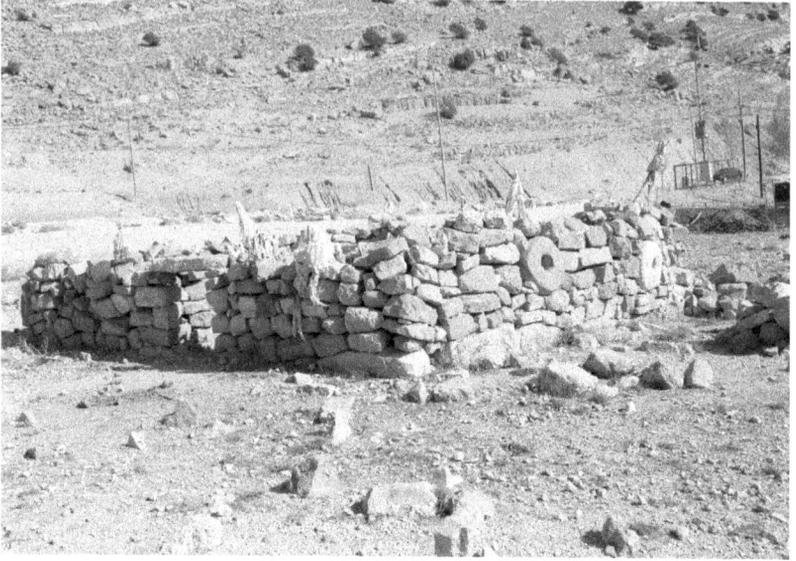

Figure 0.1. Saint graves at ʿAyn Amūn. Photo by the author.

❧ Introduction

IN THE PRESENCE OF THINGS

'Ignorant, all of them ignorant' (*jāhil, kulhum jāhil*). The judgment came without any hesitation from Hussein's mouth, loaded with utter disgust. We were on our way to meet some friends in Taibeh, just south of the Petra in Jordan, when we passed the saint graves in the cemetery at ʿAyn Amūn (figure 0.1). With an elaborate stone construction around the largest of the graves, pieces of torn cloth tied to sticks inserted into the grave, used candles, and burn marks from incense, it was evident that the graves were still used for saint intercession – at least by some people.

Hussein[1] is in his mid-twenties from the Ammarin tribe, defines himself as Bedouin, and works as a park ranger in the nearby national park of the ancient city of Petra. Unlike the older generations of Bedouin who once lived in tents and caves in the surrounding desert mountains, Hussein was born and raised in a small village, where he now lives in a house with his wife and children. His rejection should be seen in the context of religious scholars increasingly preaching a more purist, scriptural understanding of Islam in the village mosque since the late 1990s, as part of what has more generally been called the Islamic Revival (*al-Ṣaḥwa al-Islamiyya*) spreading in various forms out of Saudi Arabia and Egypt. Consequences of this increasing religious awareness in the late twentieth and twenty-first century are the development of Islamic parties such as the Islamic Action Front in Jordan, discourses of a 'return' to a true Caliphate, and a rhetoric of the existence of only one monolithic Islam and a worldwide *umma* – an Islamic community of believers. Hussein was inspired by such teachings, now seeing himself as a true and devout Muslim, although

he may only occasionally do his prayers and find fasting a bit too challenging. But the disdain for the saint graves was heartfelt. To Hussein, the material evidence of recent use of the graves was a clear sign that not everyone in the area had learned about the proper – and in his mind original and only – way of being a Muslim but adhered to remnants of a 'folk Islam'.

Yet there is more to Hussein's outburst than simply a matter of how to be a 'proper' Muslim. It was a matter of history and heritage. Like the other holy sites in the area, which numbered around thirty, these graves were, he admitted, part of tribal history, burial places of descendants of the tribes, and places associated with stories of extraordinary events. Even his close relatives would have used them in what he saw as 'ignorant' ways, and some may still do so. The contemporary practices at the sites, and, at times, even the claims of sainthood, were certainly part of history and the past, but not of his heritage. As Samuli Schielke and Georg Stauth note, the contestation of a saint's shrine is also 'a contestation of the identities and values of the people who relate to it' (2008: 15). Even if the saint graves are still there, the important question is how people relate to them, and seen from the evidence at the graves, some still do. Defining heritage in this part of Jordan is thus an important, yet also contentious matter, encompassing claims of knowledge and morality of dealing with material objects. To Hussein, it is a display of both ignorance and heresy to think you can influence the will of God by interacting with the graves. But for the (few) people who still go to these graves, such practices offer a potential closeness to God mediated through material objects, and are part of a contemporary informal heritage.

Most aspects of people's lives in this area of Jordan are about heritage or the effects of it. In 1985, Petra became a UNESCO World Heritage site. In effect, the Bedouin, who had inhabited the landscape for centuries, were forced, by a combination of international heritage protection policies and national settlement ideologies, to resettle. Two villages were built outside the Petra heritage area for the two major tribes inhabiting Petra: Umm Sayhoun for the Bdoul tribe and Beidha Housing (*Eskān al-Beiḍa*) for the Ammarin. While in the past they lived a semi-nomadic subsistence in tents, caves and vernacular houses rearing livestock – mostly sheep and goats – these Bedouin were now far removed from any general nostalgic image of camel-herding, tent-dwelling nomadic Bedouin you may have, and the effects of UNESCO heritage regulations and mass tourism are largely the cause.

In 2005, in an ironic turn of events, the Ammarin Bedouin tribe residing in the northern part of Petra, along with a few neighbouring

tribes, became part of UNESCO's newly established intangible cultural heritage list – 'Masterpieces of the Oral and Intangible Heritage of Humanity'. Although most of the Ammarin themselves were unaware of the formal international recognition of their cultural heritage, scholars and heritage agents working in the area responded to the proclamation with a mixture of proud nods of approval and baffled astonishment. On the one hand, the Bedouin incorporation on the list meant international acknowledgment of the oral traditions and skills of nomadic desert survival that the Bedouin across the Middle East have developed over millennia. It was the recognition of a type of knowledge at risk of disappearing with urbanisation, settlement and new economic structures. It was simultaneously a legitimisation of the central narrative that Bedouin culture, and tribal society at large, hold in the Jordanian national discourse. On the other hand, these particular Bedouin had for decades been economically dependent on tourism, had cars and mobile phones, spoke several languages and – not unimportantly in terms of the bafflement – were, like Hussein, settled and relocated from the area by the government as a response to UNESCO tangible heritage. It was a spatial and social change from living a life in tents and caves in the 1980s to living in concrete buildings detached from the landscape which they now, according to UNESCO intangible heritage programmes, are so intimately related to in oral traditions and skills. Furthermore, the saint intercession practices Hussein had protested so much against are celebrated as part of the intangible cultural heritage of humanity by UNESCO, even though they are now rarely practiced, and mostly frowned upon by people like Hussein. In part, this is because people no longer live close to the cemeteries previously used, but it is also due to the Islamic Revival noted above, emerging in the area through schools, mosques and television. In this line of thought, these religious practices are not viewed as a heritage embodying the knowledge of contemporary people, but rather as un-Islamic ignorance.

In a sense, what we are witnessing is a reversal of a traditional academic discussion of a dichotomy between a purist, scriptural Islam of a cultural elite or State in the urban centres (sometimes called high Islam or Greater tradition) and the folk Islam of the rural areas (sometimes called low Islam or Little tradition) (Asad 1986: 6; Geertz 1968; Gellner 1981; Goldziher 1967, 1971; Lukens-Bull 1999). While such a dichotomy may initially seem fruitful in pointing to a clear distinction between approaches to Islam, it has also been heavily criticised for resting on the idea that both the purist Islamic revival and the so-called folk Islam may be envisaged as an ahistorical single whole (in line with

Antoun 1989: 39; Goldziher 1981: 4; Makris 2006: 49–54). More than this, it also creates a geographical distinction between urban and rural, which the case of UNESCO heritage in Petra in part is reversing, or at least complicating. Here, the state and parts of the urban elite are seeking diversity, while the rural population at first sight is seeking unified scriptural dogmatism.

We are confronted with the case of a UNESCO world heritage claim to universalism – the heritage of humanity – meeting a competing Islamic claim to universalism – one Islamic community of believers, which simultaneously aims to break with a diverse range of practices associated with so-called folk Islam. In many situations, these two universalistic ideals overlap and join forces, but in other cases they also differ when questions are raised about which pasts should be recognised. Few other places in the world can present such a conglomeration of heritage ideologies, encompassing international agencies, state policies, regional heritage management and everyday disputes over the presence of the past that at least initially seem incompatible if the goal is to protect both tangible and intangible heritage. Therefore, what we see here, in essence, are central tensions and dichotomies between formal and informal, tangible and intangible heritage, purist and folk Islam, and the negotiation of the past in the present.

The preoccupation with protecting or denouncing various kinds of formal and informal heritage in Petra is at the heart of this book. Why are specific traditions and material remnants from the past around Petra so important to protect or denounce as heritage by various actors? How did specific people, places and things become inscribed as heritage by UNESCO, rather than others? These questions will be answered through a detailed ethnographic account of Bedouin life around Petra.

However, beyond the selection and denunciation of heritage, to answer such questions we also need to dwell on Hussein's remark, as it raises a range of other questions about the role of material objects in people's lives, which are deeply entangled in those processes of shaping both religious and heritage identities. We are surrounded by millions of objects, but what is it about certain objects, at certain times, that make us identify and celebrate them, or challenge and obliterate them? Is it just the 'meanings' projected onto them by people, or is there another material logic that makes people visit such graves or denounce them? How do different material objects work in fundamentally different ways where some strike back and present their own agenda? Connecting these questions is the need to understand how distinctions between the material and immaterial – if and when

they indeed make sense in people's lives – come to matter in everyday life and how they need to be framed in precise ways to accommodate religious and social ends in heritage politics. These understandings of the role of material culture, or its supposedly immaterial counterpart in heritage and religious processes, raises broader issues across the (Islamic) world in terms of identifying roots in a world of unremitting social upheaval, where claims of apostasy lead to the destruction of proclaimed cultural heritage.

Aims and Process

The central question addressed throughout the book is how, and why, do Islamic pasts and Bedouin heritage shape identities in Jordan? In dealing with this question, the book presents an ethnographic exploration of aspects of Bedouin life around Petra and the process of heritage preservation and contestation, while simultaneously seeking to expand our understanding of the role of material culture in people's lives more generally. The data used to investigate this question is based on sixteen months of anthropological fieldwork between 2005 and 2011.[2]

A first step towards answering this question is to address heritage from multiple perspectives. A micro-scale perspective on how a group of Bedouin perceive their past and revitalise a Bedouin heritage in a new sedentary context does not suffice. Nor can we reach an understanding of the workings of heritage by relying on the practices and representations of the heritage industry on either a regional, national or international scale. We need to see how the everyday life, heritage practices and infrastructure run parallel, connect, overlap or sometimes deliberately divert from each other. To understand this, the book deliberately shifts between perspectives. At times, it addresses how international institutions protect heritage; at other times, it deals with the local or national preservation efforts; while other parts discuss the everyday life of living with particular objects among the Bedouin. I have chosen this way of presenting heritage processes to illustrate how these local, regional, national and international levels are entangled and variously rely on and constitute notions of how the world is or should be present. This sort of identity formation happens as much through national and global connections as through local attachments. As Hussein showed, sometimes the universal connection to an *umma* is more relevant than adherence to past local traditions.

The first part of the book specifically explores how cultural practices among a small Bedouin tribe in southern Jordan rise to

national and international prominence through tapping implicitly and explicitly into different claims to universality. It becomes clear in the second half of the book that on this journey from local knowledge to international heritage acknowledgment, material objects – or the absence thereof – are focal points in heritage debates over what it means to be a Bedouin, Muslim and Jordanian, or variations of all three at once.[3] The starting point of this analysis is the observation that there are parallel claims as to what heritage is and is not. These claims rely on broader – yet different – claims to universalities that unfold when people ignore, discard, tolerate or identify with places, practices and things passed on from previous generations. They are claims to universality rather than actual existence of such universality. For instance, promoters of the Islamic Revival tried to disseminate the notion that there is one monolithic way of being a 'proper' Muslim across the world – seemingly in opposition to 'folk Islam' – but such claims may be dealt with in ambiguous ways locally. Even UNESCO notions of heritage, that almost all nations now accept, are challenged or adjusted to meet local interests, or rethought, as with the invention of intangible heritage lists.

The key analytical point made in this book is that we see *parallel universalities* at work, where an organisation, institution or person may justify their actions through broader universal reference. These different justifications may run parallel to each other, or they may even intersect and be used simultaneously to meet specific aims. The notion of parallel universality emphasises that the question is not how one universalism is more dominant than the other or came first. The term instead highlights how people navigate between the imbrications and incompatibilities of the parallel – and at times competing – notions of universality through material practices. It is about finding the fertile spaces between positions, where ambivalence and potentiality offer guidance, loopholes and comfort. The same practice or object may thus simultaneously present evidence for the importance of recognising a universal heritage of humanity, for instance in terms of saint veneration, while also proving the need for a universal practice of a purist Islamic faith by not recognising it. Or aspects of it may be recognised as compliant with one universality and denounced as compliant with another. This also illustrates how tensions between definitions of heritage as formal or informal, tangible or intangible, and/or purist and folk Islamic, are at the heart of understanding what heritage is and does. By situating discussions of the role of things in the everyday life of a Bedouin tribe and following their path through the tourism industry and international heritage proclamations, the book

thus explores the overlaps and gaps between the everyday life of the Ammarin Bedouin tribe around Petra and the production of UNESCO tangible and intangible cultural heritage, the shaping of Jordanian national identity, the disappearance of folk Islamic practices, and the rise of a new Islamic awareness.

With the rise of tourism and cultural heritage discourse in the twentieth century, there is also a notion of risk evolving, which is reflected in the desire to rescue authenticity and cultural diversity from loss, dilapidation and destruction (cf. Harrison 2013, ch.2; Layton et al. 2001). Authenticity is seen to exist 'just prior to the present' (Clifford 1987: 122), and the notions of 'distance' and proximity (whether in time or space) are often linked to the aesthetic presentation of the materials of the past. Through heritage, people, organisations and states can engage in the powerful blame game: who is to blame for the dilapidation of cultural resources or practices? Or as David Lowenthal also notes, 'To neglect heritage is a cardinal sin, to invoke it a national duty' (1998: xiii).

Following Mary Douglas's (1992) insight that risk is about blame (including self-blame), an argument recurring throughout the book is that protection against whatever is considered a risk – heritage protection in particular – is about the duality of exposure: a recognition of vulnerability – of being exposed – and thus adhering to a shared idea that something is valuable; and displaying and confirming the appropriate ways of achieving such protection. In other words, while the protection of heritage may be galvanised by the risk of losing it, the act of protecting it simultaneously displays the propriety and ability to act properly by those protecting the valued objects or traditions (see also Harrison 2013: 26–28). This view forces us to explore the social entanglement of protection as an act against whatever constitutes a risk and whatever protective traditions, materials and political means the act of protection makes use of.

From such a position, it seems that the relationship between the material and the immaterial – often simply translated into the tangible and intangible, or presence and absence – is not as clear cut as one would presume; neither in tangible or intangible heritage proclamations by UNESCO, nor in everyday life. Rather, the relationship between seemingly opposing concepts, or even links between materiality, presence and tangibility, is somewhat ambiguous, and no less so when we are talking about religious objects. This ambiguity offers space for social tensions, defining subjectivities and mitigating social instability. It is a presence that is not simply about whether an object is there or not, but rather *how* it is there, what it does, and what people do to it.

Taming Things

In my analysis I employ the notion of 'taming' to understand how people constantly frame a material world that otherwise threatens to overwhelm them (taking my cue from Goffman 1974). Taming is thus an analytical, rather than ethnographic, term that aims to highlight the processes taking place in cherishing or abolishing aspects of past practices and materials. At the most basic level, the human brain is the first line of defence, subconsciously sorting out what is relevant to notice. For instance, when driving a car, some things demand attention more than others, and yet some things may be simply impossible to ignore. The notion of 'taming' rests on the premise that the presence of things may force itself upon us, wherein excessive aspects of things need to be neutralised, while more cherished and relevant aspects are highlighted. For instance, think of the way smell in a toilet is either subtracted through ventilation or overpowered through the addition of other smells.

Hussein's outburst exemplifies a broader discussion about the ways in which humans should engage with things. Human life unfolds through material objects, but that does not make all things equal. The notion of 'taming' entails that at certain times we ignore, discard, to-lerate or identify with what is in our presence. Some things we identify strongly with and care for – at times to the point of being indistinct from oneself or a person: an heirloom, wedding ring, ashes from a family member and so on. Some things we tolerate and accept: the ugly chair or the dust mites on the floor. Most things we simply actively ignore or do not notice, such as the floor panels or background noise. And then there are the things that we seek to negate: when there are too many dust mites in inappropriate places or, to return to the heritage scene, when a former political regime's statues need to be removed.

Things have an affecting presence (Armstrong 1971), and people are in a constant process of sorting out what aspects need attention. This process of sorting out is thus what I call a 'taming process' that helps us to understand the different relations and qualities of things that people engage with. 'Taming' is not fixed once and for all, nor is it simply an autonomous individual act, but one that may be embedded in social or religious movements. Through law, politics and everyday life, it may become naturalised as the evident thing to do or way to think. But in each case, further analysis shows that it is indeed a process of highlighting, accepting or negating certain aspects of things. The question of how things are 'there' is thus a question of taming their materiality in a meaningful way and engaging with the social propriety of handling their effects and affects.

To sum up the answer to the central question of how, and why, Islamic pasts and Bedouin heritage shape identities in Jordan, I argue that universalistic ideals of how things should be present are tamed by naturalising the duality of exposure – acknowledging vulnerability and displaying propriety. While this taming process of establishing what is heritage or not (formal/informal, tangible/intangible or Islamic/un-Islamic) may rest on parallel universal claims at a general level, these are heavily entangled in everyday material practices, where certitude, ambiguity and ignorance compete in shaping identity. Before we embark on trying to understand Hussein's irritation towards the saint graves, and the advancement of a small group of Bedouin to international fame, we first need to know the larger context of the role of the Bedouin in Jordan.

Building a Modern Bedouin Heritage in Jordan

In art, film and public discourse there has at times been a romantic representation of the Bedouin as a tribal society roaming the desert since time immemorial, herding camels, acting with honour and valour. Empirically, however, the Bedouin have transformed tremendously over the centuries. By the 1950s, for instance, most Bedouin were at the fringes of society almost everywhere in the Arab world. There was widespread illiteracy among the Bedouin, most had no access to modern health care, and they probably experienced the region's highest rates of infant mortality. They also suffered from a decline in market demand for caravans, camels and horses, with few alternatives in terms of employment (Cole 2003). This situation was further exacerbated by drought in the late 1960s among the large camel-herding tribes (Lancaster 1997: 100). All over the region, the nomadic Bedouin were encouraged, or economically forced, to settle and lead a so-called modern sedentary life either in government-designed or vernacular houses and villages.[4] This was not just an adaptation to the environment and to new technologies of transportation, however. WHO, UNESCO and many Middle Eastern governments had also decided to initiate an intensive sedentarisation programme for the pastoral nomadic Bedouin tribes. These organisations predicted that encouraging or coercing the nomadic Bedouin to settle would help the Bedouin cope with growing health problems, poverty and hunger (Bocco 2000: 199, 214).

The mobile, pastoral way of life had become increasingly problematic after the decline of the Ottoman Empire as the Bedouin formed

a 'state within a state' (Chatty 1986: 154) and referred to themselves as Bedouin (or ʿarab) rather than as Saudi or Egyptian. They did not pay taxes and crossed modern national borders at will, which led to accusations of smuggling and of being responsible for extensive land degradation (Chatty 1986). Yet, the Bedouin in Jordan, in contrast to their counterparts in other Middle Eastern countries, were venerated as the backbone of Jordanian identity.

The Hashemite Kingdom of Jordan was established in 1946, when it broke away from its colonial ties. The British mandate of Transjordan, founded in April 1921 (Masalha 2007; Robins 2004), had been established in a collaboration between the British (most notably T.E. Lawrence and Pasha Glubb), the Bedouin tribes of southern Jordan (the Howeitat in particular), and the Hashemite family from Hijaz in contemporary Saudi Arabia. These parties revolted against the Ottoman Empire to establish Transjordan. Emir Abdullah, who would later become King Abdullah I, administered the 300–400,000 inhabitants of Transjordan, of which about 80 per cent were nomadic.

The early independence years of the Hashemite Kingdom of Jordan were turbulent. King Abdullah I was assassinated in 1951, and King Talal, who succeeded him, abdicated shortly thereafter due to a mental condition. For the rest of the twentieth century, Jordan was ruled by King Hussein, who needed to balance British, American, Palestinian and Arab political and economic interests in the area. The country became increasingly divided during the late 1980s and early 1990s in terms of economic prosperity. The economic difficulties eventually resulted in an IMF intervention. Southern Jordan (here understood as approximately south of the Dead Sea) had few development plans and little economic growth compared to the north; southern Jordanians consisted mostly of lower-class farmers, and settled or pastoral nomadic Bedouin population. The southern Jordanian tribes have historically shown strong support for the royal family, so their economic struggles became an even more sensitive political issue (Joffé 2002; Robins 2004). Upon Hussein's death in 1999, the current King Abdullah II ascended the throne in a controversial change of succession with Prince Hassan, who some saw as the rightful successor. Since then, a fine balance in international and national politics has kept Jordan relatively stable.

At the end of my fieldwork in 2011, Jordan had an estimated 5,600,000 inhabitants, mostly living in northern Jordan's major cities, such as Amman, Irbid, Zarqa and Mafraq. It is commonly held that most Jordanians are actually of Palestinian descent, but it is a highly contentious topic, as it puts pressure on the perceived 'Jordanian-ness' of Jordan. Additionally, between 750,000 and one million Iraqi

refugees arrived after the second Gulf War (Masalha 2007: 637).[5] To counter these developments, the national campaign 'Jordan First' sought to make Jordanians set aside their differences and unite under a common national heritage, as 'Jordanians' and as 'Hashemites' (Al-Mahadin 2007a). 'Jordan First' has, however, also facilitated a crackdown on critical, anti-government and Islamic voices, as represented by the opposition Islamic Action Front party, which has close ties to the Islamic Brotherhood in Egypt.

Jordanian heritage discourses are based on shaping a multifaceted history of Jordan by incorporating the roots of the royal family within the Bedouin culture, as well as stressing the importance of Christian sites and community, and minority groups such as the Circassian, and only more recently have Jordan's Islamic roots been showcased more prominently (Addison 2004; Neveu 2010). In Jordan, tribal society – and in particular the Bedouin – is critical to representations of Jordanian national identity. Bedouin heritage has been highlighted since the birth of the state, as it has been made to represent notions of hospitality, courage, protection and honour. The selection of the Bedouin heritage to represent the country is also a way of silencing other pasts or political voices. Tribal influence continues to be a topic in elections and in the development of the political infrastructure, particular through the Bedouin tribes.

Yet despite the critique of tribalism being unsuited to a democracy, tribes continually figure in the royal family's rhetoric of unity, solidarity and heritage. King Abdullah II, for example, responded to the critique by stating: 'We have a deep-rooted culture and a strong national fabric that make us invincible to challenges. We are the inheritors of the Great Arab Revolt; the homeland of Arab Islamic Hashemite heritage and the country that is rich with its tribes that will remain the pillar of its strength, steadfastness, stability and progress'.[6] Statements such as these make use of the general idea that Jordanian national identity emerges from three main stories: the Great Arab Revolt of 1916–1918 against the Ottoman empire; the tracing of a monarchy lineage back to the Prophet Muhammad; and the role of the tribes throughout Jordanian history (Layne 1994). With the Hashemite royal family claiming a Bedouin lineage, the Bedouin are lauded for their role in the uprising against the Ottoman Empire and in upholding security through claims that 'the army is still a heavily Bedouin army' (Layne 1994: 11–12). The Bedouin have until recently been represented to an international audience in brochures and discourse as the 'only people in Jordan' and the symbol of Jordanian hospitality (Layne 1994; Massad 2001). The Jordanian state is therefore generally conceived as being based on the 'nobility' of the Bedouin

as its original inhabitants. However, several scholars have rightly pointed out that the colonial and orientalist background that produced this image is largely ignored, along with this background's continuous influence on postcolonial governmentality (Butler 2001; Daher 2007a; Daher and Maffi 2014a; Maffi 2009, 2011; Massad 2001).

Simultaneously, the Bedouin in Jordan, as in other parts of Middle Eastern state administrations, are seen as 'the source of all troubles, a backward entity that stands in the way of national progress … [where the] pastoral way of life … is a holdover from an irrational past' (Chatty 1986: xix). Even more recently, Kamel Abu Jaber, former foreign minister and director of the Royal Institute for Interfaith Studies, said that whereas Jordan may not yet be a full-fledged democracy, 'The Jordanian community has succeeded in transforming from a bedouin society into a civilised society in a short period, and we have lots of great accomplishments that we should be proud of'.[7] In other words, in Jordan the Bedouin are ambiguously positioned between embodying honourable traditions, heritage and personal character and an incompatible empirical category in a modern state due to its tribalism and mobile pastoralism foundation.

Bedouin Representations

It may come as some surprise then, that according to the Department of Statistics, only 132,671 of the approximately six million inhabitants in Jordan were, at the time of my fieldwork, registered as 'Bedouin' – equalling around 2 per cent. The image of the role of the Bedouin in Jordan marginalises the position of the majority of Jordanians, who have their roots in Israeli and Palestinian territories. The representation of the Bedouin heritage offers a sense of historically and territorially rooted national identity, despite its apparent demographic distortion (Anderson 2005; Hazbun 2004, 2008; Massad 2001). The role of the Bedouin and tribalism in national discourse has, however, often been criticised, especially during the 1984 parliamentary elections, in which King Hussein, like King Abdullah II after him, came out defending tribalism as a foundation of the state (Shryock 1997: 7). In that sense, the construction of official (national) heritage is continually reshaped or strengthened in the face of dissonance or alternative competing claims to belonging, memory and history through more unofficial heritage discourses. As some heritage scholars have noticed, what matters is not the past but one's relation(s) with it (Hewinson 1987: 43). Legitimising the role of the Bedouin and tribal society in discourses as well as through the archaeological records, is aimed beyond a national

scale towards a context of wider regional politics and a break with the colonial past (Al-Mahadin 2007a, 2007b; Corbett 2011; Hageraats 2014; Maffi 2009, 2014). In that context, defining what a Bedouin is becomes a way of doing heritage work. Is a Bedouin a pastoral nomad? Could he, or she, be a settled pastoralist? Or could someone working in an office, with little knowledge of the desert or pastoralism, be a Bedouin if they uphold certain traditions? As this book attests, recent decades have shown how deliberate work is performed to construct an image of what a Bedouin is, ranging from highly essentialised orientalist images of an empirical category of subsistence to naturalising representations of a social identity based on skills and traditions. 'Bedouin', in this sense, is simultaneously a strategic narrative, a sense of belonging, skills and practices, and an identity-marker.

Defining cultural heritage, particularly in terms of the desired official recognition from UNESCO, generates a certain kind of ordering of the past that is entangled in negotiations of local, cultural and national identities through the power structures involved. In the case of Jordan, the leap between establishing a modern nation and tracing tribal traditions seeks to consolidate Bedouin culture and tribal society as the roots and backbone of Jordanian national identity. Simultaneously, Petra is the symbol of Jordan, epitomised in the national news agency of the same name and emblazoned on everything from paper money, to commercials, government signs, tourist brochures and so on. The Nabataeans, who carved the rock facades in Petra more than two millennia ago, are by many people considered to have been pastoral, nomadic pre-Islamic Arabs: hence, 'proto-Jordanians', living like the Bedouin. Such a link between Petra, the original inhabitants and national identity is also present in a heritage management report on Petra National Park from UNESCO, which states that 'Petra posses [sic] great meaning for the people of Jordan, giving them a tangible connection to their ancestral lands and traditions' (Management Analysis 1996: 13), and the monuments help to connect the 'ancestral lands and traditions' to the Jordanian people, thus materialising the image of unity and belonging. Furthermore, the Jordanian economy is based on tourism, mining and substantial expatriate and international funding. Tourism, particularly heritage tourism, is one of the main industries in Jordan and contributes around 11 per cent of GDP,[8] and according to some estimates, as much as 90 per cent of the tourist revenue originates from Petra (Comer 2001: 1). Petra, as the major tourist attraction in Jordan, is thus both a crucial economic and social factor in Jordanian politics.

Against this background, the productive use of the past in heritage discourse is of little surprise, as the ruling powers are struggling to

shape their legitimacy and a united Jordanian national identity. The productive use of heritage 'always entails protecting a specific idea of the past, and excluding other pasts' (Daher and Maffi 2014b: 35) – for instance, downplaying the Ottoman past in Jordan. Images of traditions and roots are therefore heavily politicised in a post-colonial Jordanian context, as Irene Maffi and others have shown, where the state continually tries to impose juridical and coercive efforts to define and redefine Jordan's national and Bedouin identity. Thus, despite the history of 'outsider' interest – the colonial rule, the Hashemites from Hijaz, the Palestinian majority, IMF intervention – the past in Jordan, as in any other country, often situates national identities and unity within changing contexts of identity formation (Anderson 2005; Corbett 2011; Daher and Maffi 2014a; Layne 1994; Massad 2001).

Studying the Bedouin

Within the context of redefining nomadic Bedouin ways of life, and their role in the national narrative in the twentieth century, there is also increasing ethnographic interest in these changes (Cole 1981; Marx and Shmu'eli 1984; Nelson 1973; Salzman and Galaty 1990; Salzman and Sadala 1980). There has been a somewhat disproportionate interest in studying those considered to be the 'most' Bedouin, seen as those travelling farthest with camels; this interest prevailed in early nineteenth- and twentieth-century ethnographies, compared to other topics in Middle Eastern anthropology, or even the smaller scale semi-nomadic pastoralists, such as those around Petra (Cole 1975; Doughty 1883; Jabbur 1995; Lancaster 1997; Raswan 1935). Since the 1970s, studies have concentrated more on the transitional role of herding (Meir 1997), socio-geographic analyses of education (Abu-Rabia 2001; Abu-Saad 1991), employment and unemployment (Chatty 2000; Gardner 2000), tourism and heritage (Chatelard 2003, 2005a; Cole and Altorki 1998; Hood and Al-Oun 2014; Kooring and Simms 1996; Wooten 1996), traditional medicine (Abu-Rabia 2005a; Al-Krenawi and Graham 1996; Bailey and Danin 1981; Kressel et al. 2014; Sincich 2002) and, especially in Israel, the often severe impact of the political measures of sedentarisation of the Bedouin (Abu-Rabia 1994; Dinero 1997; Lavie 1990). Studies on the Bedouin have also reached beyond the confines of a Middle Eastern regional anthropology to a broader academic audience via studies of poetry, women, nationalism and tribal histories (Abu-Lughod 1986, 1993; Layne 1994; Massad 2001; Shryock 1997).

The disproportionate focus on the Bedouin and the rural areas, however, has recently been radically supplanted by an almost exclusive focus on the urban centres in the Middle East. Ethnographies concentrate on places like Damascus, Cairo or Beirut, or take root in archival studies. This has led to decreasing anthropological knowledge about what is occurring in rural areas in the twenty-first century, even though these areas are mainly where the 'Arab Spring' uprisings originated. It is in these more remote areas that the social and economic developments have had the least impact: places where poverty and unemployment is ever-present, and where the population has limited political influence to change their conditions.

The 2011 uprisings also point to the crucial role of both politics and religion in the Middle East today, if those spheres can even be separated. An inspiring amount of work, particularly by Lara Deeb (2006), Sabah Mahmood (2005), Charles Hirschkind (2006) and Liza Wedeen (2008), has eloquently shown how a piety trope is emerging and is part of everyday life, whereas Samuli Schielke (2012) has shown how piety may not be as certain a stance, but may be constituted by ambiguity, doubt and uncertainty. It is in this anthropological context of – and oscillations between – collaboration and dissociation between urban and rural imaginations that this book offers an ethnographic understanding of what goes on in the rural areas around Petra in terms of negotiating the role of the past. It is about understanding how 'folk traditions' may not just be discarded by adhering to an emerging piety trope, but also need to address the materiality of protection that sustains ambiguity and uncertainty.

Aside from the general shift towards urban anthropology in the Middle East, there has also been a profound lack of attention paid to the Bedouin's material world. Material culture, as an integral part of social life emerging in other fields of anthropology from the 1980s and onwards, has been largely ignored in studies of the Bedouin (and of the Middle East at large) with few exceptions, most notably relating to architecture (Bienkowski and Chlebik 1991; Bille 2017; Ferdinand 1993, 2003; Katakura 1977; Layne 1987, 1994; Pütt 2005; Weir 1976). More recently, a few studies focusing on material culture in Middle Eastern anthropology have emerged (Daher and Maffi 2014a; Limbert 2008; Meneley 2008; Starrett 1995) and, as illustrated in this book, more can be said about how social conflict and balances are achieved through the material world. To illustrate this, I now introduce the people for whom these negotiations of heritage and the proper ways in which to engage with material culture are an essential part of life.

The Ammarin

During the late 1970s, a discourse of modernisation and caring for the (semi-)nomadic pastoral Bedouin tribes emerged, together with a wish to protect Petra's archaeological landscape as it succumbed to increasing pressure from goat herding and tourism. The wish to protect the archaeological record resulted in the end of Bedouin inhabitation of the Nabataean caves and plains in Petra, to the lamenting voices of both scholars and residents (Shoup 1985).[9] Some of the Bedouin tribes from Petra claim that their genealogical origins lie with the Nabataeans (Nielsen 1933: 207; Ohannessian-Charpin 1995; Russell 1993: 16; Shoup 1985: 288), and use this narrative to argue that they are treated unjustly by the government and heritage industry. They are thus not only displaying a long-held 'right' to inhabit the landscape, but equally, as 'Bedouin', become the epitome of Jordanian national identity (Massad 2001). The tribe that received most scholarly attention was the Bdoul, who had occupied the heartland of Petra (Angel 2012; Ayad 1999; Bienkowski 1985; Bienkowski and Chlebik 1991; Kooring and Simms 1996; Ohannessian-Charpin 1986, 1995; Russell 1993, 1995; Shoup 1985; Wooten 1996). Yet, other tribes living in the greater Petra area were also affected, and this book primarily deals with one of these: the Ammarin in Beidha in the northern part of Petra.

The ancient city of Petra lies within the sandstone formations of the Sharah Mountains. The main entrance to Petra is through the city of Wadi Mousa (previously known as Elgi). Wadi Mousa means the Valley of Moses after the biblical story of Moses's striking his staff into the rock to obtain water. It is both the name of the large valley and the main city. The city is inhabited by about 35,000 people – predominantly farmers from the Liathneh tribe. If one drives north on the small winding road from Wadi Mousa, one first enters Umm Sayhoun, the village where the Bdoul tribe from central Petra was primarily relocated (figure 0.2). Further north is an area called Beidha. The government built Beidha Housing for the Bedouin tribes north of central Petra, predominantly the Ammarin tribe. This is the southernmost territory of the Ammarin tribe. It is within view of the tourist site Siq al-Barīd, also known as Little Petra (about 1.7 kilometres to the west). Beidha, like the rest of Petra, is located on the upper part of the mountain range leading from the Arabian plateau through the sandstone mountain of Petra and down to Wadi Araba in the west.

Inhabited today by around 350 people, Beidha Housing was built by the government as part of the 1985 relocation from Petra, and

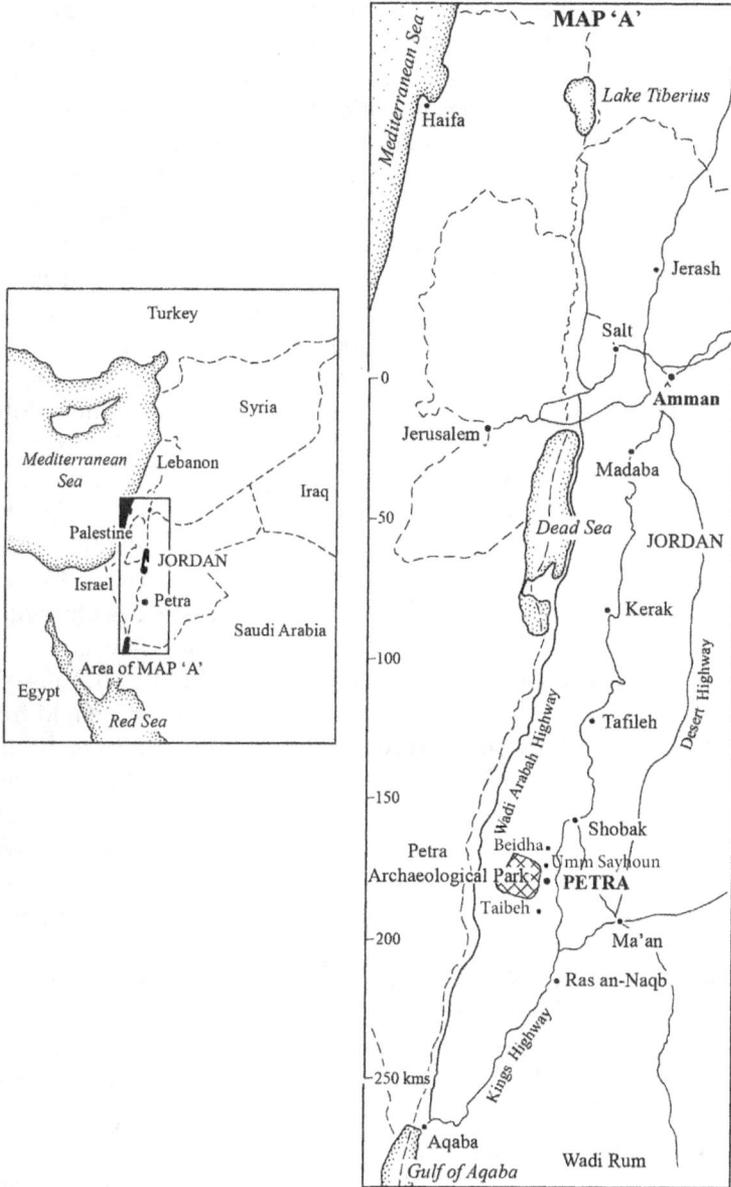

Figure 0.2. Map of Jordan and surrounding countries. Inset enlarged in Map A to the right: Map of Jordan Rift Valley including the Petra Archaeological Park. Adjusted version of Ruben and Disi 2006: 12, published with permission.

effectively meant that the Ammarin resettled from the land they had inhabited for at least three centuries as semi-nomadic herders, and to a limited extent, small-time farmers. The village has a mayor (*mukhtār*) and several sheikhs or tribal leaders, although none are considered head of the Ammarin tribe at large.[10] The Ammarin tribe is part of the larger Beni Atieh confederation,[11] which also inhabits the Sinai, Negev desert and Saudi Arabia, where they claim to originate from.[12] Today, what the Ammarin consider as their territory extends from Wadi Dibdiba and Siq al-Barīd in the south, to just south of Wadi Feinan to the north. To the west, the Ammarin stretch from the village of Qurayqera in Wadi Araba (south of the Dead Sea at around 400 b.s.l.), and to Bir ad-Dabaghad on the Arabian plateau to the east (around 1100m a.s.l.). Tribal boundaries are not clear-cut, and different tribes may inhabit the same area.

During my fieldwork, fewer than five households from the entire Ammarin tribe in Jordan were full-time tent dwellers, and most of these had no small children. The vast majority live in the three main villages: Qurayqera, Beidha and Bir ad-Dabaghad. The largest village of the three, according to the Department of Statistics, is Qurayqera (1,021 inhabitants, 147 houses), followed by Bir ad-Dabaghad (783 inhabitants, 135 houses) and Beidha (332 inhabitants, 50 houses).[13] Aside from the Ammarin, Beidha is inhabited by one household from Meraske (a small tribe of six core families from further north), one family from Merei (a tribe mainly from northeast of the Ammarin area towards Shobak), one from Sayydīyyn (a tribe from the west and south in Wadi Araba) and one man from Bdoul, whose second wife lives here. On the outskirts of the village are two uninhabited houses: a person from Wadi Mousa owns one, and someone from Maʿan owns the other (figure 0.3).

Officials from Petra Regional Authorities estimate that within recent years, 90 per cent of the land around Beidha has been sold by the Ammarin to people from Wadi Mousa, Bdoul and Amman. The major reason for selling off land that was not nationalised as heritage in 1985 is that only a few people need land for either agriculture, tent dwelling or grazing, because they now have employment elsewhere. In addition, land prices are rapidly increasing, especially since Petra became one of the 'New Seven Wonders of the World'[14] in 2007, and with the persistent rumours of imminent tourist development plans around Beidha. Still, during wet years, people, the Bdoul from Umm Sayhoun in particular – but also people from Ammarin – are increasingly beginning to move into tents again in spring, suggesting that even in areas of tourism sedentarisation is not a one-way process (cf. Baumgarten 2011: 227–33).

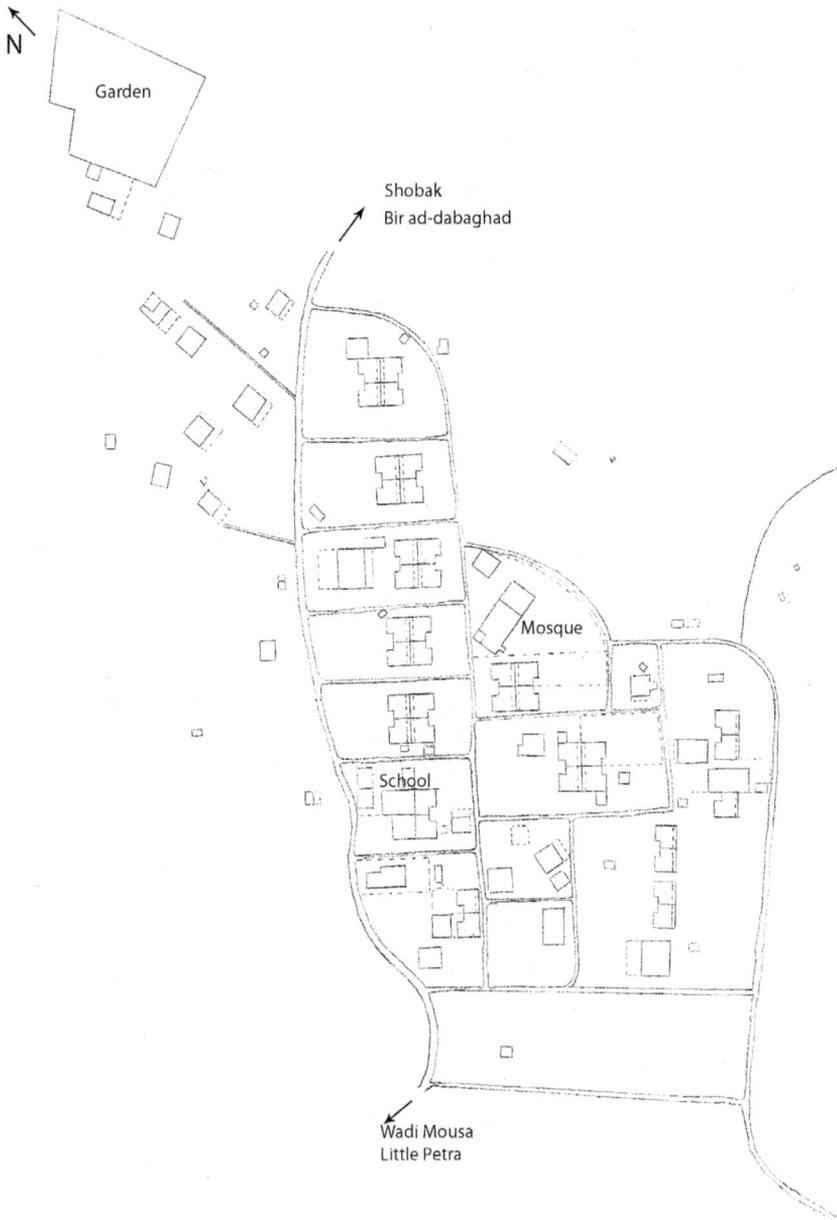

Figure 0.3. Map of Beidha Housing in 2006. Map created by the author.

Particularly for families with cars, it is easy to adapt to varied ways of life now that an extensive road network has been built.

The Ammarin are Sunni Muslim, *madhhab shāfiʿī*[15] with the exception of the small Christian fraction in Kerak.[16] Since settlement into government planned villages (rather than caves, tents and vernacular houses) in the late 1980s and particularly late 1990s, there has been a considerable change in Bedouin ways of life in this region. They have needed to adjust to a more settled life, with an increasing tourist economy, instead of living as pastoral semi-nomads, with, occasionally, small-time farming.

Since the early 1960s, the increasing move to more standardised Islamic teaching has been apparent in the villages and cities through-out Jordan, established through an infrastructure of mosques and schools, and later satellite television (Antoun 1989). It is particularly apparent today that through schools, mosques and satellite-transmitted Islamic programmes, the resettlement has increasingly incorporated people into a more standardised Islamic piety, influentially described by other scholars (Deeb 2006; Hirschkind 2006; Mahmood 2005; Wedeen 2008). Since the relocation, the Ammarin have increasingly developed a more scriptural understanding of Islam than they have historically practiced, although by no means are they understood as 'hardliners', 'fundamentalists', 'Islamists' or other terms currently designated in the media and political scene. The influence of religion has increased through the educational system and teachings from the village mosque. For instance, by 2007, nine female heads of household (around 25 per cent) in Beidha were wearing the full-face veil (*niqāb*), not seen a few years earlier during a pilot study in 2005. The rest wear the typical veil (*hijāb*), unless they have not reached puberty when they do not wear a veil. People increasingly perform public prayers and fasting, whereas other religious practices more often associated with 'folk Islam', such as saint veneration, are rapidly decreasing, now seen as un-Islamic and part of past ignorance, as Hussein illustrated.

The religious transformations mentioned above point towards the development of a particular kind of understanding of Islam, articulated through the increasing access to satellite television that is often produced by Muslims inspired by Salafi, Wahhabi and Muslim Brotherhood understandings of Islam (see also Mittermaier 2010; Moll 2010). The theological inspiration is evident in arguments undergirding the emerging awareness of and resistance against so-called materialism in the face of the increasing wealth of the population in the area. 'Materialism' is presented as adherence to consumer society at the expense of the spiritual realm: that is, forgetting one's spiritual needs

while focusing on buying more stuff and defining oneself through a reliance on new, as well as old, things. Things, such as food, clothes, mobile phones, cars, houses, etc., are of course needed, but one should not rely too much on them. The car is important, but if it becomes too important and a person relies too much on it to assert his or her status, it is a problem. The material object, in a sense, takes over from being a representation of one's personal character, to presenting in material form this character. With Hussein, the problem is not about caring for the memory of past generations at the grave, but about the idea that the dead can mediate with God through material objects. In other words, the specific presence or absence of things is at the centre of discussions about what it means to be a good Muslim, to care for the past and to be a modern Bedouin.

Outline of the Book

The book is structured in a narrative that takes the reader from the interplay between heritage organisations, national and more regional authorities, and individual actors on the heritage scene in the following three chapters, to chapters dealing more with local processes of navigating between more abstract universal religious claims and local traditions. This also implies a move from relying largely on archival research in Chapters 1 and 2, towards qualitative ethnographic methods used to explore the affecting and mediating role of present or absent objects and the potentials they afford.

Chapter 1, 'Preserving Heritage – Marketing Bedouinity', outlines the heritage context of the Bedouin by discussing the consequences of the rapidly spreading universalising claim of a world heritage, which culminated in the UNESCO-backed heritage protection of Petra. A perception of the pristine, depopulated landscape inherent in the heritage strategy has been instrumental in shaping spatial changes by settling the Bedouin and transforming nomadic life into an economy based on agriculture and tourism. The chapter argues that, in effect, a hyper-nostalgia is presented through iconic Bedouin objects, such as the camel and the tent, that solidify new identities among settled Bedouin. To the tourists, Petra is represented as a remote place, where visitors can relive ideas of discovering a 'lost city' and even meet the Bedouin, who have been the focus of romantic narratives in both Western and Arab minds. The chapter scrutinises more closely the link between national identity, premises for preserving heritage in Petra, and the local adaptations to the tourism economy. This is done through 'imaginings of presence'

unfolding in nostalgic narratives and re-enactments shaping an image of Bedouin presence in the area. The chapter argues that the tensions and contradictions between heritage management, discourses of preservation, and people living in the area have produced nostalgic narratives to meet tourist demands and post-nomadic negotiations of Bedouin identity.

In part through archival research, Chapter 2, 'Taming Heritage', explores the process of safeguarding intangible heritage through UNESCO heritage lists. The power of the past in grounding cultural identities relies on its ability to create desirable objects out of historical figures, traditions and things. While these traditions or things may have changed rapidly or been left to dilapidate, it is when they almost disappear – that is, in the transformation from presence to absence – that people become aware of their social, material and political importance. In essence, the chapter shows how the potential absence enforces strategies that in effect assemble a particular presence anew. This is seen through the case of the international celebration of Bedouin traditions. Of course, this does not imply that people today necessarily want to live under the conditions that fostered the tradition. Yet claims to be 'near' – either genealogically, spatially, in practices or as caretakers – are powerful tools in negotiating cultural and national identities. By investigating the multiple interests that link local actors with national and international policies, the chapter argues that through the process of enlisting the Bedouin in UNESCO's universal ideals of safeguarding and promoting intangible heritage, the very notion of 'Bedouin' is transformed from an empirical category of (semi)nomadic pastoralism into a definition of cultural practices that many settled Bedouin, and even non-Bedouin, may identify with. The chapter thereby captures how national identity is shaped by taming particular kinds of Bedouin figures through universal heritage recognition.

Chapter 3, 'The Shameful Shaman', concerns the effects of fitting the past into the present to suit spiritual needs, where there is not just one, but multiple versions of a renowned figure from the Bedouin past. In the UNESCO documents discussed in Chapter 2, the figure of 'Bedouin shamans' occurs, and this chapter explores the origins of this figure. The chapter shows how New Age discourses about original universal shamanic roots are applied to the Bedouin saints and healers by an urban, non-Bedouin elite of heritage entrepreneurs. This shamanistic turn, however, conflicts with local ideals where the past is told through an emerging Islamic revival. The chapter argues that multiple versions of religious figures may coexist to support individual claims to

universality because the precise definition of what the figure is remains undecided. In this chapter, we thus turn to the broader question of heritage in tourist representations and the spiritual universes within which Bedouin heritage in Jordan is entangled.

Chapter 4, 'Dealing with Dead Saints', maps out the saint graves in the Petra region and investigates protective practices and oral traditions relating to the graves, which are celebrated in the UNESCO intangible heritage proclamation. The people visiting the graves are not certain that healing will occur, but rather recognise the potential for healing. The chapter includes a discussion of how the 'potentiality' of the dead saint to interfere in people's life is a crucial feature in debates about the role of protective practices in a context of Islamic revival. Here, Hussein's statements which opened this book, resting on the universal ideal of one unified Islamic practice, are competing with the local folk Islamic narratives of the power of things. In that sense, we are moving from parallel efforts to solidify the notion of where and what the Bedouin is, to engaging with discussion of how things are present in those negotiations.

Chapter 5, 'The Allure of Things', explores the protective strategies that the Bedouin have used (and to some extend still use) to protect themselves against misfortune, discussed in the UNESCO intangible heritage proclamation. These material strategies are part of local conceptualisations of heritage and traditions and are presented in ethnographic museums and to tourists as essential Bedouin cultural heritage. Yet these objects are also increasingly contested as un-Islamic among the Bedouin themselves, thus raising questions for interlocutors of how the amulets actually work. The chapter examines how the material practices and traditions of protection against danger enter a contested scene of displaying religious deviance through conceptions of materiality. What is needed is a notion of presence that enables protection, resting on being a materially irreducible – and spatially present – object.

Chapter 6, 'Ambiguous Materialities', continues the exploration of how to handle misfortune by examining the predominant way of protecting against misfortune, namely Koranic merchandise. This merchandise constitutes an ambiguous material category. It is not understood as essentially material, but rather as the immaterial 'Word of God', which carries with it a wide range of moral prescriptions on how to deal with their materiality. The chapter thus deals with a radically different kind of presence than in Chapter 5. The social stakes are high in the precise understanding of the relationship between human, thing and God as conceptualised in protective registers and

traditions. Chapters 4, 5 and 6 thereby also touch upon the question of the everyday life of being a Muslim, Bedouin and Jordanian, where past and modern practices and conceptualisations merge, often in a seemingly unproblematic manner, while at other times minor deviances carry with them powerful social effects. The chapter addresses spiritual healing, spirit possession and fortune telling, which still occur in the area, even if religious scholars denounce these practices as heretical and ignorant. In line with recent literature on ignorance, the chapter argues that ignorance is not just a matter of not knowing, but also of social evaluation. The chapter extends this insight by highlighting how ways of knowing and not knowing tie into the religious morality of dealing with the presence of things and the processes of taming them.

Finally, the conclusion summarises the arguments and outlines how notions of materiality and processes of taming help us to understand how claims to universality and establishing a dichotomy between a purist and folk Islam come to matter. Such concerns are increasingly important as Jordan's neighbouring countries are set aflame, threatening national unity, cultural identities and the very presence of tangible remnants from the past, and the practices that have been passed over and reformulated for generations.

Notes

1. Pseudonyms are used for all interlocutors unless they hold an official position or have published documents by which they can be regarded as publicly accountable for their opinions and statements.
2. This book is mainly based on thirteen months of anthropological fieldwork in Beidha Housing living with an Ammarin family of two adults and eleven children in a house with two rooms that was extended with an extra storey during my stay from summer 2006 to summer 2007; it followed seven years of archaeological fieldwork, undertaken every summer since 1999, and an anthropological pilot study in 2005. Two more months of postdoctoral fieldwork followed in 2011. Interviews and conversations were conducted predominantly with men but also with fifteen women.
3. As always, there is an 'ethnographic present'. I deliberately avoid dealing with processes which evolved after my last fieldwork in spring 2011. Since then, the Arab uprisings have changed many things in Jordan, with a major influx of refugees, together with various oppositional political voices calling for both calm and solidarity. In this context, the question of heritage and the role of things has not lessened. This is particularly evident in the large-scale destruction of and illicit trade in archaeological artefacts in Syria, which show that things matter – even if in this book I do not investigate these further developments.

4. The settlement policies represented the beginning of a period of rapid change which affected nomadic Bedouin culture all over the Middle East. This also led to increasing ethnographic interest in these changes (Cole 1981; Marx and Shmu'eli 1984; Nelson 1973; Salzman and Galaty 1990; Salzman and Sadala 1980), perhaps even disproportionate compared with Middle Eastern anthropology in general. There was an increased passion for studying the 'most' Bedouin, i.e. those travelling farthest with camels, that had prevailed in nineteenth- and early twentieth-century ethnographies (Cole 1975; Doughty 1883; Jabbur 1995; Lancaster 1997; Raswan 1935).

5. Since 2011, with the uprising in the Arab countries, and the Syrian civil war in particular, the country has been one of the highest recipients of refugees.

6. *Jordan Times*, 2 July 2008.

7. http://www.jordantimes.com/news/local/jordan-made-leap-modernity (accessed on 5 August 2015).

8. According to Prime Minister Bakhit in *Jordan Times*, 3 June 2007. Other sources claim 6.9 per cent in 2004 (Daher 2007a: 23), and 8.5 per cent in 2000 (Hazbun 2008: xv).

9. Few families still live in the area. However, in times of economic instability, many otherwise settled Bedouin move, at least briefly, into tents again.

10. There are four major sheiks (tribal leaders) of the Ammarin tribe in Jordan: Sheikh Abu Susha and Sheikh Abu Tawfik in Qurayqera, Abu Rakat in Bir ad-Dabaghad and, during my fieldwork, the official Sheikh Suleiman Mohammed Shtayyan Abu Adef resident in Aqaba. On the death of the latter in early 2008, his place was given to Sheikh Atallah Mohammed Abu Khaled. Beidha has a mayor and a local sheikh, both from the Awwad family line, and one sheikh from the Hmeid family line, who often act as official representatives in issues of tourism development. Furthermore, splinter groups and families of the Ammarin are living in Aqaba, and a Christian section in Kerak.

11. Other scholars claim that they are part of Howeitat (Banning and Köhler-Rollefson 1992: 187). This may be due to an alliance between Beni Atieh and Howeitat; however, my interlocutors would claim that their origins lie with Beni Atieh. One version of Ammarin genealogy bases their origins on mythical or historical people such as Adnanyyīn, followed by Asad, Rabaʿ, Atieh, Maʿaz, Ammarin, Abdallah and Mansour. Interestingly, when I accompanied some of the men to Amman, they would claim that they were from Howeitat or Beni Atieh, rather than Ammarin, as a way of gaining respect from people they met, instead of being associated with Petra, with its connotations of tourism.

12. The Ammarin in Jordan consist of ten major family lines (*ayal* or *fekhdh*). The three major family lines are Hmeid, Awwaḍ and Bekhit, from which others derive, such as Mʿteb and Hassasīn from Bekhit, or Suelim, Jummaīn, Jumaʿh and Salem from Awwad. Some lineages, such as the Awwad, claim centuries-long genealogies. Others are new, for example the Jummaīn lineage, which derives from the Awwad line three generations back. The major family lines in Beidha are the Hmeid and the Awwad. The Awwad in Beidha Housing mainly (but not exclusively) used to live around al-Fersh, whereas the Hmeid mostly lived around Sidd al-Ahmar. Both lived in the

now abandoned village of Khirbet Neg ʿa from the early twentieth century, close to Beidha Housing, which today functions as a storage facility.

13. Department of Statistics Population and Housing Census, 2004. For comparison, Umm Sayhoun has 1,352 inhabitants (predominantly Bdoul tribe), 197 households, and Wadi Mousa has 14,162 inhabitants (predominantly the Liathneh tribe), 2,446 households.

14. http://www.new7wonders.com.

15. The Bedouin in Jordan for most part belong to the *shāfiʿī*-school of Sunni Islam. However, Canaan (1930) notes, in case of the Bdoul in Petra in 1929, that this was more in name than in practice. He observed that among his interlocutors none of them could recite the opening verse (the first and most important verse of the Koran), and none of them prayed regularly, in contrast to the Liathneh of Wadi Mousa. While this has changed, the social positioning in terms of religious awareness is to a certain extent still present among the tribes. Today, the surrounding tribes tend to be condescending towards the Bdoul for their practice of Islam, which in general is more relaxed than that in Wadi Mousa or among the Ammarin.

16. One member of this part of the tribe, Nazih Ammarin, became a member of the Jordanian parliament. The stories about how this family became Christian differ, but it is commonly told in Beidha that at the end of the nineteenth century, a male Ammarin fell in love with the daughter of the owner of a major farm around Kerak. The father of the girl accepted their marriage on the condition that the Ammarin converted to Christianity and raised the children as Christians.

℘ 1

PRESERVING HERITAGE – MARKETING BEDOUINITY

Introduction

It is impossible to avoid being invited to dinner when living with the Bedouin and a lot of time is spent in cars to and from parties, thus constituting a steady input to field note entries. One evening, for instance, I was returning home from a dinner with a goat herding Bedouin family that lives in a tent in the mountains inside the Petra National Park. I was in a car with Ahmed – a young man in his mid-twenties with a university degree – and his older sister and mother, when we saw a distant light flickering on one of the monuments carved into the sandstone. To Ahmed, this called for action. Like many other Bedouin, he was employed in part as a park ranger, responsible for upholding the national park legislations in the area. We drove towards the light and soon saw a large group of around twenty tourists, sitting comfortably among the Nabataean and Roman monuments, around a small bonfire, with water pipes, ouds playing and a group of six or seven young Arab men entertaining them. I initially saw nothing odd in this, since I often took part in such evenings with the Bedouin in the desert. Except, I did not know these young men, it was at night, and it was within the national park perimeter.

Ahmed jumped out of the car and rushed over to the group, while the two women stayed in the front of the car and, due to limited space,

I was left standing on the truck body of the pickup. The group of Arabs quickly came to meet Ahmed and made it clear that they were from Wadi Mousa – the neighbouring village dominated by farmer tribes – and that they had organised a small tourist trip to the area to experience the desert night sky. There was a clear sense of hostility in the air. Ahmed, knowing very well that neither fire nor tourists were permitted within the park area at night without permission, insisted that they leave the park area and reconvene somewhere else. What the tourists and young men from Wadi Mousa were doing was a clear violation of regulation and would lead to the destruction of heritage-protected monuments. The young men, however, could not risk losing face by having to move a lot of tourists. They suddenly started pushing Ahmed, one pulled out a metal pipe, and they got ready to fight. When that happened, the two women came out of the car, and I jumped off the pickup truck and rushed to his aid, eventually calming things down.

Aside from dinner invitations and car rides, there are two more things anyone living in this area knows for certain: no one touches a woman from one of the Bedouin tribes, and no one gets in a fight with a foreigner. In the first case, you will have a lot of tribal members on your back, since violating the sacrality (*ḥurma*) of a woman (also *ḥurma*) is one of the most heinous acts (see also Bourdieu 1966; Kressel 1992). In the second case, the police who insistently wish to secure the reputation of Petra as a safe, tourist-friendly area rarely trust the words of a young, local, male tourist guide over a foreigner.

We ended up driving away and called the police and some of the other Ammarin in the village. It only took a few minutes to get to the village, but a group of forty adult men, with more coming in pickup trucks, had already gathered in the village, waiting to hear what had happened. In the end, the police came and picked up Ahmed, his brother and me, and drove us to the group of Wadi Mousa men and tourists to mediate. While Ahmed, his brother (a secret police officer), the police and a spokesperson from the group talked, I chatted with one of the other people from Wadi Mousa. He explained that the tourists wanted to have a 'Bedouin experience'. Jokingly, I asked why, then, did the tourists not come to the 'real' Bedouin instead of the farmers (*fallāḥīn*) from Wadi Mousa; to which he simply explained, 'tonight, we are Bedouin'.

The example illustrates many aspects of living with the Bedouin: from the role of women and tensions over the tourist economy, to the lengths people will go to in order not to lose face, even when clearly in the wrong. More important, however, is the fact that despite being relocated from the archaeological landscape of Petra due to

the preservation legislation of the monuments, the Ammarin take the task of protecting it very seriously. Clearly it is their job, and the monuments are their livelihood as tourist destinations. Yet it is also seen as a collective responsibility beyond their individual jobs as park rangers. For instance, as the Bedouin walk the mountains with their goats, there is a constant awareness of something out of place. It is an act of protection that involves their landscape: it may not be 'theirs' by law, but it is in their minds through their historical attachment to it. It is a landscape filled with oral histories, with names linking specific families to places, either by stating who owned it at some point in the past or by narrating a story of an event – for instance, a place which is named after a mother giving birth there. In that respect, any infringement on regulations – at least when done by non-Bedouin – is met with a seriousness not seen in most other situations, as if the fact that they no longer live there makes the responsibility to care for the landscape even more pertinent. Caring for the archaeological landscape comes to stand in for the absence of an intimate dwelling relationship. The example also shows that – at least in the meeting with tourists – a certain enactment of being 'Bedouin' by farmer groups, who otherwise often show resentment towards the Bedouin, is framed by nostalgic images of desert evenings for the tourists.

In this chapter, I explore how the act of protecting the monumental landscape in Petra entails a premise of removing and 'modernising' the Bedouin by re-settlement. In this process of detaching the Bedouin from the landscape, however, a range of double standards also become evident, where non-Bedouin can do things the Bedouin cannot, thus illustrating tensions between government agencies and local practices. This, I claim, has led to an even more focused concern on, and room for navigation towards, who is entitled to which rights in relation to preservation legislation. The politics of preserving the landscape are followed by exploring the way in which new economies emerge in the light of increasing tourism, and the potentials of this for shaping post-nomadic Bedouin identity, both among the Bedouin and, as we saw, among the farmers taking on a Bedouin identity at certain times. The point is not to essentialise who is Bedouin, as the term is both a discursive and strategic category (Eickelman 2002: 65). This is important to note, as even the Ammarin – beyond tourism contexts – refer to themselves in Arabic more often as ʿarab (as a category between settled and long-distance nomadic pastoralism) than as *bedu* or even *arab* (without the ʿayn) (see also Abu-Lughod 1986: 44; Layne 1994: 15–16). When *bedu* is used, it is more often invoked to denote the heritage connections of nomadic Bedouin groups across the Middle East.

A central analytical focus in this chapter is how anticipations and desire for presence of and in a landscape inflict on politics and identity formations.[1] The heritage protection of landscapes relies on the universalising claims of UNESCO heritage protection, which here become the catalyst for configuring oneself as caring for and invested in the landscape. By looking at the desire for presence, we may better explore the object-like appearances that landscapes develop, as in heritage preservation strategies where people are relocated. Firstly, we take a broad-scale approach through archival studies and statistics and turn to the policies and effects of settling the semi-nomadic Bedouin in response to preserving ancient monuments. Then, through more ethnographic methods, we turn our focus to how local initiatives are developed concerning the tensions between government and locals. The key point is how a universal notion of preservation is spreading as an effect of UNESCO heritage recognition, through which the local Bedouin adopt and navigate their lives and economies.

Preserving a Pristine Landscape

In 1985, Petra was proclaimed a UNESCO World Heritage site.[2] The recognition of its outstanding value to humanity as an archaeological site was born of the increasing attention from archaeologists and heritage organisations during the previous decades, and the increasing pressure from tourism (see Comer 2012). Aside from protecting the scientific and aesthetic value of the Nabataean monuments, the UNESCO proclamation meant a further step towards transforming the Bedouin around Petra into a settled population.

The settlement process of the Bedouin that had taken place in most of Jordan in the 1960s had failed here. In one instance in Petra, a brief armed rebellion even broke out among the Bdoul inhabiting the central area of Petra (Shoup 1985: 283). By the mid-1970s, the Bdoul had eventually accepted a resettlement site. The government had decided to build two main villages for the Bedouin on the outskirts of what became Petra Archaeological Park: Umm Sayhoun predominantly for the Bdoul, and Beidha Housing predominantly for the Ammarin. But settling the Bedouin was by no means an easy process. Little archival documentation is available for the Ammarin, but the Bdoul had accepted on the basis of a building plan provided by the UNESCO architect 'Abd al-Wahed al-Wakil, which incorporated self-built houses, walled gardens and places for the animals (Management Plan 1994: 76). Yet, the type of houses that were eventually built had no places for

the animals, no walled gardens, and were too small. This resulted in a situation where, at least until recently, one may find buildings with animals instead of people in them – as some people instead lived in tents in the village. To add to the problems, the village was built on land owned by the Hassanat branch of the rival farmer tribe Liathneh from Wadi Mousa. The Hassanat were not compensated for their land, nor for the olive trees they had planted in protest (Management Plan 1994: 77). Another plan to relocate the Bdoul was ill-received, and eventually dropped by Petra Regional Planning Council[3] (Brand 2001: 969). The whole settlement process was thus one where the tensions between government, Bedouin and local tribes were forged.

The process was much more problematic for the Bdoul, in the heartland of the tourist area, than for the Ammarin. But like the Bdoul, the Ammarin were also included in the modernisation process that intended to strongly encourage the Bedouin tribes to become farmers and abandon mobile pastoralism. Within a single week at the end of April 1985, the same year that Petra became a UNESCO site, a solution was finally found and eighty Bdoul families moved from their tents and caves to the houses; fifty-two more families moved in 1987 (Farajat 2012: 152; see Geldermalsen 2006: 265–69 for a personal account), while the Ammarin in Beidha would move a bit later. One source of motivation for people to move quickly were rumours that unless people accepted the houses, the authorities would withdraw the offer of the properties, thus leaving people with nothing.

On 9 March 1993, after several advisory teams and experts had visited Petra,[4] the area was declared a national park. It is known in English as the 'Petra Archaeological Park' and was at the time of my fieldwork directed by Dr Suleiman Farajat. The official document, signed by a council of ministers, established the 264 km² park – located within the larger Petra Region in Ma'an governorate[5] – which was to be administered by the Department of Antiquities (DoA). According to most reports, the aim of the park is to protect the archaeological remains, preserve the environment and develop it as a tourist attraction. Therefore, certain restrictions of use for the area apply: local tribes are only allowed to exploit certain areas for grazing, depending on their tribal affiliation, and they can only harvest grain. Along with the restrictions in the official document and subsequent management reports, it is also prohibited to build in concrete within the area, and grazing herds in the Petra basin is discouraged and restricted, since goats – more than sheep – wear out the archaeological remains in the soft sandstone (PAPOP 2000: volume 2, section 2: 50). While grazing does still occur, even in central Petra, heavy fines have been imposed (Addison 2006: 79).

Inherent in the UNESCO reports, recommendations and eventual protection strategy, is the notion of protecting the integrity of the landscape (Addison 2006: 102; Palumbo and Cavazza 2004: 13). This is particularly clear in the more correct translation of the park's Arabic name, *maḥmiyya athariyya al-batra*, as 'Petra Archaeological Reserve'. The term 'reserve' denotes a non-interventionist approach, where people should only leave the smallest mark possible on the nature and archaeological remains, also known from the US National Park Service, as a site of preservation (Addison 2006). The difference between 'reserve' and 'park' is not pedantic semantic. The emphasis in Arabic on 'reserve' rather than 'park' entails the decision to remove the inhabitants, and in a sense 'dehumanise' the very notion of landscape with object-like features. In essence, the protection strategy was about constructing a landscape, with no local people or marks of their previous presence. This conceptualisation of the landscape is related to, but also contrasts with, the local notion of landscape, which they call *al-barr*. *Al-barr* denotes a landscape where there are no roads or modern houses; however, centrally, it is not a landscape devoid of people. Much like the English term 'wilderness', *al-barr* is a place to go to, where wildlife lives – a place where one can live in a tent, hunt and go camping. It is a place for the idealised 'Bedouin way of life' but is also in contrast to the official national reserve legislation.

The notion of the 'integrity of the landscape' rests on a very modernist kind of protection paradigm that relies on the Enlightenment dictum that landscape is 'pristine' and 'wild' (Sweetman 2004), which spread rapidly across the globe during the twentieth century (although it is also increasingly contested by indigenous movements). In Petra, this notion incorporates human encounters in times past, particularly the Nabataeans and Romans, but it excludes the Bedouin living there over the last several centuries, under the presumption that they have predominantly had a negative impact on the environment. Even if this may be the case in certain areas, it could be argued that the policies adopted in order to preserve the landscape were in themselves interventionist by removing people from the 'equation' (Addison 2006: 107–109; Chatty and Jaubert 2002). To let Petra come to life and to secure its preservation, the Bedouin needed to be kept at a distance. Today, only a limited number of Bedouin live within the park and those who do live away from the main tourist areas. There are still tensions between the Bedouin and the authorities, but now the Bedouin only rarely use the Nabataean caves and tombs, as they used to, as dwelling places and animal sheds; meanwhile, their activities as tourist guides now help to prevent tourists from getting lost or having accidents. In

large part, this is the result of the particular logics of UNESCO heritage preservation and the expert guidance that follows.

Actors of Protection

Four major management reports have been written about the protection and preservation of Petra. In the rare cases when these include information about the Bedouin, it is mostly about the Bdoul. However, the plans and regulations also apply to the Ammarin and other tribes. The first report was the *Master Plan for the Protection & Use of Petra National Park* from 1968 (henceforth 'Master Plan 1968'), prepared by the US National Park Service. Here, the definition and intention of a national park, as a universal entity, is clear:

> Generally, *National Parks* are established to preserve outstanding examples of national heritage. They are in a sense, greater outdoor museums requiring only such developments as are needed for the areas' protection and administration and as required for the comfort, understanding and convenience of those who visit them for the recreation and inspiration they offer. Commercial uses such as farming, livestock grazing, hunting and mining are inconsistent with this concept. (Master Plan 1968: Foreword, original emphasis)

In other words, the aim is to protect the landscape and prepare it for visitors. In this report, the intention concerning the local Bedouin population is also unmistakably clear – to modernise the Bedouin economy:

> Resettlement of the Bdoul tribe is one of the most urgent requirements of this plan if the government is to preserve and develop Petra as one of the great national parks of the world …the overall objective of this program is to help the tribesmen to take up successfully a village-farming way of life with such social benefits as basic education and medical help being provided. (Master Plan 1968: 22, 24)

In 1994, the first major report with recommendations from UNESCO, after the enlistment in 1985, was published: *Petra National Park Management Plan*. Here, the recommendation and problems encountered by the impact of tourism on the monuments are outlined. It also deals with the social problems – particularly relating to the Bdoul. This report marks a slight shift towards viewing the local population as actors in protecting Petra, where previously they had been largely ignored. Although this report mainly deals with the preservation of the monuments and environment, it gives several recommendations that include the local population. For example, in the case of the Ammarin, the report suggests making a tourist rest house in Khirbet Neq'a near

Little Petra, as well as a zoning project to limit erosion and grazing. By 2007, only the zoning project had been initiated. This report is the basis for many of the projects and regulations that still apply to the Petra Park today. Yet, as we shall see, the recommendations are often exceeded by various actors.

By 14 December 1996, the *Management Analysis and Recommendations for the Petra World Heritage Site, Jordan* was submitted, which followed both the 1968 and the 1994 reports in only sporadically incorporating the local population in the management of the park by encouraging handicrafts and museums (Management Analysis 1996: 92–94; Management Plan 1994: 188). Most engagement with local populations focuses on the potential development of settled communities, including income generated from sectors other than tourism. The reports also insist that the Bedouin must engage with the landscape in ways that will minimise the 'threat' to the environment and archaeological remains by overgrazing. In a similar vein, reconstruction is not recommended for any structure or landscape in Petra (Management Analysis 1996: 79). However, in contrast, reconstruction and applications of new stonemasonry techniques are part and parcel of several of the archaeological projects being undertaken there, such as at the Great Temple monument and the Theatre. Yet as administrative rulings often surpass the legislation, there have at times been rumours of Petra's removal from the UNESCO heritage list.

The detailed *Petra Archaeological Park Operating Plan* (PAPOP) followed the 1996 report. Published in 2000, the plan was a collaboration between the Jordanian Ministry of Tourism and Antiquities and the United States National Park Service. Here, the implications of tourism and use wear are documented.[6] The report included a detailed plan on which jobs and positions were recommended for managing the park, and focused on the impact of the site's use. In particular, it addressed the impact of modern technologies on the environment and animal life, such as artificial light during night-time (PAPOP 2000: volume 2, section 2: 62).

In all these reports, the importance of 'sustainable' use and preserving the 'integrity' of the landscape is stressed, often by restricting the local population in their engagement with it. Yet, those putting forward such recommendations are in a constant battle with investors who want to prosper from the economic growth provided by the many visiting tourists. Heritage protection in that sense creates desirable objects for tourists and investors and being on UNESCO's world heritage list is bound to increase tourism and investments in an area, and thereby increase the pressure to effectively manage whatever protective strategy has been adopted.

Unlike the rejections and problems that emerge when local Bedouin take the initiative to establish their own shops, investors have often succeeded in establishing themselves at the site. A discrepancy thus seems to develop between what central government and large companies can do, and what the local populations is allowed to do. In Petra, evidence of this is provided by the technically legal constructions within the main tourist area. There is a Crown Plaza restaurant, a Bdoul managed restaurant, new hotels in restricted areas, and a sound and light show during the night ('Petra by Night' or Mövenpick parties in Little Petra). These developments are approved due to the many overlapping responsibilities involved in managing and protecting the park.

In relation to the issues of protecting the 'integrity of the landscape', and ideas about non-intervention and greater outdoor museums, they appear inconsistent, however, among Bedouin interlocutors, heritage consultants and the heritage industry itself. The overlapping responsibilities stem from the several institutions involved in managing the area. One is Petra Regional Authority (PRA), which was established in 2002 as an extension of the Petra Regional Planning Council, which dates from 1995, and governs the development of the region.[7] Another is the Petra Archaeological Park (PAP), which is responsible for the actual management of the park and its adherence to strategies and policies developed by the Ministry of Tourism and Antiquities and the Department of Antiquities.

However, PAP is often not sufficiently funded to carry out major work in the area and the Bedouin tribes are rarely represented in the decision-making process.[8] This has left a sense of disempowerment among the local Bedouin that many of my interlocutors expressed by saying 'we were here first'. The Ammarin tourist shops in Little Petra have so far been ignored or have only very slowly had new regulations introduced to avoid escalation of a tense situation. But, most often, new initiatives are prohibited from developing within the park area. It is in the light of this heritage protection and limited access to developing tourist features for the Bedouin that the initial tension between Ahmed and the Wadi Mousa group must be seen. The protection efforts are dominated both in governmental heritage offices and in the private tourist industry by personnel from Wadi Mousa – which is also the city that governs the entrance to Petra physically.

The double standards of preserving the monuments by resettling the Bedouin, but allowing for economic developments within the zone, have also been criticised internationally by statements in UNESCO journals, such as: 'from now on we are making sure that nothing which can have a negative impact on Petra will be built' (Ayad 1999:

41). The general threats to Petra by its users (including the Bedouin) are attested to by Petra's listing on the World Monument Watch in 1996, 1998, 2000 and 2002.[9] As a result, in 2007 a new by-law was implemented for the Petra Archaeological Park administration to avoid overlapping responsibilities and development. What is important in these protective guidelines is that there is an inclination and desire to treat the landscape as a 'reserve', as something 'untouched' and as a 'natural' object, which provides a direction for the heritage strategy, rather than incorporating the local inhabitants into the conception of the landscape. The reports listed above increasingly accept the local population and try to incorporate them in some way. However, most often it is on the condition that they do whatever they do outside the park, and that they give up their pastoral nomadic way of life.

All local interlocutors expressed the importance of protecting Petra against destruction, as witnessed by Ahmed's actions in relation to the tourist events in the mountains. But most disagreed on the impact that grazing and tent-life have on the protection of Petra. As one interlocutor stated, 'camels are not hurting the reserve, the reserve is hurting the camels'.[10] An eighty-five-year-old interlocutor was more outspoken: 'The reservation harmed us and left us with nothing. As if it is in another country. You are not allowed to plough, to build a wall. The Park is protected ... Conservation and conservation, what's this nonsense?'

Along with PAP and PRA, 'Petra National Trust' (PNT) must be considered one of the main actors involved in managing and developing the park.[11] PNT is a non-profit and Non-Governmental Organisation. Despite its independent connotations, it is closely linked to the Royal Family, particularly Queen Noor, who has been a patron and chairperson since its inception in 1989, when Prince Ra'ad bin Zeid was president of the Board.[12] It has seven full-time and nineteen part-time employees. In principle, it has the mandate to preserve the antiquities, environment and cultural heritage of Petra. In practice, it has rarely included Bedouin cultural heritage. One of the organisation's aims has been to develop a management plan for the Petra Region that coordinates the many different institutions and departments that are involved in preserving, developing and maintaining the Petra region. Therefore, they have worked closely with PRA to implement the recommendations proposed in the UNESCO Management plans cited above.

PNT considers its own role to be one of acting through advocacy. PNT is often called the watchdogs of Petra by others and ensures that developments in the region are in accordance with UNESCO's recommendations and legal jurisdiction. PNT has often been able to

ensure that projects, such as the conservation of the hydraulic systems (for which the Nabataean builders were famous), are completed and employ local Bedouins over extended periods. Their work faces several obstacles, however. One obstacle is 'precedence', which makes it difficult to ban one development, such as concrete buildings in Petra, because others have previously been successful in obtaining permits. This situation relates to the second problem. While overall ideas of preservation are employed universally as a condition of being included on UNESCO heritage lists, the many overlapping responsibilities developed locally create opportunities for unwanted development, such as hotels in restricted zones. Thirdly, the local population has not received much attention from governmental bodies beyond accommodation, education and healthcare, and some still find it very difficult to earn a sustainable income. Some people have achieved considerable wealth, but sustained economic growth for every part of the communities has been limited outside the main tourist areas in Petra, Wadi Mousa hotels and, to a lesser extent, in Taibeh, further south.

There is a general agreement among officials, inhabitants and NGOs that since resettlement only limited support has been given to the Ammarin to help them adjust to their new conditions or to enable them to shape their own lives in sustainable ways. While this relationship has slowly improved over the last twenty years, most decisions are made with little or no direct input from the Bdoul and Ammarin. The heads of organisations and offices that deal with the management of Petra are from Wadi Mousa or based in Amman.

In line with other reports and preservation perspectives on Petra, the aim of PNT is to 'preserve the integrity of Petra's unique combination of archaeological heritage, cultural heritage and the natural environment', while integrating 'the interests of all local stakeholders into preservation efforts in Petra and its region'.[13] However, PNT itself argues that the relationships between stakeholders are somewhat uneasy, since the Bdoul are restricted by the space available to them, and the Ammarin by access to tourist income. Little has been done to preserve or present Bedouin cultural heritage on their part, despite UNESCO recommendations to incorporate them. Furthermore, as mentioned above, these two tribes have only limited direct influence on the management and development of the area, which is dealt with primarily by people from Wadi Mousa.

The preservation paradigm outlined above is typical across the world, where local communities are rarely incorporated into decision-making processes, and the basic premises are in terms of preserving something pristine and seemingly untouched (or only touched

negatively) since ancient times. The protection process aims at creating a desirable object out of the remnants from the past. Accepting that monuments need protection is not only about making sure that they do not further deteriorate; it is also about protecting them in the right way, using the right methods and materials. But the strategies are not merely about the science of preservation. It is also, particularly in Petra, about a main tourist narrative to 'discover a hidden city' devoid of encountering Bedouin living quarters (figure 1.1). This image of a lost city is most potently conceived in Hollywood blockbusters such as *Indiana Jones and the Last Crusade*. Yet, people, even the tourists, still have to be able to enter the area, and as the monumental Petra landscape reaches ever more fame as a desirable object, so too do the emergent economies become centre of attention.

Shaping New Economies

While there are no hotels in Umm Sayhoun and Beidha, development has been dramatic in Wadi Mousa. In 1982, there was one hotel. According to May Shaer (2008), a conservationist working in Petra, there were sixty-two in 1995. The average length of stay for tourists in Jordan in 2007 was 4.3 days,[14] and in Petra alone, 393,186 people visited the Archaeological Park in 2005 and paid 21 dinars as an entry fee (Jordanian residents pays 1 dinar). This was a 26.7 per cent increase compared to the year before, and 26 per cent of the visitors came in March and April. In 2006, only 359,366 visited, partly due to the Israel–Hezbollah war. During this period, there were days when only around one hundred people entered Petra. However, 2007 was a record year, with 580,000 visitors to Petra. The increase is attributed to Petra's nomination as one of the 'New Seven Wonders of the World', which occurred on 7 July 2007. The numbers highlight how income in Petra is highly dependent on regional forces and international recognition and publicity, and thus so are the local inhabitants.

The Bdoul in Umm Sayhoun are surrounded on three sides by the national park. The Liathneh from Wadi Mousa own the last side. During the twentieth century there had consistently been conflict between the Bdoul and the Liathneh from Wadi Mousa, who control most of the tourism resources, such as hotels, shops and horses (Kooring and Simms 1996). While space is a major issue among the Bdoul, for the Ammarin it is access to the economic benefits of tourism that is of primary concern. Little Petra, which they control, is not attracting as many tourists as hoped for, and they often come in buses with their

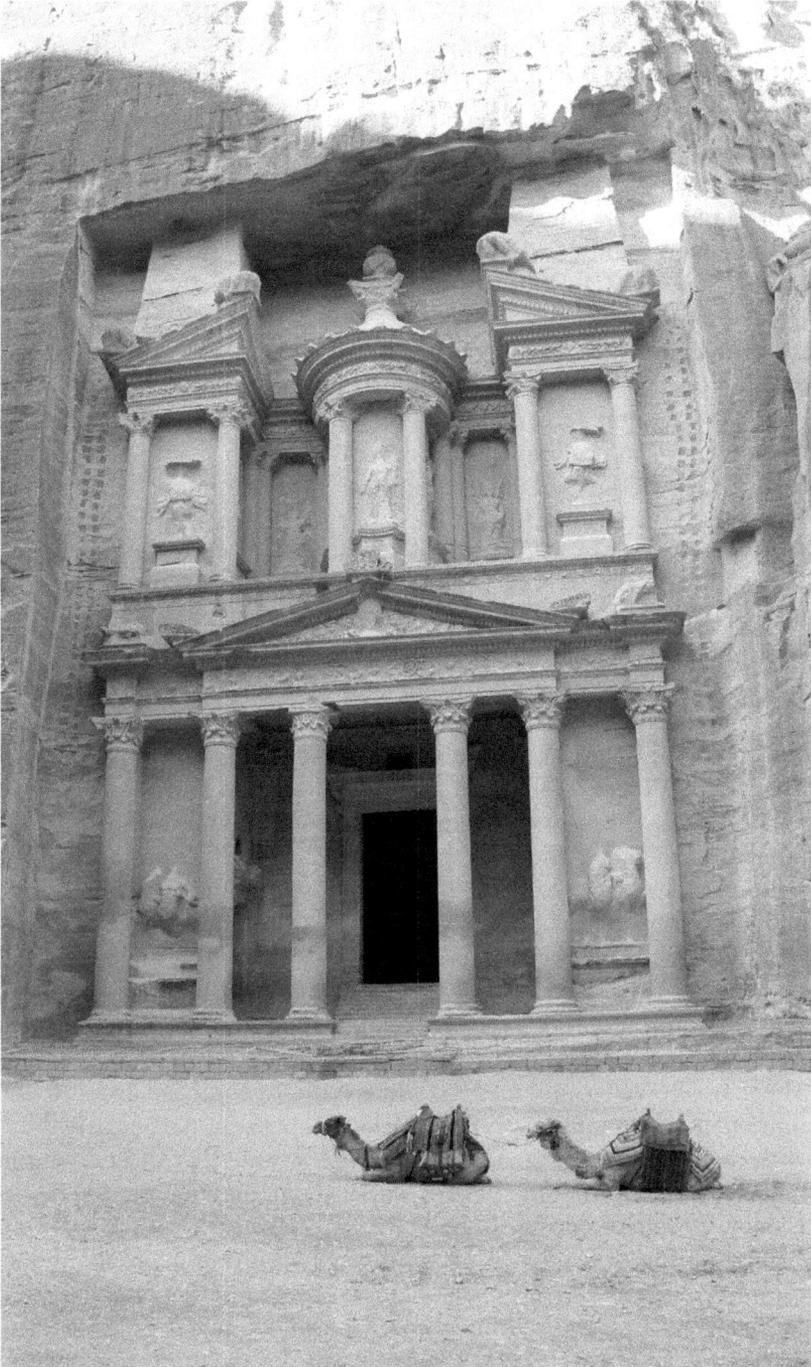

Figure 1.1. The Treasury at the end of the Siq. Photo by the author.

own guide who may generate personal economic benefits by advising tourists to buy from dealers other than those in Little Petra. Local initiatives to construct attractions are mostly refused on the grounds that they violate UNESCO recommendations and jurisdiction.

Tourism is the main source of income in Umm Sayhoun and Beidha. The Bedouin work as guides and run small shops with refreshments and souvenirs. In contrast, in Wadi Mousa (Liathneh) employment in the government and private sector is also common, in addition to tourism services. The local population does not directly receive money from the entry fee; however, those who work with the tourists in Petra have much higher incomes than would be otherwise possible.[15] Yet, political instability renders tourism very vulnerable. When the political situation forces itself upon the area, projects are initiated to activate the unemployed population, such as archaeological excavations. Because of the comparatively limited influx of tourists to Little Petra, the Ammarin, on the other hand, have previously dealt with the challenges differently to some degree. There is thus also a striking difference between the Bdoul and the Ammarin in terms of their economies. This is even the case between the Ammarin in Bir ad-Dabaghad on the plateau, and those in Beidha in the mountains. The former group has little interaction with tourism, but a much higher level of education and employment.

The Bdoul have set up both authorised and unauthorised shops. They have almost established a monopoly inside Petra with respect to the tourist shops and donkey tours. The Liathneh mostly run the hotels and the horse industry from Wadi Mousa to the entrance of the *siq* (gorge) leading into Petra.[16] Furthermore, individuals from Bdoul, and to a lesser extent the Ammarin, have set up travel guide companies and desert camps for tourists, and also work on archaeological excavations in the area. Thus, provided there are no regional problems, most Bedouin working in the tourism industry have at least at some points during the year a fairly sound, although fluctuating, economy. There are, however, still many families without sufficient access to the tourism market that are severely stricken by poverty, particularly those with many infant children, divorced elder women, or those living in tents on the fringes of the park area. For them, moving into the desert is one way to reduce expenses.

Despite the dependency on tourism, the perception of its impact on the local population is very varied. Fathers particularly feel that tourism has a negative influence and harms young people (see also Al-hasanat and Hyasat 2011).[17] Yet, tourism and the protection of Petra have not been all bad for the Bedouin. The children attend schools,

water is more easily accessible and there are doctors and hospitals nearby (cf. Ayad 1999; Baumgarten 2011; Brand 2001; Comer 2001, 2012; Farajat 2012; Kooring and Simms 1996; Ohannessian-Charpin 1995; Shaer 2008; Shoup 1985; Wooten 1996). The improved health and education situation has caused an explosive increase in the Bedouin population. The Bdoul in Umm Sayhoun have increased from 40 families in 1985 to 350 in 1999 (Ayad 1999: 41), and similar growth rates have been seen in Beidha. Attempts have been made to evade the non-expansion rules in Umm Sayhoun by building houses outside of the legal zones of the village. One instance of this in 2000 had tragic consequences, with the police killing three young men from Bdoul at close range, which eventually caused riots.[18] This again shows that tensions between tribes, as well as between governmental structures and local sentiments, as a consequence of the incorporation on the universal list of outstanding heritage, are lurking under the surface.

The Wastewater Plant

Another recent development that has provided a sustainable income for some, but which seems incompatible with the 1968 'greater outdoor museum' view of national parks – and is an example of the double standards mentioned above – is a wastewater plant within Petra Archaeological Park. The aim of the plant is to re-use the water from Wadi Mousa and surroundings, which is so important in a country where water, unlike remnants from the past, is a scarce resource. It was constructed in Sidd al-Ahmar, north of Beidha (see Addison 2005, 2006). The Wadi Mousa Wastewater Re-Use Project, funded by USAID in cooperation with the Water Authority of Jordan, began in 1998. By 2001, the Wastewater Treatment Plant was established.[19] It allowed the newly established Sidd al-Ahmar Society for Farming with Reclaimed Water, which comprised people from Ammarin and Wadi Mousa, to use the land within the national park owned by the Department of Antiquities for farming.[20]

Studies have suggested that within the last century, Sidd al-Ahmar experienced 58 per cent deforestation from 1924 to 2002, and the wastewater plant has not stopped this (Addison 2005, 2006). Quite the opposite: between 2003 and 2006 there was a further 4.23 per cent decline in tree cover. This is mostly because of the barbecue culture of *hash w nash*, where camp fires are lit using nearby trees. The new roads have made it possible for families from Wadi Mousa, Umm Sayhoun, Beidha and as far away as Aqaba (125km) to come and picnic in the area (Addison 2006: 83).

There are many restrictions on what type of plants may be grown in the area, as the waste water contains traceable elements from the treatment process that may be harmful to people. There have also been controversial issues surrounding planting exogenous plants and dumping chemicals in the park. Although the wastewater plant has been positively received, many interlocutors commented on the irony of a wastewater plant's location inside the national park, where they are themselves discouraged to live. This confirms their perception of the inability to shape their own lives, and the structural injustice being done to them. While farming in this way is economically viable, as some of the crops could be harvested monthly, my interlocutors saw it as harder physical work than herding goats, and requiring a fair amount of implementation capital. The agricultural area is mechanically harvested, unlike other places in the area where the Bedouin still harvest grains by hand. My main interlocutors had only cultivated their fields for one year and would thereafter decide whether they would continue. However, it is undisputed that this would offer a more sustainable income than tourism or herding in this area.[21]

The above shows how preservation of heritage is not simply about protecting remnants from the past. At a broader level, tourism and heritage preservation is also a vehicle for development, even if that development does not always include the voices of the local communities. This relationship is perhaps best encapsulated in the name of the central governmental agency in the region: Petra Development and Tourism Regional Authority. The heritage strategy in Petra is in essence then an effort to make present and absent certain materialised ideas about the integrity of landscape. However, what is more interesting is the way in which the very notion of 'being Bedouin' is becoming a resource. Not only are the farming communities in Wadi Mousa using the term strategically to make an income with tourists, so too are the Bedouin increasingly forced to rethink the role of the Bedouin in contemporary society, as we shall discuss below.

Shaping Post-nomadic Identities

To the Ammarin, the UNESCO proclamation in 1985 stands as *the* event leading to the relocation of the Bedouin, even though the process of settlement had begun some fifteen years earlier. From an emic – that is, from within the social group – point of view, modernisation, settlement and heritage were in effect indiscernible. The proclamation marked the departure from what they now perceived as authentic

Bedouin lifestyle, towards a new type of Bedouin, despite the fact that the Bedouin have always adapted to the political context through settlement, mobility or technology (cf. Salamandra 2004). Among the Bedouin themselves and scholars in the area, however, many bemoaned the passing of a lifestyle and the restructuring of Petra, claiming that, 'when the Bidul [*sic*] have all left, Petra will be a dead city' (Shoup 1985: 283). In light of the few alternatives available, the Bedouin, however, generally received the relocation positively, at least that is how it appeared to them, in hindsight, twenty years later.

Today, young men working with tourists in particular narrate and perform the Orientalist image of an 'authentic' Bedouin that many urban Arabs also seek and expect to find when visiting – illustrated by offering so-called 'traditional' meals such as the *mansaf*, or performing poetry and songs. They perform the iconic image of the Bedouin, living in tents with camels, creating 'hyper-nostalgic reminders of a glorious Bedouin past of which their ancestors perhaps never partook' (Wooten 1996: 72). It was also a time, they recall, where money did not matter, unlike today. There was less greed and materialism, and hence it was a better time, according to this nostalgic narrative.

This hyper-nostalgia is ambivalently playing with the gaps between what Svetlana Boym (2001) calls restorative and reflective nostalgia. On the one hand, there is, particularly among young men, a hope and wish to live in the world as it once (allegedly) was – restorative nostalgia. This is what they act out when some of them go hiking for days alone, sleep in the desert or take tourists out in the desert to show them a 'real' Bedouin experience. The young women, on the other hand, rarely expressed such bemoaning tones, rather enjoying the reduced hardship of life in the villages and the possibilities offered by education.

The other nostalgia is reflective nostalgia that 'dwells on the ambivalence of human longing and belonging and does not shy away from the contradictions of modernity' (Boym 2001: xviii). The Bedouin can be seen to navigate these two different nostalgias, which otherwise 'distinguish between national memory that is based on a single plot of national identity, and social memory, which consists of social frameworks that mark but do not define the individual memory' (Boym 2001: xviii).

The representation of 'being Bedouin' to the tourists was consistently one of distinct otherness, yet a nostalgic one, in a timeless trope. One interlocutor had written an email that he liked to distribute to the tourists he met for a few hours or a day. It was important for him to explain that he was a Bedouin, even if he did not live in a tent anymore:

> I love our beduin culture so much. It makes me feel I am man, it teaches me to be honest, to be friendly with the people, and I am really so happy in this life. The beduin guy is different from the guy who lives in the town. … In the past, the life was very different from now. The beduin don't use money [at] that time almost. And there was a great hospitality in this time. Now of course with the modern life and the village, many things have changed, but we still keep our strong traditions between us, and in the summer time especially, we still enjoy our lives by this way. We go for many days hunting in the mountains and the desert, we care about our animals, outside, we eat by the fire, we make our bread.

Because visitors to Petra expect to encounter 'otherness', the Bedouin have an incentive to reinforce their Bedouin identity, as notions of uniqueness and authenticity are ways of talking a language the heritage industry and tourists understand. Young, unmarried Bedouin men in particular may live in a way that is far removed from the ideal they seek, yet they shape their identity in an image that confirms such otherness. Many Bedouin families are increasingly acquiring camels, something that was rare fifty years ago. They do this as a symbol of their 'Bedouinity', to shape an image of being 'more Bedouin' than they perhaps ever were – what has also been called 'neo-authenticity' (Wooten 1996). Through their interaction with tourists, the young Bedouin men showed their mountaineering skills, their hospitality in the desert during guided tours, their ability to tell stories of 'how it was back in the old days' (*kān zaman*), as a means of demonstrating their Bedouinity (cf. Baumgarten 2011: 61–70). It is an identity shaped through the mimesis of foreigners and foreigners' images of what a Bedouin should be. This is of course not to say that the many young men interacting with tourists did not once live in the desert and know a great deal more about it than the visitors. Rather it is to say that the narratives of 'otherness' are enhanced in the meeting with tourists and that they tap into broader notions of indigenousness, the simple life, a symbiosis with nature, and Orientalist images of the nomad.

Boym has noticed that 'Nostalgia inevitably reappears as a defence mechanism in a time of accelerated rhythms of life and historical upheavals' (2001: xiv). Settlement may have brought education and increasing religious awareness to the Ammarin, but it also brought rapid social change where concrete houses, agriculture and tourism have for most parts replaced tents, caves and herding goats and sheep. Engagement with tourists provides the opportunity to play out nostalgic narratives through performance of a Bedouin image that often has more recourse to general ideas of the Arabian nomad than to the specificity of tribal life in Petra. This mourning of the past establishes links with history in the present through what remains as anchors for

nostalgia, which act to negotiate the past, and to re-imagine the future (Eng and Kazanjian 2003).

Therefore, this act of selecting pasts marks how young men, as in the email above, continuously enact a notion of 'Bedouin' taking shape between what is absent – the real or imagined Bedouin lifestyle – and what is present – the re-enactment and thereby re-materialisation of selected pasts in interplay with tourist imaginings. It is a desire for presence of the past; a presence which is always slightly distanced from reality, but which nonetheless can be strategically selected. Past life, with all its negative and positive aspects, is thus tamed to only include those aspects which are suitable for present purposes, where the desire for presence enables affective connection between self and world (cf. Rose 2006: 545). In this process of desiring presence, a particular kind of temporality is shaped, while bringing other temporal orders of decay and conservation together. To turn these insights to the evening with Ahmed, his mother and sister: the farmers from Wadi Mousa had reinserted the figure of the Bedouin into the landscape – an act they had no justification or right to do, since it taps into the relocated Ammarin Bedouin's desires for presence.

Showcasing the Bedouin

The desire for presence is further illustrated in the establishment of an Ammarin Bedouin camp. While the case of the wastewater plant showed how protecting Petra has been managed and accommodated by local and national interests, the case of the Ammarin Bedouin Camp shows how representations of Bedouin culture are tapping into the nostalgic narratives noted above.

One way that the Ammarin have dealt with their settled situation, in which they have little influence or possibility for generating alternative income, was to establish a cooperative Ammarin Tourist Association in May 1998. It is governed by different branch sheiks, the mayor of Beidha and, until his death, the official Ammarin sheikh Suleiman from Aqaba. Five members of the board work on behalf of all members when there is need to contact the government or discuss tourism issues. They now have around 140 members, who each pay a 110 JD membership fee. Any profit gets deposited into a bank account. When the account reaches 500 JD for each member, the profit is paid out to the member.

This association is also the owner of the Ammarin Bedouin Tourist Camp, located next to Little Petra, in the area called Umm al-Aldi and Umm al-Kak. The area was leased out in 2000 to Ziad Hamze,

an Amman based investor, who arranged and collaborated with the tourist association to get permission and the necessary Environmental Assessment Report in order to build a tourist camp inside the national park.

Ziad Hamze built the camp with Bedouin tents, Western toilets and bathing facilities, water tanks, electricity, a kitchen and a museum in a stone building (figure 1.2). It now receives around 3000 guests a year at a price of 30 JD a night, including dinner. Many people visit the camp only for dinner, or for specially arranged parties.[22] The staff in the camp, which in terms of daily management is run by local Ammarin, make food, serve guests, arrange for tea and tend the fireplace. They also put on music performances and take guests on guided trips into the surrounding landscape. The camp thus provides a steady income for many local Ammarin families, including women who prepare food in the village. The camp is described on the Internet, as well as in tourist brochures and flyers, as a 'magical place', a place where 'time stands still', thus tuning into the romantic notions of a timeless Bedouin culture. It has a motto: 'At the Ammarin Bedouin Camp you can sleep under a billion stars and not in a hotel with 3, 4, 5 stars…'

Hamze has been a crucial figure in representing the Ammarin to a broader audience. His engagement has created many jobs and a relatively sustainable income for many Ammarin in Beidha over the years, and his work has been repaid with great respect among the Ammarin. However, the establishment of the camp is also highly

Figure 1.2. Toilets at the Ammarin Bedouin Camp. Photo by the author.

controversial, as other tribes – most notably the Hilalat (a branch of the Liathneh tribe) from Wadi Mousa – have a similar Bedouin camp, but have been forced by the regulations to locate it outside the national park. Many Ammarin laugh at the idea that a farmer (*fallāhīn*) tribe has a Bedouin camp, yet it only goes to show that in an area of tourism, who is and who is not a Bedouin is contextual and contested.[23]

The potential for economic development in the area has been largely neglected by other private and public actors in the Petra region, thus Ziad Hamze sees the Ammarin camp as a just way of developing the area, as he explained in an interview with me:

> For the Bedouin in Beidha, this is going to be the only income-generating project for the community. Ok, I know, if you want to go by the book, you cannot have any of this. You should move it every day. But why are you going to stop this little piece of income generating project, and you don't stop 3000 people coming in to Petra every day, destroying it? Why the double standards? You want to stop the real Bedouin from enjoying their heritage, showcasing their heritage, and you don't stop the big companies going in to Petra every day [making money] off the tourists.

The Ammarin Tourist Association got permission for the camp from the Ministry of Tourism and Antiquities, despite protests from groups, such as PNT, that constructing the campsite would be against several UNESCO recommendations and regulations. The situation worsened in 2005, when Ziad Hamze and the Ammarin organised a Bedouin festival inside the national park, with camel races, etc.[24] While these controversies are now settled, a solution still needs to be found for the use of sound and light shows, in addition to the impact on the archaeological sites that are located on the dusty road leading from the main road to the camp. Most people, including those critical of the camp's establishment, have come to feel positively about it and acknowledge the 'sensitive' manner in which it was constructed. Several officials and archaeologists, however, allegedly boycott the camp because of its location inside the park (Addison 2006: 72).

The material culture used in the camp is partly from the Ammarin, although two of the tents raised in the beginning were bought elsewhere. The spatial structure and decoration is not particularly like that of the Ammarin. It is more elaborate than one would otherwise see in the Bedouin tents in the area. Yet it does represent aspects of the traditional image of Bedouin ways of life without compromising comfort, such as Western toilets and cold drinks that are needed in a tourist setting. The camp offers the tourists a glimpse of life in the desert: sitting by the fireplace watching the night sky, enjoying the sweet tea or coffee, listening to the Bedouin telling tales or performing poetry.

The Museum

In collaboration with Rami Sajdi from Amman, who had studied the Bedouin in southern Jordan since the 1990s, Hamze also established a small museum in the camp. Here, a small range of selected items and pictures display Ammarin history and culture. The camp and museum are generally well received among the Ammarin since they provide jobs, although some bemoan the alleged cutting of trees for the camp (Addison 2006: 72). The signs in the museum are all in English; none are in Arabic. They tell the story of the Ammarin, their healing and spiritual practices, and pilgrimages, as illustrated in the following chapters. In terms of visual presentations, fourteen large sepia-toned photos of old Bedouin men and women offer close-ups of their wrinkled faces, taken no more than fifteen years ago, yet looking much older. These photos cover the walls, and give an image of tradition and authenticity, which are on the verge of being lost.

A woman, Torfa al-Bint Sabbah, is singled out, and her life story is presented to the audience. The focus is on the herbal, 'magical' and spiritual aspects of Bedouin culture – aside from the musical instrument the *rabāba*, a rug and a few coffee utensils. Some of the items, for example, a cloth *burqa* (face veil with cowry shells), rather than representing the specificity of the Ammarin in Beidha, show Bedouin lifestyles from other areas. As Rami Sajdi explains, 'The museum is based on all the things I learned from the Bedouin around the Ammarin, not even the Ammarin, even in Wadi Araba, the people around the southern Jordan'.

By displaying artefacts other than those belonging to the Ammarin, we see what Barbara Kirshenblatt-Gimblett calls 'the banality of difference' (1991: 433), where museums deny the provenance (or dating) of the material on display, while appearing to be specific or contemporary. Or as Sharon MacDonald also warns, 'Museums are, among other things, public statements of what counts as significant or "worthy" culture. Making such statements is not only a matter of assigning value to cultural stuff, however. It is also a means of defining and asserting identities through material culture' (2002: 117). The late official Sheikh Suleiman, for instance, had hoped that it would reflect a wider image of the different traditions and practices of Bedouin culture, and not be limited to the spiritual and herbal aspects of culture. The museum construction of the Bedouin portrays an image of a homogeneous Bedouin culture that hinges on a recently vanished culture where the focus was on the spiritual aspects of life. Sajdi is more enthusiastic and sees the museum as an eye-opener for the local Ammarin: 'They liked it, because, when they opened it, they found

out that they have an identity that is lost and I presented it through the camp, so they started going and bringing me other things that I never remembered'.

What is at stake with the museum – with the limited space it has available – is that it displays a uniform time perspective. It promotes itself as a place where 'Time does not exist' – and indeed there is no indication of what exact time it does represent. 'Time' is further obfuscated by the sepia-toned images of elder men and women. In that sense, the representation of the Bedouin in the camp, despite all its good intentions and the positive reception from the Ammarin and the tourists writing in the guestbook, relies on the same image of loss of authenticity, and on presenting the last remains of a vanishing culture that is static and homogeneous. In essence, it is about construing a particular kind of absence, or almost absence, of Bedouin culture that is selectively dealing with the issues that seem to disappear with the impact of modernisation.

Being emplaced in Petra creates the specificity of the Bedouin, and they enact cultural performances such as dances and stories for the tourist crowd. Yet they simultaneously tap into wider narratives of Bedouin culture and the materials produced elsewhere in another time through the banality of difference. This notion of the generic Bedouin is further enhanced by Hamze who sometimes brings his two saluki dogs – a Bedouin hunting dog used in desert areas, not mountains – to the camp in the mountains. The term 'Bedouin' thus emerges as one of social self-identification rather than an empirical category as pastoral nomadic desert dweller. This follows Young's (1999) insight that 'Bedouin' is a discursive identity, negotiated in the context of people having to define themselves in relation to others, rather than a static conception, and the term may be used both in proud and more ambivalent derogatory senses (see also Chatty 2014; Hood and Al-Oun 2014; Peutz 2011; Prager 2014a). Taking this position also means taking Dale Eickelman's insight seriously: that rather than asking 'what is a Bedouin?', one may better ask 'who says of which group that they are Bedouin, and why?' (2002: 65). And this is exactly the question raised by the incident where the tourist guides from Wadi Mousa wanted to fight with Ahmed.

For Sheikh Suleiman, the time aspect was, however, an issue at stake. There was little doubt for him that the museum was important as a place for preserving and documenting traditions. Yet, just as we saw an eradication of the Bedouin in the preservation of the Petra landscape, he was also concerned about the eradication of time in the representation of the Bedouin:

> We must change with the world. We must register everything and leave
> it for the next generations. We must register the old heritage, which we
> live in and must give it to you, so you can register it and keep it for the
> next generation. We must also take a look at the new heritage and people
> must hand it over to the next.

The point for Sheikh Suleiman was that heritage is not fixed and stable.
Rather, it changes as it is lived, practiced and adapted to new situations;
and this fluidity needs documentation. As another interlocutor in
Beidha complained:

> Every year the heritage (turāth) is different. Especially now. Every year
> we get new heritage, new culture. If you compare between this year and
> 10 years ago, there's a big difference … Something they keep, but it is
> also very different. Twenty or thirty years ago, when some people talked
> to the old men, they only told the myths, now some foreigners believe
> this is our culture.

The most common understanding of the notion of heritage (*turāth*), as
encapsulating the material fabric of monuments, here becomes more
nuanced and fluid (see also Daher and Maffi 2014b: 8–11). This version is
quite different from the discourse and awareness of the strategic tourist
tropes of being Bedouin, when young Bedouin men engage with the
tourism industry. That version has very little to do with the specificity
of the Ammarin mostly living in the mountain regions between Bir
ad-Dabaghad and Qurayqera, and only rarely included camels. In
the twentieth century, their way of life was mostly characterised by
dwelling in tents, caves or houses as sheep and goat herders and small-
time farmers, in addition to their incorporation as part of the military or
government office workers in the later part of the century.

From a local perspective, the camp is in many ways proof of the
disempowered position of the Bedouin. A common sentiment among
both male and female Ammarin is that they are not allowed to do
anything within the area. Restaurants such as the 'Basin' in the heart
of Petra, the Mövenpick hotels with a panoramic view, etc., are all
constructed inside protected zones of the national park. They all have
the correct permissions and Environmental Impact Assessments,
making them 'legal'. However, achieving the same result would not
have been possible for local Bedouin tribes. Only when aided by Ziad
Hamze, an influential man from Amman, are the Ammarin allowed a
presence inside the park. As a result, many Ammarin feel that they do
not have a say in what happens because they do not have the sufficient
connections – *wasṭa*.[25] They feel that all their ideas are turned down
because they violate regulations. Other actors, such as PNT, are willing
to help local interests, but only through projects that do not incorporate

activities that may harm the archaeological sites or environment, and so not the camp.

The many different interests and organisations involved in Petra, combined with the unequal representation of the Bedouin in decision-making processes, have shaped a view of top-down heritage management through the different responsibilities navigating between the non-interventionist approach of UNESCO and US Park Services, and the investors' economic interests in tourism. It is also clear that the local population is to some extent capable of shaping their own interests without government interference. Tourism is a powerful tool for shaping images of unity and 'Bedouinity'. Tourism hence allows the Bedouin to tap into broader contemporary conceptualisations of Bedouin ideals and identity as desert-dwelling camel herders that many tourists are looking for, despite the often different – but related – past reality.

Taking the Bedouin out of the Landscape

This chapter has shown that the premises and effects of establishing Petra as a heritage site relying on the universalistic idea of a collective human heritage promoted through UNESCO – which entails notions of a pristine landscape – has had a profound impact on the Bedouin. It has shown how heritage can be a motor for developing jobs and settlement, but also how the notion of Bedouin has become a resource for understanding one's role and link to tourism, the heritage industry and landscape. This may come in ways where non-Bedouin take on the role of 'being Bedouin' for the tourists, or it may be in more everyday narratives of identity as 'a Bedouin', despite the absence of sand dune desert, camels, goats and tent. The universal reach of the heritage industry to preserve monuments has, in other words, also meant a local identity struggle among the Bedouin (and related business men) to figure out how to tame the past in a tourist context. Here, certain things may still be a resource in a tourist economy, while other things are simply a matter of letting go and embracing what the new life offers in terms of understanding how heritage is changing and fluid. The local Bedouin thus also reconceptualises what heritage and the past is – ranging from an extreme fixation on an unchanging and simple past, to more dynamic understandings of the continuously changing present and the obligation to document what has happened.

The changes in the Bedouin lifestyle over the last thirty years, the dissociation from the Petra landscape, and an increased engagement

with tourism caused by tangible heritage management, were all recognised in 2005 by UNESCO as threats to the cultural diversity and heritage of the Bedouin. As we shall discuss in the following chapter, this shows that not only do contestations between local Bedouin and UNESCO regulations sometimes collide, so too do the simultaneous tangible and intangible heritage of Petra and the Bedouin. Hence, while the effort to protect Petra has mainly dealt with the materiality of monuments and left Bedouin traditions largely ignored, the Bedouin themselves have found effective means of influencing the broader public with cultural performances and a museum. It thus seems that a disassociation of the local Bedouin emerges with preserving Petra as a consequence of universal ideals of tangible heritage preservation. But the act of caring for the landscape, whether by removing people to preserve it, or by formulating nostalgic images of Bedouin culture in the landscape, represents strategic ways of establishing one's relationship with the pasts and the places that constitute an affecting presence connecting people to their world. It is in this way that the desire for presence assembles past, landscape and Bedouin.

Notes

1. Inspiration for exploring 'the desire for presence' is found in Mitch Rose's work on Dreams of Presence (2006).
2. It should be noted that ICOMOS (International Council on Monuments and Sites) initially recommended that Petra should be deferred from the Heritage list on the grounds that the nomination was insufficiently documented; http://whc.unesco.org/archive/advisory_body_evaluation/326.pdf (accessed 7 January 2008).
3. Later to become Petra Regional Authority in 2002.
4. See *World Heritage Newsletter*, June 1993, issue 2; http://nabataea.net/ppark.html (accessed 7 January 2008).
5. One of the twelve governorates in Jordan.
6. For example, a geological study indicates that from 1990 to 1999 the visible original stonemason dressing marks had decreased from 15–20 per cent to 5–10 per cent.
7. http://www.petra-pra.com.jo/goalsen.htm (accessed 1 May 2008, no longer valid).
8. There is also a college offering bachelor degrees associated with the park. Its curriculum focuses on archaeology, tourism and hotel management. Its students mainly come from Wadi Mousa, which creates a social and economic gap between Wadi Mousa and the people in Umm Sayhoun and Beidha.

9. http://www.wmf.org/watch_past.html (accessed 10 January 2008). The 1996 listing concerns the Southern Temple, while the rest relate to the Petra Archaeological Site in general.
10. Unrecorded quote, 25 October 2006.
11. Another minor actor is Friends of Archaeology (FOA).
12. http://www.petranationaltrust.org/cms/index.php?option=com_content&task=view&id=16&Itemid=27 (accessed 4 January 2008, no longer valid). In Jordan NGOs are often called 'NGO-hybrids' (Brand 2007) such as RONGO: Royal Non-Governmental Organisation, because a NGO is supposed to be independent from government ties, and yet the Royal family is predominantly part of the organisations.
13. http://www.petranationaltrust.org/cms/index.php?option=com_content&task=view&id=13&Itemid=33 (accessed 4 January 2008, no longer valid).
14. This data covers the year up to 30 September 2007.
15. A park ranger's monthly salary in 2007 was around 130 JD, while an archaeologist with a bachelor degree receives c.150 JD a month. A half-day trip to a viewpoint with a group of tourists may yield 80 JD, and a three-hour guided tour with an official guide pays around 35 JD.
16. However, changes are occurring that tend to organise the tourist industry more officially, such as removing some of the horse and donkey tours (*Jordan Times*, 15 September 2009).
17. 92.6 per cent of respondents, highest in Beidha, lowest in Umm Sayhoun (Nasser and al-Khairi 2003: chapter 4).
18. http://news.bbc.co.uk/2/hi/middle_east/690713.stm (accessed 10 January 2008).
19. It was not until 2002 that the water was actually used for agricultural purposes. Initially the intention was to pump the recycled water into the valleys towards Wadi Araba; however, with less than 200mm of rain per year, this was considered hazardous to the already fragile eco-system in the park (Addison 2005).
20. The area (1069 donums) is used today by the families of the Society to harvest grass for goats and sheep, and grain, both of which can be sold off. It is divided into forty-three fields, of which the Liathneh from Wadi Mousa, who have many years of experience and tradition with the agricultural processes of planting and harvesting, manage ten fields.
21. Furthermore, cultivating the fodder themselves also meant that traditions of herding goats in the mountainous area would be less relevant. In particular, if grasses were delivered to their houses, their knowledge of the landscape would change, as those who normally walk with the goats would no longer engage with the places, gorges, valleys and mountains, see plants and animals in the same way, and discuss good places for gracing.
22. One party accommodated around 2000 young people from Amman and tourists.
23. This also includes the Ammarin who often claim that they are less 'Bedouin' than, for example, the Sayydīyyn, who live in tents and herd camels in Wadi Araba.

24. The main discussion concerns not so much the activities on offer as their location, with PNT wanting it outside the national park. When permission was sought to film the 2006 Ramadan Bedouin television series *Rās Ghlais*, however, these concerns appeared to be less problematic to the involved parties, even when filming took place within the park, with trucks, generators for electricity, etc., again highlighting the double standards at work.

25. Translated as 'network', 'nepotism', 'connections to power', or simply the ability to be at the right place at the right time (cf. Cunningham and Sarayrah 1993).

ᘒ 2

TAMING HERITAGE

Introduction

I met up with the then director of Petra Archaeological Park, Dr Suleiman Farajat, to talk about the national park and the tenuous relationship between protecting the archaeological remains of the rock-carved city of Petra in Jordan and allowing the Bedouin population a life there. He described the dilemma with an Arab proverb: 'We don't want the wolf to eat all the goats, or the wolf to die from starvation'. It sums up the profound case of overlapping heritage politics in Petra. The social consequences of managing the tangible heritage in Petra resulted in better education, health and wealth among the Bedouin, but also disengagement from the physical fabric of collective memory, as illustrated in the previous chapter. The theme of this chapter[1] is related but also somewhat different. In an ironic turn of events, the very same Bedouin tribes around Petra who were relocated under the headline of development and UNESCO heritage protection in 1985, were in 2005 inscribed on UNESCO's list of 'Masterpieces of the Oral and Intangible Heritage of Humanity', together with Bedouin tribes around Wadi Rum – a desert area in southern Jordan famous for its role in the Great Revolt.

The Bedouin were selected for their particularly rich intangible heritage, in terms of oral traditions with poetry, dance and songs, their pastoral nomadic skills of animal husbandry, tent weaving and

knowledge of plants and environment, along with their religious practices grounded in that particular landscape. Thus, rather than the objects or monuments celebrated as tangible heritage, these practices and knowledge are considered intangible, even if situated in a particular material setting. The heritage acknowledgment is striking in so far as the Bedouin in Petra no longer inhabit the landscape which now comprises the UNESCO world heritage site nor live a predominantly nomadic life, as illustrated in Chapter 1. The process of invoking Bedouin culture or paraphernalia as signs of authenticity and roots, rather than as a particular way of life, has been widespread in the Arab world in recent years (Cole 2003; Dinero 2002; Hood and Al-Oun 2014; Peutz 2011; Wooten 1996). However, here we see a large-scale institutional recognition of Bedouin heritage previously unseen, while there are active processes of settling the few remaining nomadic Bedouin. We have in Petra, in other words, a very practical heritage paradox of keeping while changing: keeping the heritage of the Bedouin, while changing their way of life.

To understand what may seem like a contradiction in heritage policies in the overlaps between officially recognised tangible and intangible heritage in Petra, I argue in this chapter that we need to focus on 'heritage' as a practice of assembly that consolidates Petra as an epicentre for Jordanian heritage, rather than an object per se, even if an intangible one (see also Harrison 2013: 33–35; Pendlebury 2012; Smith 2006). The chapter is an investigation of the institutionalised process of taming all the different stories about and objects from the past to make sense in the present to different parties. Such a 'process perspective' on heritage illustrates 'the multiple, heterogeneous and often highly specific actions and techniques that are involved in achieving and maintaining heritage' (MacDonald 2009: 118). Heritage is not only a practice of those who perform, maintain or interact in everyday life with whatever is officially termed heritage. It also involves those initial stages where the discourses, places and objects are selected and stabilised as heritage to the general public, heritage institutions and practitioners in various forms. As noted before, focusing only on the institutional level or the local inhabitants runs the risk of missing out on how parallel ideals and processes are forming and intermingling. This chapter shifts from interviews and archival work on the level of producing heritage to everyday life among the Bedouin that mostly runs parallel to, but at times comes into conflict (at least tangentially) with the heritage industry. This shows how the actual process of inscription – even when unsuccessful – is arrested among global and local interests and networks (cf. Scholze 2008).

The notion of intangible heritage is heavily discussed in academia (Ahmad 2006; Alivizatou 2012; Hafstein 2009; Kirshenblatt-Gimblett 2004; Kurin 2007; Ruggles and Silverman 2009; Smith and Akagawa 2009). When heritage is designated as 'intangible' through official institutions such as UNESCO, it becomes important to scrutinise the links between everyday events, skills and oral traditions, and the more or less professionalised processes of articulating, materialising and appropriating a heritage discourse (Herzfeld 2009; Joy 2012; Smith and Akagawa 2009). In examining the process of heritage inscription in Petra, I expand upon the genealogical approach by highlighting the multivalent and incommensurable voices from local, national and international spheres that are involved – and find legitimisation – in the process of inscribing the Bedouin on the international heritage lists.

As will become clear below, the international valorisation of heritage begins quite literally with an assemblage of documents and persons linked to pasts, practices or materials. Such an assemblage is composed of a wide range of connections between persons, places, organisations and nation-states by shaping a whole from heterogeneous parts, only at some point to become materialised as an accepted nomination within the UNESCO offices (taking inspiration from DeLanda 2006; see also Harrison 2013: 33–35). The specific order of the past in the present is, however, not given, but made – justified or not. As John Law argues, 'Perhaps there is ordering, but there is certainly no order' (1994). There is no single order, and orders are never complete; 'Instead they are more or less precarious and partial accomplishments that may be overturned' (1994: 1–2).

Taking this approach of assemblages into a heritage context enables us to take a critical look at the asymmetrical powers integral to the processes and premises embedded in shaping a heritage nomination. The heritage nomination is made up of a process of selecting relevant pasts and omitting others, or what I call a taming process. Shifting and fluctuating hierarchies of resources, and access to them, may potentially redistribute power, and step in and out of the process of achieving and maintaining heritage status. In this sense, a particular kind of presence is achieved through the heritage assemblage, whereby 'Bedouin' is made to denote intangible practices and oral traditions, rather than an empirical way of life. Yet it is a very momentary presence, materialised in reports and recognition, where the various elements in reality just as easily link up to other parts, which is subsequently also illustrated in Chapter 3. By examining the documents and interviews with some of the key characters, it appears that the announcement to safeguard Bedouin heritage rests on a wide range of seemingly

contradictory motivations: from legitimising the role of the Bedouin in the national narrative, to discourses of shamanism and primitivism over issues of reconciliation, to the adaptability of the Bedouin in a modern Jordanian state. In other words, studying heritage may entail both an exploration of the process of inscription that may unravel political motivations and interests, as well as a view from the everyday practices of people. With so many different interests, the question then becomes: how is this diversity tamed?

In the following section, I describe how a heritage nomination emerges from coincidences, collaborations, individual interests and a referral. In brief, the nomination started off as a local initiative and then evolved and circulated between different local and national actors, all trying to safeguard the Bedouin in what they saw as the right way, eventually to end up as a nomination to UNESCO. After a reworking of the initial nomination, the Petra and Wadi Rum Bedouin tribes were granted recognition from the international community through UNESCO. For the sake of clarity, I concentrate here on the situation of the Bedouin in Petra and the related city of Wadi Mousa, with a few turns to Wadi Rum (for more on Wadi Rum, see Chatelard 2003, 2005a, 2005b). The central argument is that the universalising claims seen with UNESCO tangible heritage in Chapter 1 run parallel to, and at times in conflict with other simultaneous universalities. This makes UNESCO intangible heritage a product which is both somewhat related and detached from everyday life, but which affects what constitutes 'a Bedouin' as a set of skills rather than an empirical category.

Heritage Protection as Development

To many observers, the resettlement of the Bedouin from Petra aimed at presenting the area as a sort of pristine landscape, rather than incorporating the local population into the heritage industry, even though they are an integral part of the site's history (Abu-Khafajah 2010; Baumgarten 2011; McKenzie 1991; Shoup 1985; Steen et al. 2010). The inscription on UNESCO's heritage lists has become a mark of modernity and displays a moral obligation to care for the cultural heritage of humanity (Kirshenblatt-Gimblett 2004). It shows how negotiations of cultural identity are entwined in what, at least at the international UNESCO level, seems to be a celebration and safeguarding of cultural diversity. Yet cultural heritage representations do more than just preserve things and practices. They are, among many other things, public statements of an appreciation and selection of elements

of the past and designation of cultural value; in this process, they create desirable objects out of people, places and things (Kirshenblatt-Gimblett 2004, 2006; MacDonald 2002, 2006).

UNESCO's announcement of heritage is more than a list of sites, things, practices and skills of 'outstanding value to humanity'. It is used for development and shaping national discourses. Countries use international and national recognition to attract tourists and investors, as well as to shape social inclusion or exclusion. The political capital of national unity through the strategy of preservation is accomplished by having Bedouin roots. At the same time, it achieves an 'invitation to absorption' (Povinelli 2002: 184) into the Jordanian governmental system of the Bedouin through enforcing state law, school education and governmental administration among the settled Bedouin.

Heritage studies highlight how people display and tell themselves who they are, who they would like to be or have been, and where they come from, through things. Claims to a common heritage (or silencing other versions) are powerfully mediated through the material world as proof of 'possessing' cultural heritage (cf. Graham et al. 2000; Harrison 2013: 31–39; Tunbridge and Ashworth 1996). Even 'intangible traditions' such as hospitality, honour, and nomadism are cases in point in Jordan, which are then materialised in Bedouin coffee utensils and black goat hair tents – used in statues and imagery of hospitality, on bills, and in public discourse of heritage. Proclamations of heritage and traditions are thus strategic narratives about the past produced in the present, most often concerned with material objects or people's engagement with them.

In some cases, the material world even publicly displays what people either want to forget (saint worship), what they have almost forgotten and which thus works as mnemonic devices (historical sites), or what they have to remember and reconcile with (Holocaust atrocities). The material world imposes itself on people to recall and/or re-narrate those stories in the present. Heritage, in this sense, is in a constant dialectic between being a strategic talk about things (or engagement with them), and things that 'talk' back. Laurajane Smith has rightly argued that on an analytical, etic level, there is no such 'thing' as heritage, except through the practices, processes and discourses about it (2006: 11). However, from an emic perspective, one is struck by remnants from the past that have an affecting presence that has to be dealt with (Armstrong 1971; Bille et al. 2010).

A state or organisation may achieve an image of being a 'caretaker' for the heritage of humanity through UNESCO by selecting and highlighting what it cherishes, and often this relates to what it considers

to be at risk. Heritage protection thus becomes part of a technology of risk that reveals what I see as a central property of heritage: a concern about exposure. Besides celebrating and presenting identity and history in the present, heritage protection is about exposing the fact that something is (potentially) at risk of disappearing and exposing the fact that the state, organisation or person is taking care of it in the appropriate way – although the premises for such appropriateness also change. As the short press release from 2005 on UNESCO's website about safeguarding Bedouin culture states:

> The provision of education, housing, health care and sanitation has made a sedentary existence more attractive for many of them, leading, however, to the erosion of skills developed by the Bedu over generations. The increase of desert tourism and its demand for 'authentic Bedu culture' should not be allowed to further degrade the intangible heritage of the Bedu in Petra and Wadi Rum.[2]

Safeguarding of the Bedouin entails safeguarding the oral traditions performed through songs and poetry, the weaving, climbing and camel herding skills and the medical and religious practices, even though the nomination explicitly states that some of the religious practices have ceased, partly as a consequence of previous modernisation strategies. Yet the UNESCO heritage paradigm offers the mechanisms and regulation for conforming to the 'right way' of perceiving risk. In that sense, 'Safety is not merely the absence of accident or the avoidance of error …safe operations encompasses both compliance with external regulations and technical conditions and a positive state of operations that are reflexively expressed and mediated through human action' (Rochlin 2003: 128).

Paradoxically, with very few individual exceptions, the Bedouin in Petra do not currently live in ways that are predominantly associated with Bedouin culture; that is, living in tents with camels or practising large-scale goat herding. While the Bedouin throughout history have shifted between different modes of dwelling and employment, and we still see in Petra today that people may move into tents with goats one year, only to return to villages and office work later, the tent and nomadic lifestyle is a central feature of Bedouin culture and imaginary. Furthermore, many religious practices have ceased in response to an increased Islamic awareness spread through mosques, schools and satellite-broadcast religious guidance programmes (Baumgarten 2011). Even long-held religious traditions such as collective pilgrimages to prophet Aron's tomb at Jebel Haroun in Petra have ceased; they are now considered an innovation (*bid'ah*), and not in accordance with standardised Islamic conduct as it has developed in the area in recent decades.

A Place for Bedouin Heritage

Timothy Mitchell aptly stated that 'One of the odd things about the arrival of the era of the modern nation-state was that for a state to prove it was modern, it helped if it could also prove it was ancient' (2001: 212). In the case of Jordan, various aspects of its history have been employed as testimonies of deep-rooted inheritance, particularly the Nabatean monuments of Petra and the Bedouin and Islamic roots of the Hashemite Royal family, as discussed in the introduction. Jordan itself is a fairly new nation, erupting from the Ottoman Empire and British mandate in the early twentieth century, making the desire to prove its roots perhaps even more essential. As also illustrated in the previous chapter, the link between ancient sites, contemporary national identity and acts of 'patrimonialisation' is quite explicit, regardless of the composition and origins of the Jordanian population (Maffi 2002, 2009, 2014).

Jordan has witnessed a regular population explosion, particularly from the Palestinian territories, whose descendants now make up the majority of the population. A wide range of mechanisms are employed to legitimise these national heritage claims: from museums, statues and monuments to the more banal nationalism of governmental emblems, postal stamps, money and cultural events (Billig 1995; Katz 1999; Maffi 2002, 2005, 2011; Massad 2001). Salam al-Mahadin (2007a, 2007b) has eloquently shown how these mechanisms have not been static throughout Jordanian history, but are changing in light of events such as Black September in 1970–1971, which led to a restructuring of national signifiers. Irene Maffi has similarly shown how museums have played a crucial role in rethinking national identity according to the shifting role of the Hashemite history and Palestine in the displays (2011). Aside from Petra, one of the central figures to feature in the Jordanian narrative, at varying times and intensities, has been the Bedouin. As an archetypical figure, they become the backbone of national narratives through the image of a tent-dwelling camel- or goat-herding nomad. This happens even if only between 0.5 and 2 per cent of the population today are registered as living by this particular type of subsistence. Nonetheless, the Bedouin have a leading role in the representation of Jordanian heritage.

Perhaps nowhere in Jordan is the Bedouin heritage more explicitly represented in material culture and practices today than in Petra and Wadi Rum – highlighted as UNESCO intangible heritage, and also as two major tourist attractions integral to Jordan's history. Wadi Rum was, for instance, the point of origin for the Great Revolt against the Ottoman Empire that consolidated the power of the Hashemite

as rulers of the territory, with the help of the Bedouin tribes and the British government. Through such links to national origins and military success, the Bedouin have become an important symbol in the representation of Jordanian national identity and the tourism industry (cf. Al-Mahadin 2007b; Hazbun 2008; Massad 2001; Shryock 1997).

With heritage tourism being one of the main economies in Jordan (between 8 and 11 per cent of GDP), considerable effort goes into promoting, sustaining, producing and developing Petra and the Bedouin heritage, as well as many other sites, to extend the stay of, and thus money spent by, visitors to Jordan. In such promotions, traditions are also presented at a commercial level in highly standardised 'traditional' handicrafts. Waleed Hazbun observed that in Jordan such demand for heritage tourism has 'led to the creation (some would say fabrication) of a recognisable "traditional Jordanian style"' (2004: 331). This has helped to 'foster the emergence of a stronger, more coherent sense of a historically and territorially rooted sense of Jordanian national identity' (2004: 331).

This is particularly apparent in Petra. Here, investors reconstructed an old, partly abandoned village as a luxury hotel (Daher 1999, 2005, 2007a; Hazbun 2004, 2008). The creation of 'traditional Jordanian style' is further elaborated through uniform red, white and black textile patterns, and by presenting the eagle-tipped coffee can ubiquitously as souvenirs, as sculptural elements in roundabouts and as a material emblem of hospitality essential among the Bedouin, and tribal society at large.

Hospitality is indeed promoted as a salient characteristic of Jordanian national identity and an example of how heritage politics makes use of the international recognition of cultural prosperity. In 2004, the link between hospitality and the Jordanian people gained international recognition when Jordanian hospitality was placed on UNESCO's 'Harmony List for Cultural Practices'. In her acceptance speech, Jordanian Princess Basma bint Talal stated that '"Hospitality" is a national asset that is to be treasured, because it is priceless. It costs so little yet adds so much value to our lives'.[3] The UNESCO recognition linked an intangible heritage closely associated with the Bedouin to the Jordanian nation as an 'asset', whereby the importance of the Bedouin and tribal heritage in Jordanian society was reasserted.

A year later, in 2005, UNESCO recognised Jordan's Intangible Cultural Heritage in the form of the Bedouin of Petra and Wadi Rum, in their proclamation of the 'Masterpieces of the Oral and Intangible Heritage of Humanity'. Here, hospitality also played an important part in the nomination. The proclamation of intangible heritage once

again established Petra as an essential place in the cultural heritage of Jordan – further emphasised in 2007, when Petra was announced one of the 'New Seven Wonders of the World'. The Bedouin figure is thus continuously manifested and naturalised in the national discourse through international institutions such as UNESCO and their lists of universal value to humanity.

In such processes a cultural freezing is implied; however, that is not only a top-down process from the government or heritage industry. It is likewise produced through hyper-nostalgic narratives among the Bedouin themselves about a past that they may never have been part of themselves, as seen in Chapter 1. It also happens among the primarily young Bedouin men tapping into popular culture such as Indiana Jones, or, more recently, emulating the physical appearance of Captain Jack Sparrow from Pirates of the Caribbean or Ghlais from the 2006 Ramadan television series *Ras Ghlais*, produced in Petra (see also Prager 2014b). The strategic revival of cultural practices and 'invention of tradition' becomes the means of reinstating a 'temporal depth'. It does this by formalisation and ritualisation, where heritage is an essentialised resource for generating a future through the image of a Bedouin past, even if the way in which they actually live may not correspond to the representation (Butler 2006; Fabian 1983). Heritage thereby becomes 'a mode of cultural production that gives the endangered or outmoded a second life as an exhibition of itself' (Kirshenblatt-Gimblett 2006: 168).

Taming the Past From the Bottom Up

The actual documentation and representation of Bedouin culture in Petra as heritage began long before the official process of nomination for UNESCO started. Central to the Bedouin inclusion on the UNESCO intangible heritage list is the Ammarin tribe. The Ammarin have continuously struggled to find ways of attracting tourists. They do not have the same access to the booming tourism industry of central Petra as the Bdoul. Since 2000, the Ammarin Tourist Association, headed by Ammarin Sheikh Suleiman Mohammed Shtayyan, has showcased some of their traditions to a broader audience with the help of two Ammani investors, the aforementioned Ziad Hamze and Rami Sajdi. Yet none of them initially had the intention of submitting a nomination for UNESCO's intangible heritage status. For Sheikh Suleiman, Hamze and Sajdi, the central concern was to document, preserve and represent Bedouin traditions and material culture to

tourists. They built the tourist Bedouin camp with a museum (see Chapter 1) where they recite poetry, tell stories, sing and make food. The camp became the starting point for the initiative to document and showcase Bedouin culture. Sheikh Suleiman aimed at documenting the Ammarin traditions, as he explained during an interview: 'We must register everything and leave it for the next generations'.

Once aware of UNESCO's intangible heritage list, however, Sajdi in particular wanted to present the UNESCO committee with something solid and considered the Ammarin Bedouin Tourism Camp to be ideal. Unlike the Bedouin living in the desert as camel herders, the Ammarin in Petra had an infrastructure ready to be presented to a broader audience: a Bedouin camp, a museum, a dance performance and a region where tourism flourishes. He reasoned that the solidity and territorialised fixation of the Ammarin meant that it would perform well in a nomination to UNESCO, compared to the nomadic Bedouin whose culture would be difficult to present or even fix in place, and hence would be vulnerable to the critique of why these particular Bedouin tribes should be selected.

Sajdi, in particular, has been a key figure in promoting the Bedouin in southern Jordan to an English-speaking audience. He has focused on representing the spiritual aspects of Bedouin culture. In the museum and on webpages, members of the Ammarin tribe are presented as adhering to shamanism, where they reach spiritual trances, foresee the future and manipulate spirits. Tourists are invited to visit the shamans' houses and wells. The Bedouin shamans represent a link to an 'original' spirituality shared by indigenous people across the globe, and the shaman trope is mentioned in the nomination to UNESCO, explored further in Chapter 3. However, in the current context of Islamic revival spreading among the Bedouin in southern Jordan, this shaman discourse is a controversial topic which is strongly debated and denounced among the Bedouin. My Bedouin interlocutors instead promote another version, wherein these people were blessed by God and only in that capacity were they able to make good judgements and help. In this part of the heritage process, Sajdi and Hamze thus strive to promote a particular version of spiritual potency that – although contested by the Ammarin conception I encountered during fieldwork – also has the potential to bring recognition and economic prosperity for the future by caring for the past. The urban elite cherishes the practices that the rural population increasingly dissociate themselves from.

Taming the Past From the Top Down

A completely different process of assembling a heritage nomination started in 2003, when Princess Basma, as head of the Non-Governmental Organisation 'Jordanian Hashemite Fund for Human Development' (JOHUD), wanted advice on presenting Bedouin heritage as intangible heritage. JOHUD initiated contact with two non-Jordanian anthropologists: Dr Riccardo Bocco, who had worked with the Howeytat in southern Jordan, and Dr Geraldine Chatelard, who had worked with the Bedouin in Wadi Rum. Bocco and Chatelard advised JOHUD to use a Jordanian anthropologist from Yarmouk University, Dr Abdel Hakim Husban, who, despite his lack of fieldwork among the Bedouin, had substantial knowledge about tribalism in Jordan.[4] The information he gathered was later incorporated into the writings of Sajdi and Hamze in the UNESCO nomination.

A large part of the documentation for this nomination is found within Husban's report 'The Socio-anthropological Value of Oral and Intangible Expressions of the Bedu in Southern Jordan', later published in the academic journal *Dirasat* (Husban 2007). The report is very explicit in not viewing Bedouin culture in pejorative terms. In particular, the report stresses the role of women as important in the transmission of culture, sociality and in sustaining the family, rather than as suppressed subjects. A large area around Petra and Wadi Rum was surveyed, but, ironically, when looking into details, most information on the Bedouin in Petra was collected in Wadi Mousa from the non-Bedouin Liathneh tribe. The Liathneh are mentioned in the nomination but are not its focus.

In terms of representations from Petra tribes of Ammarin, Bdoul and Sayydīyyn in the nomination, Torfa bint Sabbah is highlighted for storytelling, Abu Gassem for *rabāba* (musical instrument) poetry, and the Ammarin Tourism cooperative (representing around 140 members of the Ammarin tribe) for the *samer* dance performance. The nomination states that the appendix list of individual interlocutors is by no means exhaustive but indicative of the knowledge and skills that still exist locally, and highlights that many are performed by women. None of the individuals mentioned by name are under 55, although there are younger individuals within the broad cooperatives of the Ammarin Tourism Cooperation and the Wadi Rum Mountain Guides. Yet the vast majority of people on the list of interlocutors are not even from the Bedouin tribes. Their family names – al-Tweisi, al-Nawafleh, al-Masha'leh and Hlalat – show that they are branches of the Liathneh

tribe in Wadi Mousa. None seem to be directly represented from the Bdoul or Sayydīyyn, while interlocutors from Wadi Rum are mainly from the Bedouin tribes in question. The initial nomination was considered weak by the expert panel, and the nomination was thus rewritten. In this initial report, the Sayydīyyn were not mentioned. However, several other tribes and branches from the Shobak area further north of Petra, whose attachment to Petra is less pronounced than that of the Ammarin, Bdoul and Sayydīyyn, were highlighted.[5]

In his report, later published in a journal in 2007, Husban states that the principal goal of his study is to show the importance of preserving the intangible cultural heritage that is now threatened by the impact of modernisation, whereby 'in the name of progress, civilisation, and democracy, the oldest and richest cultural traditions are disappearing' (2007: 1). The report cites several reasons for the importance of preserving the Bedouin culture. Firstly:

> Bedouin culture must be considered as a basic element of human history, and the Bedouin mind reminds us of Lévi-Strauss's (the famous French anthropologist) notions on *the savage mind* (La pensée sauvage). The oral and intangible expressions of the Bedu in southern Jordan can provide us with *a very effective tool to study the structure of the primitive mind.* (2007: 1, my emphasis)

From this reasoning about finding a tool to study the primitive mind, Husban continues that Bedouin society 'can be classified as a simple form of society with important parallels to ancient societies' (2007: 15). The assertion implies that the Bedouin (or, more correctly, the image of the 'camel-herding tent-dwelling Bedouin'), represents an 'authentic', relatively unchanged culture under threat from civilisation and democracy.

The second reason for choosing the Bedouin in Husban's report relates to the consolidation of a national heritage, as was also addressed earlier:

> One of the results that can be reached by the documentation and the transferring of the oral and intangible expressions is the construction of a Jordanian national identity based on the cultural diversity. The Bedouin culture is offering for the Jordanian an authentic cultural form *that can be added to the cultural identity that the Jordanians are seeking for.* Jordan as all other nations in the world is *interested in building a national identity based on [a] concept of cultural diversity* … In our globalized world where the question of identity is posed on all levels due to the hegemony of particular cultural patterns and the marginalisation and the disappearance of others, oral and intangible expressions of the Bedu can *serve as an effective tool to strengthen and to rebuild a wider Jordanian national identity.* (2007: 16, my emphasis)

The link between national cultural heritage and Bedouin culture by means of international heritage recognition is as clear as it was with the tangible cultural heritage of Petra in the heritage reports discussed in Chapter 1. The report constructs an image of traditions, morals and lifestyle that both the Bedouin in Petra and the general national narrative identify with. This again points to the 'banality of difference' implicit in the links between heritage, tourism and history, where the desire for presence offers orientation and identification (Kirshenblatt-Gimblett 1991: 433); i.e. whether it represents a *specific* truth is less relevant than presenting a *possible* truth.

Husban implicitly refers to Sajdi and Hamze with respect to the contemporary formulation and representation of Bedouin identities, particularly the spiritual practices: 'Worthy to note that until now the Bedu are not producing their own discourse about themselves but Jordanian educated intellectuals in the urban centers who are mainly producing this discourse and then the image of the Bedu' (2007: 17). While Hamze and Sajdi's goal is mainly to preserve and document Bedouin culture in order to increase economic opportunities for the Ammarin, especially as it relates to the spiritual aspects, Husban argues for safeguarding Bedouin culture to shape the nation and the broader understanding of humankind. In other words, we have two perspectives – that of Sajdi and Hamze, and that of the academic report by Husban – that are part of the same process of assemblage but which relate to different realities of knowledge and traditions that are aimed at different audiences.

Another perspective on the importance of safeguarding these particular Bedouin groups is offered in an unnamed report by French anthropologist Anna Ohannessian-Charpin, who had previously contributed to the 1994 UNESCO Master Plan report on the tangible heritage of Petra. She recognises the passing of many Bedouin practices, such as participation in saint pilgrimages and caravans, which have been important to the greater history of the Bedouin and Islam. She stresses that unless they are documented now, knowledge of these religious activities will be forever lost. Only a few elderly people remember them from stories told by their late fathers, who may have practiced them, thereby returning to the point that caring for heritage is part of the social potency of dealing with risk. This report is clear in locating the blame for the demise of Bedouin oral history and hence the imperative to safeguard it:

> The oral tradition is almost lost by now due to the development interventions following the 2 Master Plans ... No steps have been take[n] toward rescuing or even 'recognising' the local bedouins' traditions

and practices as cultural traits. On the contrary, the impact of tourism development has been negative for these issues even if there were some positive fall outs on the economical level. (Ohannessian-Charpin n.d.: 1)

This untitled report by Ohannessian-Charpin therefore highlights how blame and recognition also figure importantly in the choice of the Petra Bedouin. Multiple ways of constructing Bedouin culture in this sense compete in the reports leading up to the UNESCO nomination. Based on the reports from Ziad Hamze, Sajdi, Sheikh Suleiman, Husban and Ohannessian-Charpin, the UNESCO nomination, the nomination report 'Oral expressions of the Bedu of Al Shara and Wadi Rum, southern Jordan', was submitted for technical review to UNESCO in October 2004 by the Jordanian Commission for Oral and Intangible Cultural Heritage (JCOICH 2004a). This was the initial step in a review process that, at a later stage, would include evaluations from experts external to UNESCO.

During the technical review, the nomination was considered weak, which led to the decision to reshape the nomination. While not officially stated, part of the problem, according to insiders, was that there was a bemoaning tone regarding salvaging the last remnants of a culture that was dying without allowing for modernisation. In January 2005, JOHUD recruited Chatelard to revise the UNESCO nomination for the Jordanian Commission for Oral and Intangible Cultural Heritage (JCOICH). Chatelard attributed a new name to the project, 'The cultural space of the Bedu in Petra and Wadi Rum', to stress the importance of place. Along with the nomination, there was also an eleven-minute film showcasing the intangible heritage, such as medicinal knowledge, poetry and mythology. Furthermore, she stressed the adaptive, modernising and evolving processes that the Bedouin cultures are experiencing and capable of dealing with. As the new nomination states:

> This submission recognizes that the lifestyle and cultural heritage of purely nomadic bedu is rapidly vanishing and that significant effort is required to preserve their rich complexity for future generations. Yet it refuses to romantically bemoan the passing of the 'traditional' bedu. Rather it is proposed to look constructively at the extraordinary adaptability of their culture. (JCOICH 2004b: 29)

The idea is that younger generations of Bedouin should become interested in the intangible and oral heritage and seek knowledge from older generations. Thus, the primary goal in this nomination is not so much to create an archive of recordings and photographs, but to ensure the continuous possibility of performing the traditions.

Renaming the project to fit in with the UNESCO category 'Cultural Spaces' meant that it became oriented towards showing the people in place in the particular landscape they inhabit (recalling Sajdi's focus on the tangible connection through the tourist camp). DeLanda's (2006) idea about the constant territorialising and de-territorialising process that has the effect of stabilising, destabilising and re-stabilising an assemblage is quite literally here a matter of situating the Bedouin in a particular territory for UNESCO. Bedouin heritage has to be territorialised spatially into the stability of material things. It thus seems that the physical fabric of being situated in a tangible place is more important than the phrase 'intangible heritage' initially implies.

The Jordanian Commission for Oral and Intangible Cultural Heritage (JCOICH) accompanied the nomination with an 'Action plan' containing implementation suggestions. It states that the aim is to 'support the maintenance and revival of bedu oral and intangible heritage in the area of Petra and Wadi Rum' (JCOICH 2004c: 2). It also aims to place this in the hands of the local people, which in the long term would 'locate culture and intangible heritage in development for bedu communities in the areas of Petra and Wadi Rum' and 're-establish cultural pride and a sense of place among bedu communities' (JCOICH 2004c: 2). The action plan suggests developing living museums, heritage centres, sound and light shows, and an outreach project that includes academics from Jordanian universities. While preservation is the principal issue, for participants the notion of 'revival' and 'reconciliation' for the loss of pride and place appears to be an integral part of the process of shaping the UNESCO nomination. Thus, the process of inscription on the heritage list was in many ways kept together by an attempt to officially reconcile and recognise the dispossession and sense of alienation the previous proclamation of Petra, as a UNESCO World Heritage Site, had caused for the Bedouin tribes in Petra. No doubt this heritage process was politically motivated, but it was also shaped by the specific material and spatial settings.

In November 2005, the Intangible Cultural Heritage committee met in the headquarters of UNESCO in Paris, with Princess Basma as head of the committee. Here, each member was given a short summary and shown a film of the more than fifty nominations. The Bedouin nomination was successful, and the Bedouin tribes from Petra and Wadi Rum became part of the 'Masterpieces of Oral and Intangible Heritage of Humanity' on 25 November 2005. Very few initiatives have, however, been initiated in the Petra region relating to the proclamation. One notable, but late, exception is the establishment of the Princess Basma Centre for Safeguarding Intangible Cultural Heritage in 2011 at

the Al Hussein bin Talal University (for more information on intangible heritage among the Bedouin, see Al-Amaren 2015).

Selecting Traditions to Safeguard

The proclamation of the cultural space of the Bedu of Petra and Wadi Rum as UNESCO intangible heritage highlighted specific elements to protect, divided in two sections: the oral traditions of the Bedu communities in Petra and Wadi Rum; and the traditional knowledge and skills related to the nomadic-pastoral culture of the Bedu. Most of the traditions noted under the headings could be applied to any Bedouin group, anywhere, which was the problem the committee had with the initial Jordanian nomination. I will mainly concentrate on the latter, which deals with practices within places and material culture and the main reason that these specific Bedouin were chosen, whereas what is presented on the Intangible Cultural Heritage website[6] prioritises the former.

Aside from the many oral traditions, the nomination considers the contact between the young Bedouin men and the tourists to be increasingly eroding the cultural traditions. The women and girls, who are not in contact with the tourists, are thus considered to use and preserve cultural traditions. For instance, in terms of naming and navigation where tourists require maps – which contain the official state-designated names[7] – local Bedouin are increasingly adopting these tourist names, while forgetting local names.

The same goes for food traditions, where the nomination stresses the threat these practices are confronted with as a result of new types of food, subsistence and healing practices. This change results in a high risk of losing the 'unique cognitive relationship' between the Bedouin and their environment. Nowadays, many of the young Bedouin are only able to recognise up to ten species of plants and herbs. The nomination seeks to construct a link between local knowledge and 'harmony' with nature and global issues of medicine and spirituality by stating:

> Bedu knowledge of natural resources is used to enhance their ability to harmonize with nature for their needs and to develop various kinds of uses for general wellbeing and healing remedies for various conditions. This traditional knowledge is a wealth of resources to local communities and global communities as we very well know the strong and immediate link between modern remedies, medicines, treatments, cosmetics, spiritual uses and traditional medicine of the past.

Through the nomination we see how, rather than the empirical category of pastoral nomad, specific oral traditions and skills are selected to represent a Bedouin culture that is threatened by globalisation. There is little mention in the nomination of the fact that the Bedouin were in fact removed due to UNESCO and national and international development policies. Thus, the nomination is highlighting – as does UNESCO heritage in general – the distinction between local and global, while actual lives are constantly shaped in amalgamation of the two through settlement policies, cultural industry, tourism and new technologies.

In the nomination to UNESCO, the pilgrimage to Aaron's tomb is highlighted as one 'intangible' element of Bedouin culture and tradition that is at risk of disappearing in the wake of globalisation. The nomination notes in particular that in terms of saint veneration, globalisation, tourism and rapidly spreading orthodox Islamic teachings are causing the abandonment of centuries of belief and practices of Islam. The pilgrimage as such is recognised as no longer a 'living tradition', yet it still remains in the memories of the elders: 'Preserving its detail will enrich the heritage of generations to come, demonstrating and strengthening the link between the various tribes in the region and the relation between the people, the land, and Biblical history' (JCOICH 2004b: 26). Beyond the nomination, the pilgrimage has held a central place in the scholarship on Petra. The very first Western encounter with Petra is based on Burckhardt's visit to the place (Burckhardt 1822: 419, 420, 430). A century later, in 1929, during fieldwork on the topography of Petra, Palestinian doctor Tawfiq Canaan (1930) also documents saint veneration among the local farmers and Bedouin. The description of the pilgrimage in the UNESCO nomination states that it normally occurs in October, and is based on the memories of a seventy-year-old lady from one of the families from Liathneh in Wadi Mousa – note the central question about who represents Bedouin culture, when asking a woman from a tribe predominantly associated with farming lifestyle:

> The ceremony would start when a man called a *darwich* launched the inaugural call, after having dreamt that Nabi Harun had visited him during his sleep. The populations of the different villages and encampments of Petra would set off on foot or riding horses and donkeys to gather in the village of Wadi Musa, wearing their most beautiful clothes for this occasion. Olive oil, candles and white cloth were carried to the summit where the shrine lies.

> The march from Wadi Musa to the shrine takes approximately six hours. Once they had arrived at the summit, the visitors performed ablutions and then entered the shrine, repeating specific chants. They would then light candles. Incantations and religious songs were uttered for several hours as all the pilgrims took their turn inside the small shrine.

> While returning home, the people transgressed many social taboos: men
> and women would walk back together, so would members of different
> tribes who had not settled blood disputes between them. On the day
> following the visit to the shrine, the population organised a series of
> horse races, while women sung and danced. At the end of these collective
> ceremonies, people would return home to their houses, tents or caves.
> Each family slaughtered a sheep or a goat on the entrance of their home,
> asking for the blessing of Nabi Harun for the months to come.

The pilgrimage is thus one with deep cultural roots, both locally and in
the scholarly history of Petra. It is also the only practice that relies on the
specificity of the landscape in Petra. The other aspects of the nomination
could be said to be so broad that they may also apply to a Syrian, Saudi
Arabian, Omani or Palestinian Bedouin in different variations, and
therefore locate the proclamation anywhere. Therefore, this pilgrimage
is particularly important in establishing why this area should be part of
the intangible cultural heritage list. But the contemporary contestation
of saint intercession also runs the risk of countering the intentions of
UNESCO's intangible cultural heritage to only safeguard traditions
that are still alive, vital and sustainable (Kurin 2007: 11). However, it
could also be argued that a few (elder) individuals may still perform
the rituals in clandestine ways, and therefore it may also be justified
according to article 2.1.

According to the nomination, part of the religious elite and some
members of the government have since the mid-1990s deemed certain
saints legitimate and their tombs worth a visit, and the nomination
states that this includes the rehabilitation of Nabi Haroun, prophet
Aaron (cf. Abu-Rabia 2007; Miettunen 2013; Muhammad 1998). In this
framework, the idea is that preserving the details of the pilgrimage,
although not actively revived, will enrich the heritage of generations
to come, and strengthen the link between the tribes, land and biblical
history.

The Ambivalence of Spirituality

To Rami Sajdi, there was more at stake to setting the pilgrimage to
Jebel Haroun on the list. It would give the opportunity for Muslims
and Jews to have a collective meeting point, where rituals could take
place, thereby enhancing mutual respect and awareness (cf. Albera &
Couroucl 2012). As he explained in an interview:

> I wanted to open up a trail for the Israelis to come and visit Aaron's
> tomb and sacrifice, along with the Bedouin. This will bring these people
> together, and make their hearts less harsh. In opening indirectly a trail to

Wadi Rum without the government you are just doing something very positive for interfaith culture. I wanted indirectly to open this trail for them, but what happened when we opened the camp, the Israeli intifada started. Before that we had a lot of Israelis coming and visiting, so it is tough during that time. So that is why the Jebel Haroun trips did not manifest. But they should manifest, because this is the attraction that you have to bring the people from the other side ...Aaron's tomb is a holy site and a sacred site, so you have a space that Israeli, Christian and Hebrew or Arabs can go and worship and make rituals together, that's why, for me, Aaron's tomb is very important. ... Prince Ghazi [Bin Muhammed] wrote a book (1998), where he promoted the holy sites and he put in Aaron's tomb. If you want to make peace you have to start doing what we did a long, long time ago. To visit these places together.

Thus, to Sajdi, there is a link between current political tensions, the peace-making process and recognition of Aaron's tomb. The tomb was restored in 1998 (Lindner 2003: 193), and the Bdoul guardian told me that a green cloth, which is used in other sites as well to honour the saint –symbolising the Islamic sainthood of Aaron in the grave – had been removed since my earlier visit in 2005, so the tourists could see the inscription. At my last visit in 2007, someone had ignited incense, and the guard argued that it was partly because of the nice smell, and partly to scare away the *jinn* (spirit). The guard's opinion was that while he had participated in the pilgrimage (*ziyāra*) when he was younger, it was now considered *jāhiliyya*, part of an ignorant past. Among my interlocutors, the tradition is mostly seen as un-Islamic and they dissociate themselves from saintly mediation, because the participants would ask Aaron for blessing and hence commit heresy by 'worshipping' him instead of God.

In terms of safeguarding heritage, the pilgrimage thus does not exist as a living tradition, except among very few people performing it alone, or who may only vaguely remember it, as opposed to still performing it. If people still perform it, it is not done in the collective seasonal manner as it used to be. In relation to the local understanding of the past in the present, however, such interest in the pilgrimage and other religious practices is problematic. The question of who represents a culture, and how safeguarding intangible heritage allows for change, is pertinent if it is to be more than a folklorisation and documentation practice. This can be exemplified further by one part of the nomination stating that the Bedouin believe 'That nature is an organic part of the human being which can be controlled by him on some level, they also believe in the possibility of beckoning the coming of rainfall' (p.17).

To show this point, the practice of 'rainmaking' is used in the nomination. No specific example is mentioned in the final nomination,

although a story is retold from Wadi Rum. However, the nomination mentions that there are certain differences from one region to the other in these rainmaking practices – for instance in gender divisions: in Petra both sexes are part of the ritual, compared to the strictly female practice in Wadi Rum. The initial nomination, however, notes that the inhabitants around the al-Sharah mountains (which Petra is part of) would tie a white cloth to a stick and wave it, followed by collecting wheat, oil and *samn* (clarified butter), which is then baked and redistributed.

Such representations appear highly problematic, as there seem to be very important distinctions between the rainmaking ritual described in the nomination and the rainmaking ritual that is widely practiced all over the Islamic world. The King of Jordan would, for example, perform the *ṣalāt al-istisqāʾ* in years of drought. Yet this ritual, unlike what seems to be presented in the nomination, is a prayer to God to bring rain, as it is believed that God is the sole entity in control of bringing rain, crops, animals, etc. The purpose is to influence the 'world of the unknown' (Abu-Zahra 1988: 507), not to control it.

I did not myself witness the practice mentioned in the nomination, nor hear of anyone performing it this way now when I asked (however, see Musil 1928). But to the best of my knowledge, it seems highly unlikely that any of my interlocutors today would state that they could beckon rain or plants in any way other than by praising God, who then would decide – as drought is caused by injustice and ingratitude to God. In all cases, acts such as those proposed in the nomination, or as Nadia Abu-Zahra (1988: 518) describes them in Tunisia – tying knots on sacred trees or sticks – is now denounced as un-Islamic by most interlocutors. We here thus see a clear split between a more purist Islam and folk Islam.

Chatelard explained the spiritual aspects of the nomination as something that has a place in Bedouin heritage, but an ambivalent role, very much in line with the interpretations offered here:

> Rainmaking and pilgrimage to Jebel Haroun were there [in the initial nomination] and I didn't know what to do with them, you know, because in both cases I know that they are practices that are not... they are not alive anymore none of them and why they are not alive ... I would say although I haven't done a study about it, but I think I can guess, mainly because the whole islamization process to schooling in particular and the imposition of the normative practice and interpretation of religion. So as you said before, we've been discussing this, you know, I'm very aware that both could be qualified as practices of *jāhiliyya*.

In continuation of this, and as we shall also turn to in Chapter 3, Chatelard also argues that in terms of local heritage construction, these practices are not forgotten, even when no longer practiced, as they

consolidate a Bedouin history and something to look back on with both pride and disapproval. Chatelard notes:

> Still today, maybe not the youngest generation of the Bedouin, but the people who are 25 and above will also recount willingly what remains in their memories of the big tribal disputes and raids that used to happen in the past. Nobody would pretend [it is] something that they would like to revive today, but people would say it would be nice to document them because the memory is vanishing. So, I believe that rainmaking can be viewed in this context, it is a *jāhiliyya* practice, but in the same time ... it is part of their history, so I think rainmaking can be framed in this context, you know. People can talk about it as a practice of the past, which used to make them specific as a Bedouin ... It is part of the heritage, but it is part of this heritage, which is not, you know, valued anymore, and which people do not want to actualize and to transmit. It is part of the past, but it is part of the history of what Bedouin used to be in the past.

Chatelard thus rightly points to the notion of the ambivalent heritage (cf. Chadha 2006) pronounced in Ammarin conceptions of the past in the present. In other words, these practices situates cultural specificity along with a distinction between past and present, and incorporating the one into the other on the condition that it is articulated as a past, not present, practice. While one could claim that tent-life is still practiced to some extent by some in the area at certain times of the year, the spiritual practices are far more controversial, and almost abandoned. They highlight the problematic nature of safeguarding the UNESCO intangible cultural heritage, as they may rapidly change. The intention, at least to Chatelard, has not been to revive these practices, but rather to document them – which, however, still puts them at odds with the intentions of the Intangible Cultural Heritage proclamation.

The Aftermath

UNESCO granted $50,000 of the $80,000 requested, and Said Abu 'Athera, a specialist in Bedouin oral traditions (cf. Holes & Athera 2005) was selected as project coordinator, along with Mohammed al-Jazi from Howeitat, a specialist in development who works for JOHUD.

On 24 March 2006, Jordan ratified the Convention for Safeguarding the Intangible Cultural Heritage before its entry into force as an international legal instrument on 20 April 2006. The Committee for Intangible Cultural Heritage (CICH) was then established in Amman on 11 March 2007 as a sub-section of the Jordanian National Commission for Science, Education and Culture. CICH is chaired by the Minister of Education and is the official competent body charged with promoting and overseeing the implementation of the Convention nationally. By 1

May 2007, a policy paper, *Safeguarding the Intangible Cultural Heritage (ICH) in the Hashemite Kingdom of Jordan,* was prepared by CICH with the assistance of Chatelard. The aim of the policy paper is to facilitate the implementation of the Convention in Jordan in accordance with the international standards.

It is a paradox, however, that in my survey of all the households in Beidha in 2007, only four heads of household knew that their cultural practices were UNESCO safeguarded: two had a chief role in the Tourist Association; another was the daily manager of the Ammarin Bedouin Camp; and the last one was working for the Department of Antiquities, thus dealing with administration of the National Park. Of these people, none saw how the UNESCO proclamation of intangible heritage had changed anything. They did not benefit economically from it and few projects had really been initiated. Some of the younger people working in the camp and the nine people performing with the *Samer* group at cultural festivals also knew about it, as they participated in the celebration of the proclamation.

This raises the question of who the heritage is for: the Bedouin or someone else? There is a paradoxical gap between universal heritage proclamation and local awareness. In other words, at least in the interlocutors' minds, there were no changes resulting from the proclamation, and the common phrase in discussions on the proclamation among the Bedouin was that 'We won the competition', but with no sense that it would have long lasting effects as anything else than a one-time event. Furthermore, it seems that the matter of whose and what culture is preserved appears slippery, as the interlocutors, at least as listed in the appendix, most often are not from the primary tribes in question, and many of the nomadic practices would appear to be more or less extinct in this area compared to, for example, in Wadi Araba, with the Sayydīyyn.

The implication of recognising the Bedouin as UNESCO intangible cultural heritage, on the part of JOHUD, as explained in the 'Action Plan' that followed the nomination, is to set up a weaving project where the women could promote the transmission of knowledge, but at the same time sell the end product.[8] The action plan, to a much larger extent than the nomination, involves the local Bedouin groups of Bdoul, Sayydīyyn and Ammarin. It seeks to serve as a catalyst for 'the collection and intergenerational transmission of oral heritage' and 'the transmission and adaptation of knowledge and know-how related to camel and weaving'. Furthermore, the misrepresentation of and prejudice concerning the Bedouin is stressed, as well as the fact that the developments and preservation should be in the hands of the local people themselves, supported by scientific research and archival work.

Reshaping the Bedouin

Barbara Kirschenblatt-Gimblett (2004) has argued that heritage is a 'meta-cultural production' in that although it may have recourse to the past, it produces something new and different from it. While I largely agree with this, the focus on the process of inscription formed by the assemblages of a wide range of voices and places allows for a shift in perspective on the discursive framing of heritage from the social constructionist 'invention of tradition' (Hobsbawn and Ranger 1983) to the politics of identity shaped by the 'intention of tradition'; that is, what the announcement of heritage does. From this approach, we may learn how various intentions to preserve traditions interlock a wide range of perspectives on Bedouin culture, rather than harmonising with them.

Yet, while stressing the political or representation as pivotal to (the practice of) heritage, other scholars have argued that what is sought in the past is not representation, but its presence. In that perspective, heritage is in many ways non-discursive, at least from a position within the social group. It is a feeling of belonging and of the presence of the past, without having to either justify or articulate what the object it relates to is precisely (Runia 2006). It is the sense of the presence of the past, but, as shown above, one that meticulously changes through continuous practice, reflection, forgetting or obliteration. As Chatelard notes, it is heritage, but not one that needs to be transmitted; rather, there should be an absence of presence – at least for some of the Bedouin – for it to be fully understood as heritage.

From the above, I wish to point to two issues in the interlocking process of shaping a heritage assemblage. Firstly, the case shows that in the process of inscription a consolidation of the social category of 'being Bedouin' occurs. The Bedouin are articulated as a practice of oral traditions, skills and spiritual practices, rather than the conventional empirical social category of desert-dwelling nomads. Secondly, this reformulation is constructive of a particular kind of image of the Bedouin forged in the discourse of Neo-primitivism and shamanism, beyond the nostalgic depiction presented in Chapter 1 by the Bedouin. This is more than just a reconfiguration of the meaning of being Bedouin, but rather aims at accessing (heritage) resources by tapping into the particular universal claim established by UNESCO through a notion of cultural diversity, most often presented visually by the elder generation or children.

By stressing social practices in the UNESCO nomination, the definition of the Bedouin is transformed from a pastoral mode of subsistence to a social identity based on skills and oral traditions (cf. Chatty 2014; Cole 2003; Eickelman 1998; Peutz 2011; Prager 2014a; Young 1999). However,

these oral traditions do not necessarily depend on nomadic life, but rather a commitment to place. Bedouin across the Middle East have long held oral traditions and desert survival skills, but to single out any of them, place is crucial. This is a dilemma, which UNESCO's intangible heritage list seems so far to ignore in its practical selection of intangible heritage.

Reshaping the image of 'the Bedouin' legitimises a Jordanian national narrative based on the Bedouin heritage, when in practice the settlement of (semi)mobile pastoralists is almost fully accomplished. Settling the Bedouin has thus paradoxically produced a desire for a heritage object shaped in the image of the Bedouin. The international recognition of intangible cultural heritage thereby shapes the national image of Bedouin roots, as well as the international legitimacy of possessing cultural richness without dealing with the practical consequences of government settlement and heritage protection policies. The recognition hence makes the traditional look modern, where 'being a Bedouin' is considered to be having a heritage of skills and practices, rather than a mode of dwelling. Therefore, the modern state looks traditional by linking to the millennium old heritage of the Bedouin (Al-Mahadin 2007b; Layne 1994; Massad 2001).

Through redefining what a Bedouin identity is, Bedouin culture can be kept, while changed: at both the national level, in the image of national identity; and among the Bedouin, in reasserting themselves as Bedouin, although settled. The image of the uncontrolled nomadic Bedouin is tamed at the state level through such redefinition, while the recognition of heritage is taming the sense of longing and nostalgia evolving particularly among the younger Bedouin. The authenticity of being Bedouin, then, becomes a moving and intangible target that is more easily negotiated than the empirical question of subsistence and mode of dwelling.

At the national level, the creation of a style of 'traditional' Jordanian heritage, in which the Bedouin have had a crucial role since the beginning of Jordan's history, is fostering a more coherent historically and territorially rooted sense of Jordanian national identity (Hazbun 2004: 331). In that sense, when both Petra and the Bedouin are adopted into UNESCO's heritage lists, they are also consolidating their importance in national discourse and historicity (Al-Mahadin 2007b). The pronouncement of the Bedouin as Intangible Cultural Heritage reveals a moral panic emerging at various intensities and levels of society from the impact of the modernisation process. The heritage recognition is a further 'invitation to absorption' (Povinelli 2002: 184) that started with the settlement, impact of schools, televisions, mosques,

detribalisation and abandonment of Bedouin law. Through the recognition of their heritage, a balance of alterity and image of cultural diversity is maintained in a compatible position with the incorporative project of a united Jordanian citizenship; 'not too much and not too little alterity', as Elizabeth Povinelli states (2002: 184). However, the process through which such heritage is construed also allows for multiple lines of interests to be invoked through the assemblages established by producing a 'desirable object' of heritage. This process is established by externalised relations that can encompass reconciliation, alternative spiritualities, interfaith practices, primitivism and preservation.

Furthermore, the process of inscriptions is formulating the radical other: those who materialise everything that is lost. By shaping an image of the 'authentic' Bedouin in the reports, international organisations and even the Bedouin can become unintentional actors in shaping a 'Neo-primitive' figure. This may be the unintended consequence of an enlightened concern about cultural diversity, but it traps the Bedouin in the demands for an impossible authenticity associated with primitivism (Kuper 2005; Povinelli 2002). This notion of the primitive is also established from within the communities of 'primitives' as it helps in gaining legal rights and recognition. This image is comprised of the representation both in the UNESCO nomination and in the museum of Bedouin 'shamans', thus potentially linking to another universal community of authentic Indigenous people. This not only occurs at the level of tourism investors such as Hamze and Sajdi. As Husban would have it, it also occurs as the Bedouin offers insights into the 'primitive mind' and therefore must be preserved.

In that sense, the construction of specific Bedouin groups as 'authentic', I argue, particularly through 'cultural freezing' and Neo-primitivism by various actors – the Bedouin included – suggests that perhaps the modern project of heritage production inherently hinges on more than protecting and formulating the 'un-modern'. It is a process that also seems to be stabilising the 'un-modern' as the foundation of the modern Jordanian state and national identity by representing the involved people as inherently traditional – even if only in the image created in both the tourism encounter and the process of UNESCO inscription.

Traces of Multiple Universalities

Examining the process of safeguarding Bedouin culture through an Intangible Cultural Heritage nomination reveals the details of

how defining Bedouin intangible culture in a heritage context is influenced by the intersections between local, academic, national and international actors. They each tap into very different, yet also closely related, universalities of UNESCO heritage, reconciliation, Islamic revival and scientific knowledge. These actors may have conflicting interests and limited power to fully structure events, and thus all reports leave a small mark on the final nomination. The unravelling of this process shows how a simultaneity of perspectives are contained within one sphere of the UNESCO nomination and draw on contentious commitments to tangible heritage management.

In the above reading of the reports and my interviews with actors involved in the process of putting together the UNESCO nomination, I have shown how aspects of the past are entangled in a network of commitments to cherish and safeguard an acclaimed cultural tradition, and, importantly, to safeguard it in the right way, through UNESCO. While each actor may share a cherishment, value and concern for Bedouin culture as represented among the people of Petra and Wadi Rum, they do so with various intentions of reconciliation, economic development, spiritual documentation and a potential to study 'the primitive mind'. That is, to follow DeLanda (2006), the relations are not stabilised, but by territorialising the Bedouin in specific places these relations may co-exist in aiming to protect or safeguard in the proper way. They are also substantially different in their power to influence the process.

The process creates asymmetrical and multi-vocal notions of being Bedouin. It is a process that may incorporate mutually exclusive elements, and yet simultaneously create an image of specific groups, which – due to modernisation, religious and tangible heritage policies – diverge from the image they ostensibly represent. Yet it follows that the process of producing UNESCO intangible heritage also produces something new: a Bedouin for the twenty-first century, released from the chains of prejudice and claims of nomadic backwardness, but empowered as a tool and foundation for displaying Jordanian cultural richness. This richness is, however, not defined in any singular manner. As we shall now explore, there is an inherent multiplicity involved, where the figure of a shaman is also lurking in the background of the saint.

Notes

1. This chapter is derived, in part, from an article published in the *International Journal of Heritage Studies* on 10 October 2011, available online: https://www.tandfonline.com/doi/abs/10.1080/13527258.2011.599853.

2. http://www.unesco.org/culture/ich/index.php?pg=00011&RL=00122 (accessed 3 May 2011).
3. http://princessbasma.jo/events/harmony_list.htm, my emphasis (accessed 9 July 2008, no longer valid).
4. With very few exceptions, there is a lack of substantial anthropological studies of the everyday life of the Bedouin conducted by Jordanian scholars written in English, German or French (cf. Al-Sekhaneh 2005).
5. For example, Al Alaya, Bani Ata, Al Shrour, Al Malahim, Al Habahbeh, Al Twarah, Al Rafaya'ah, Al Shqairat, Al Lwama, Al Sha'ibat, Al Hawarneh, Al Matalqah, Al Fraijat, Al Taqatqah, Al Btouneyeh, Al Attoum, Al Mahaziz and Al Manajdah.
6. http://www.unesco.org/culture/ich/index.php?cp=JO&topic=mp (accessed 10 September 2008).
7. For example, Siq Umm al-Hiran is the local name, but in official maps it is called siq Umm al-Alda. Likewise, archaeological sites are sometimes called by a name other than the various local names used, e.g. the Neolithic site of Ba'ja is called Umm Muhmadh, whereas Ba'ja denotes the area outside the gorge leading up to the site. Thus, there are parallel naming strategies depending on who is asking about the sites.
8. Similar to the Bani Hamida project (see Jones 2006).

Figure 3.1. The Al Samer Song and Dance Troupe. Photo by the author.

୬◉ 3

THE SHAMEFUL SHAMAN

Introduction

On 22 July 2006, the Al Samer Song and Dance Troupe stepped onto the stage of the Roman Theatre in Amman, Jordan, to perform their customary song *al-samer* in a festival celebration of Jordanian cultural heritage (figure 3.1). The troupe consisted of nine men from the Ammarin Bedouin tribe. The men wore their best newly pressed white dresses and perfectly ironed red and white chequered headgear, thus embodying the image of the Bedouin. In front of the group was the leader, the *ḥāshī*, in his black coat with golden trim. He was swinging a stick in his hand, and the eight other men followed in a slow walk behind him, forming a straight line, clapping their hands in time and singing their song. The song lasted about fifteen minutes and was received with a standing ovation. Presented alongside other cultural performances, such as the popular *dabka* dance (literally meaning 'stamping the feet') by a group from Maʿan, and a Roman gladiator fight, the Ammarin tribe represented Jordanian Bedouin culture – a distinct honour in a country that persistently lauds its Bedouin roots.

I had, however, come across a press release for the Al Samer Troupe, which presented the *samer* as a 'shamanic séance' in which the leader of the troupe, the *ḥāshī*, performed the role of a shaman entering a trance. Furthermore, as part of the heritage industry around Petra, the Ammarin have established a Bedouin camp for tourists with the convenience of proper toilets and baths. On the webpage promoting

the Bedouin camp, deceased members of the Ammarin tribe, along with their descendants, are presented to the English-speaking tourists as having 'shamanic abilities'. These people are, in Arabic, considered *fuqarā'* (singl. *faqīr*) – a religious figure characterised by poverty, like a Dervish. The *fuqarā'* are highly esteemed by the various tribes in the area and play an important role in the negotiation of reputation among their descendants. In a lot of the literature, figures such as the *fuqarā'*, and related figures like the *walī*, *ṣāliḥ*, and *derwish*, are collectively translated as saints, without insinuating any Christian conceptualisation (Bandak and Bille 2013; Denny 1988; Eickelman 2002; Makris 2006; Meri 2002; Stauth 2004). Yet to the tourists and the heritage industry at large, they are not conceived of as 'saints' but as 'shamans': the same term with which the *ḥāshī* in the *samer* were presented. Two very different versions of the traditions are thus at play: the shamanistic ritual and the cultural performance.

When it comes to presenting the past for present purposes, dissonance is ever lurking in the representation of tradition (Tunbridge and Ashworth 1996), and Talal Asad reminds us that 'any representation of tradition is contestable' (1986: 17). What is intriguing about the trope of shamanism in the conceptualisation of Bedouin traditions is that shamanism appears to be diametrically opposed to the influence of the Islamic Revival discourse that is developing among the Ammarin themselves and in the wider Middle East, as well as in the focus of much recent literature on piety (cf. Deeb 2006; Hirschkind 2006; Mahmood 2005). The representations of shamanic séances in the press release and on the web, including spirit manipulation and individuals entering trances through drum playing, seem incompatible with the emerging moral ideals of the Islamic Revival, wherein the *samer* and *fuqarā'* are rather presented as renowned cultural traditions and saints.

Taking what appears to be a customary Bedouin oral performance as my starting point, this chapter[1] shows how practices and religious figures from the Bedouin past are not just cherished cultural traditions but are framed and contested in contemporary negotiations over the past in the present at various levels of Jordanian society and extending to global narratives of spirituality and heritage. Whereas the previous chapters explored the heritage effect and process of inscription, the main interest here is to understand how multiple versions of the same figures can co-exist, even if they may initially seem incompatible. What appear as conceptual gaps between the saint and the shaman, I argue, are constantly rearticulated through parallel modes of ordering that are tied together by the social networks and material infrastructure forged

by the saints' graves, cultural performances and tourist industry. This points to the way in which multiple processes, rather than a single fixed order, emerge in framing the past in the present. Between various actors appears the productive space for reconfiguring knowledge that draws on various scales of legitimacy, in this case Islamic, heritage and New Age conceptualisations. While the *samer* and the saint may appear quite different at first, they connect in one process, in the shamanic term, while in another process they merge as performances of the historical consciousness of a cultural tradition from which the Bedouin are being rapidly dissociated.

Focusing on the multiplicity of processes and perspectives enables us to highlight some of the inconsistencies, overlaps and gaps in enactments of the past that are also present in the lives of people in the Middle East. To frame the inconsistency that is erupting in the slipstream of showcasing traditions as part of the emerging heritage industry, I take the *samer* as a point of departure, but also as a performance that strikes a chord beyond the narrow confines of the heritage industry and instead relates to questions of the conceptualisation of spirituality and the role of the Bedouin in contemporary Jordan.

In extension of Samuli Schielke's important work on ambivalence and contestation (2009, 2012, 2015), this chapter explores the tensions, gaps and dissonance between the articulations of heritage, shamanism, sainthood and forging of pious subjects. It discerns how parallel understandings of the nature of various renowned characters from the past (and present) are employed in contemporary Jordanian heritage discourse, where the *samer*, the shaman and the saint all present themselves in complex ways. By exploring the apparent gaps between these presentations of traditions, I argue that an indeterminate, even uncanny, relationship exists between shamanism and sainthood, which is continuously brought to presence through oscillations between minimising and maximising the gap. The three versions of the figures may share the same object yet are multiple in the sense that they do not share the same part. This selection of parts shapes partial connections that are used intentionally by some actors to promote shamanic or heritage discourses, while others move between foci and include other aspects to shape other moral and social regimes. This chapter offers a discussion of the practical influence of such diverse universalising processes as the Islamic Revival, UNESCO heritage and New Age movements, which cannot easily be separated into distinct spheres of social, moral or economic life. This will take us from the stage of the Roman theatre in Amman to the impact of the Islamic Revival on saintly intercession among the Bedouin, and through New Age ideas

about shamanism and back to the halls of UNESCO world heritage proclamations discussed in Chapter 2. But let us first return to the *samer*.

Celebrating the Samer

To the Ammarin interlocutors, the *samer* is one of the oldest traditions in Jordan, whereas they see the *dabka* performance as a Lebanese/Palestinian cultural tradition deriving from farming communities, lacking roots in 'real' Jordanian culture. They are thereby contributing to the sensitive politics of identity in the Hashemite Kingdom of Jordan, which has a substantial population of Palestinians, Iraqi refugees and guest workers, but in which the Bedouin have remained a central figure in national identity politics. The *samer* originates with the Bedouin, and it was members of the Ammarin tribe who presented it at public cultural performances around Jordan. The Ammarin thereby came to personify Bedouin culture although they would not in other contexts lay strong claim to being 'real' Bedouin with their now settled, goat-herding lifestyle with tourists around Petra. They saw the position of being 'real' Bedouin as belonging more to the long-distance camel-herding tribes living in tents in Wadi Araba or the Eastern Deserts. Nonetheless, through these cultural performances, the Ammarin, and Bedouin traditions more generally, are valorised and preserved in the public imagery of Jordanian cultural heritage, and are specifically celebrated in UNESCO's 'Masterpieces of the Oral and Intangible Heritage of Humanity', discussed in Chapter 2.

The *samer* is performed at weddings and other celebrations and includes an improvised poetic style. Due to changing ideas in recent decades concerning gender separation, most often substantiated by claims to Islamic morality, the role of the *ḥāshī* as the head of the group is today performed by a male.[2] In the nomination to UNESCO, the *samer* was presented as follows:

> The samer is the party before the wedding that includes song and dance of the same name culminating into the excited dance of dahiyyah. The samer song is a vocal genre that accompanies the Samer dance, which is specifically performed by men. At a later stage, and in an attempt to rouse more excitement and reinvigorate the dancers, the storyteller ends his song and invites a hashi, a female member of the tribe, to join the dance in the centre of the dance area. With a veil covering her face, she steps in wielding a sword, with which she defends herself against being touched by any of the dancers. Dancers and spectators alike become very excited and the energy level rises tangibly almost reaching trance.

At the height of the excitement, the dahiyyah escalates into an ignited dance, wherein the clapping men advance to a short distance from the hashi repeating the word 'dahu' until she succeeds in slipping out of the dance ring. At that moment, the men's voices and clapping surge to announce the end of the dance. (JCOICH 2004b)

According to the Ammarin's official leader, the late Sheikh Suleiman, the idea of creating a cultural performance of the *samer* came from the Ammarin themselves, but they needed experienced people to create it as a showcase of a cultural tradition. The Ammarin Tourist Association, established to present one tribal voice in the growing tourism industry around Petra, collaborated with Hamze and Sajdi from Amman to construct a showcase of Ammarin Bedouin cultural heritage entitled the 'Al Samer Song and Dance Troupe'. The Samer Troupe was promoted through the PR Bureau 'I ♥ Jordan'. Although no longer in use, the press release was sent to major magazines and cultural interests in Jordan, and is here quoted in longer excerpts, as it is here that the first spiritual interpretations were disseminated to the broader public:

Al Samer Song and Dance Troupe was formed in 2005 to preserve the cultural heritage of song and dance of the Ammarin tribe ... The magical performances that Al Samer Song and Dance Troupe perform are a modern replica of what is known in archaeic [sic] cultures as a 'shamanic séance'. A séance is a spiritual journey of the body and mind that is enacted by a tribal healer in the company of the tribal members ... The Troupe conductor symbolizes the shaman-doctor who heads the spiritual performance. A shaman is most clearly defined as the spiritual leader of a society, with his knowledge of healing and his capacity as a mediator between spirits and human beings ... Traditionally, a séance is conducted when a problem arises in the tribe and the shaman is called upon for guidance. The healer, through a controlled state of consciousness, puts his power into practice and journeys to the underworld of the spirits. This collective act is revived nowadays in post-shamanic cultures as a musical entertaining ceremony dissociated from any spiritual significance ... In a traditional séance [sic], the shaman voluntarily allows himself to inhibit (or be possessed by) his spiritual counterpart. The healer therefore masters the spirit he embodies, taking the shamanic journey at will ... When possessed by the spirit, the shaman shrieks in a high-pitched voice similar to a woman's. The piercing voice is that of the spirit and is therefore attributed to that of a female. In Al Samer Troupe, the black-cloaked conductor swaying in abrupt gestures signifies a female persona ... The final art of the séance takes place with a *dehiyyeh* – a traditional Bedouin chant. Historically, when a shaman is possessed, a stream of incoherent words pours from his lips. The shaman is used as a medium for the spirit to communicate with its audience by revealing the secrets of the other world, which will consequently solve the problem that the tribe wants to address ... The Troupe has therefore successfully

managed to contribute to safeguarding the intangible Bedouin heritage
concealed from our day-to-day 'civilized' lifestyles.

Through the PR Bureau, the Ammarin had entered a much broader
commercial market for cultural performances than before, when the
samer was performed mostly at local celebrations. The press release
explained the 'shamanic' roots of one of the Ammarin's most valued
cultural traditions. It explicitly states that the *samer* has 'less spiritual
edge to it' and is 'dissociated from any spiritual significance' today.
However, the official presentation of Bedouin culture as containing
'shamanism', spirit possessions and trances illustrates the potency of
defining the order of the past. Among the Ammarin, it is clearly at
odds with emic understandings of the past and current standardisation
of Islamic practice whereby spirit possession, or manipulation and
trances, if even possible or effective, are seen as religious deviance.

The promotion of the Samer Troupe as a shamanic séance in the
press release also sparked interest in the Jordanian media. In an article
in *JO Magazine*, one of the larger international magazines in Jordan,
journalist Nicholas Seeley wrote an article on the Ammarin (Seeley
2006). Seeley interviewed some of the Ammarin working with tourists,
as well as Geraldine Chatelard – the aforementioned Amman-based
French anthropologist, who has published widely on the Bedouin
culture in Wadi Rum and is central to the UNESCO proclamation.
Seeley addresses in particular the issue of shamanism when he quotes
Chatelard as arguing that 'You can use "shamanism" when you're
talking about animist societies that endow every living being with a
spiritual persona … but you can't use it here: "The Bedouin identity is
Muslim"' (2006: 91). The article further states that 'New-Age mysticism
goes down like gangbusters with today's spirituality-seeking Western
tourists, according to the PR people, but anthropologists say it's a load
of bunk, based on religious practices from other societies that have as
much to do with the Bedouin as tinfoil' (2006: 91).

I questioned my Ammarin interlocutors about the alleged shamanic
practices. Even the interlocutors from the Ammarin Samer Troupe
that I talked to, however, had no idea about the press release. In fact,
they fiercely contested it, stating that this interpretation of the *samer*
was not true and was inherently un-Islamic. It appears that the two
versions may run completely in parallel.

Hamze and Sajdi no longer use the press release, in part due to the
critique from scholars, and yet the shamanic representation of Bedouin
traditions extends beyond this press release to religious figures of tribal
pasts known as saints or 'friends of God' (Meri 2002; Miettunen 2013;

Renard 2008). The *ḥāshī* in the *samer*, it will become clear, is not the only figure from the Ammarin past that has been cast into a 'shamanic' terminology, thereby highlighting the instability and potency of defining religious categories.

Sainthood as Heritage

Sites and shrines associated with renowned figures from Biblical history have been capturing the attention of the heritage industry in Jordan for quite some time. Mount Nebo (associated with Moses) and Jebel Haroun in Petra (associated with his brother Aaron), and Bethany beyond Jordan (associated with John the Baptist and Jesus) are but a few cases in Jordan. Since the 1990s, there has been an increasing focus on Islamic heritage, not least due to the growing number of tourists (and refugees) from other Arab countries. Shrines, mosques and other sites from Islamic history have been excavated, restored or otherwise brought to the awareness of Jordanians and foreign tourists alike. For example, the recent renovation of the shrine of Abu Ubaidah Ibn Jarrah, one of the Prophet Muhammad's companions, has placed it in a prominent line of sites that celebrates the Islamic history of Jordan. Members of the Royal family – Prince Ghazi bin Muhammed in particular – are also presenting a wide range of both Islamic and Christian shrines as Holy Sites important to Jordanian cultural heritage (Muhammad 1998).

As Islamic figures and history are featured more prominently, the importance of Islam in Jordanian national heritage is being reasserted alongside, but not instead of, the Christian heritage (Neveu 2010). Saints, prophets, companions and other recognised religious figures have become players in the heritage industry, both in terms of diverting the geography of tourism and shaping the representation of Jordanian history. As well as these renowned people and sites, many more shrines of local figures associated with various versions of sainthood are located throughout the landscape, where they act as anchors in tribal historiography – especially around Petra, where the Ammarin live. They belong to local 'saints', such as *awliā'* (singl. *walī*) (other related figures are the *fuqarā'* [singl. *faqīr*], or dervish).[3] The term *walī* refers to a 'friend of God',[4] and describes a charismatic and knowledgeable person, who transmits *Baraka* (blessing) through various kinds of contact (Kressel et al. 2014; Meri 2002: 59, 73, 108; Renard 2008). It is important to note that these 'friends of God' are not 'lesser gods', rather they are mediators between humans and God.

For the Ammarin, two shrines figure prominently in the landscape and in their pilgrimage traditions. One is south of Beidha housing, where the aforementioned shrine of the prophet Aaron is located on the top of Jebel Haroun. This was the site of a bi-annual pilgrimage for the farmers and Bedouin around Petra until the early 1990s. Following a vision in a dream, a local dervish would announce the beginning of the collective pilgrimage to the shrine, where songs and rituals would be performed asking Aaron to act as their intercessor with God (cf. Mittermaier 2008). People would walk several hours to the shrine and back, with both genders intermingling and unresolved blood feuds temporarily forgotten, and would end the pilgrimage by sacrificing an animal. Although it is recognised that this practice is no longer performed, it plays a prominent role in the UNESCO intangible heritage nomination.

Another site, a few hours' walk west of Beidha, is the graveyard of the Awwad branch of the Ammarin tribe. Here lies buried the renowned forefather Salem Awwad (figure 3.2). He lived seven generations ago and is considered a *faqīr*: a poor man but, in the particularly religious sense, a man blessed by God – a saint. As one interlocutor today described a living saint:

> The saints are good people, from God Almighty. An honest, believing human. His heart is with God … With the belief that this good person prays to God … you bring the sick person to him [and] he will pray to God and say: God, I am an honest, poor and weak person, please heal this sick person. So God grants him this wish!

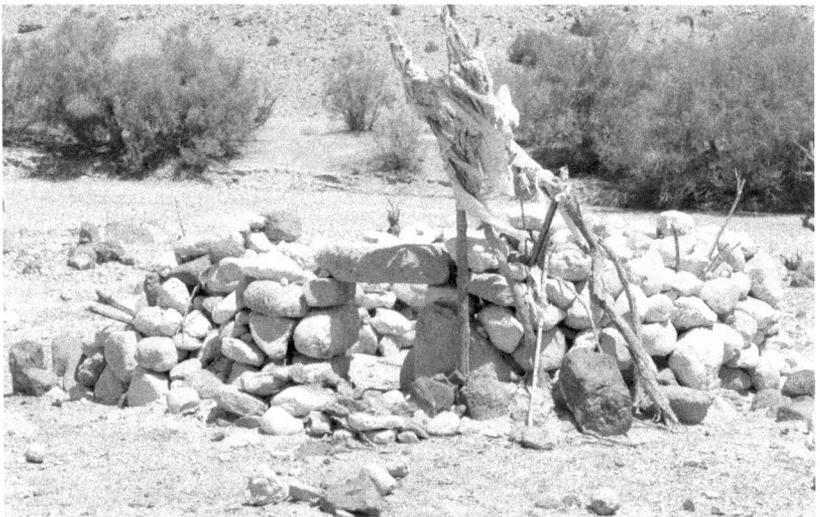

Figure 3.2. The saint grave of Salem. Photo by the author.

Salem Awwad's shrine has been used for centuries for saint intercession, with prayers, offerings, burning of candles and incense at his grave to transmit a wish or invocation to God. The saint also holds a prominent social position in Ammarin tribal history by offering deep historical links to the landscape that they are now largely removed from, and through genealogical ties, important in contemporary local politics and power structures. Today, people from the Awwad family line thus enjoy social recognition because of their saintly genealogical ties.

The Islamic revival which emerged in the mid-1990s in the area ultimately seeks to purify the world from 'magic' and 'return' to an Islam as allegedly practiced at the time of the Prophet Muhammad, shaping stronger associations of religious homogeneity in a Muslim collectivity: the Umma. The moral and pious influence of this more purist understanding of Islam has meant that the bi-annual pilgrimages to Jebel Haroun, along with visits to Salem's grave, have ceased, and these sites are now only visited surreptitiously by a few people. To most Ammarin today, the saint is a person God has chosen and bestowed with his blessing. But he is no more than a human being, not one to be set beside God or capable of transmitting messages or wishes through saintly intercession or contagious magic at his grave. These practices are explicitly termed *jāhiliyya* – belonging to the 'age of ignorance' – and are reminiscent of polytheism to many of my interlocutors.

Oddly enough, then, in light of the uniformity of defining the saint as a 'good and righteous man' among the Ammarin, I kept running into narratives and representations – as in the case of the *samer* – in which the understanding of the *faqīr* somewhat diverged from the Ammarin conceptualisation, and where the shamanism trope kept appearing. It appears that simply juxtaposing the Islamic Revival of a purist Islam with folk Islam fails to explore their complex interrelationships between texts and practice (Lukens-Bull 1999). To find out more, we need first to take a brief detour from the influence of one universal modern process of standardising Islam to an equally modernist and universalising agenda that finds its sources in the past, namely UNESCO world heritage politics.

Sainthood as UNESCO Heritage

UNESCO's recognition of intangible heritage is not intended to preserve specific lyrics or practices, but rather to allow for the continued practice of the tradition and to enable it to develop (Nas 2002; Ruggles and Silverman 2009; Smith and Akagawa 2009; UNESCO

2003). More than simply a celebration of traditions, UNESCO cultural heritage also plays a role in performing and shaping social, local and national identities (Bendix 2009; Fontein 2000; Di Giovine 2009; Hafstein 2009; Scholze 2008; Winter 2007). Among the many oral traditions and practices highlighted as 'Masterpieces of the Oral and Intangible Heritage of Humanity' were the saint pilgrimages and the *samer*. Aside from getting the Jordanian state to commit to making efforts to safeguard this heritage, and the many good intentions and moral obligations of the 'salvage paradigm' (Clifford 1987) regarding the antiquities and traditions of the late twentieth century, announcing cultural heritage is also a method of highlighting and ordering a selected part of the past in ways that consolidate claims to belonging, rights and cultural distinctiveness. Both Petra and the Bedouin play a central role in the presentation of Jordanian national identity and, through UNESCO, these narratives are further consolidated and valorised. Thus, while the Islamic Revival seeks to rid the world of magic, and the modernisation process seeks to abandon pastoral nomadism and shape citizens out of the often insistently autonomous Bedouin, another universalism process, part of the modernisation process, is seeking to safeguard what remains of outstanding value to humanity: the Bedouin intangible heritage.

Ziad Hamze, who helped the Ammarin promote the *samer* performance, was one of the main players in formulating the nomination to UNESCO. To recapitulate points made in Chapter 2, among the many things celebrated, the aspect that really located the intangible heritage in this particular landscape – rather than taking the Bedouin from any other area where they may actually still be living a predominantly nomadic pastoral life – was the pilgrimage to Aaron's shrine at Jebel Haroun. In other words, it is pilgrimages and sainthood that locate UNESCO Bedouin intangible heritage, more than the specific people or any of their other individual practices.

In the ten-minute video presentation shown to the UNESCO Intangible Heritage Committee as part of the nomination, a brief scene shows Ziad Hamze explaining how descendants of the saint Salem Awwad were 'shamans and healers'. Similarly, in the actual nomination, the word 'shaman' also occurs. While the word does not play a prominent role, shamanism just slips in, and yet seems somewhat misplaced in the Ammarin conceptualisations of religious figures.

Shamanism is usually something that anthropologists associate with Siberia or the Amazon: magic, mental trances and spirit manipulation. Even the broadest description of a shamanic practice in the anthropological literature includes direct contact with spirit 'entities',

control over the spirit and altered states of consciousness. Both the pilgrimage and the notion of the shaman were now in the UNESCO nomination, and while that may not have been the main reason why the UNESCO committee selected the Bedouin of Petra, the narratives about shamanism and pilgrimages had been legitimised, at least for those who wrote them.

How could this shaman have anything to do with the saint who, after all, was just a man to the Ammarin, 'a good and righteous person' selected by God? Perhaps the question is just one of semantics that seeks to slip in between anthropological categories to capture local history in ways that reflect popular interests; that is, as a question of translation, both conceptually and linguistically. Perhaps 'shaman' is just another word for *faqīr*, in the sense of being a blessed poor person – one that works better in English – rather than a person with supernatural abilities and spirit contact, as the term 'shaman' normally suggests. To ascertain this, we need to turn to a brief overview of some of the literature on the *faqīr* as presented to the Western audience.

Defining a Saint

Looking into the early travel literature on the Bedouin in Jordan, the image of what the *faqīr* does becomes increasingly ambivalent. Ethnographic descriptions of the *faqīr* rarely correspond to the explanations Ammarin interlocutors provide of a just and good person who emanates God's blessing. The French priest, Antonin Jaussen (Jaussen 1908; Jaussen and Savignac 1914), and also the Czech explorer, Alois Musil (1928: 400–407), for example, have left detailed descriptions from the early twentieth century in which they discuss several religious figures in Jordan. Jaussen specifically refers to them as *fuqarā'*, and describes them as performing spirit exorcism by playing the tambourine, burning incense, reaching ecstasy and even having visions of disappeared objects (Jaussen 1908).[5]

Alois Musil does not use the precise term *faqīr* but describes what they do in much the same way as Jaussen. He describes encounters between 'seers or sorcerers' and the Rwala Bedouin tribe. These sorcerers[6] are considered to have supernatural powers. The sorcerer has disciples who follow him, and one of their duties is to carry a little drum and other musical instruments. The 'gift' of seeing is hereditary, yet at times the disciples of the sorcerer also claim to have received the blessing of God by being a disciple. When curing people, the sorcerer seeks ecstasy, according to Jaussen and, here, Musil:

> If the sorcerer wants to call the spokesman-angel to him, he beckons the disciples to play, while he himself squats with his head bent down. After a while he begins to move, stands up, stretches out his hands, jumps about, contorts his body, and puts his hands, feet, and even his head close to the fire, clapping his hands. The Bedouins say of this that he is just playing, *jel ʿab,* but his disciples call it yielding to the influence of the *islâm,* ecstasy. (1928: 401, see also 403)

These ethnographic details suggest that practices such as drum playing, spirit exorcism and trance states reminiscent of Sufi traditions and non-conformist peripatetic religious figures elsewhere have occurred in other places in the territory now known as Jordan (Frembgen 2006).

Even more recent studies in medical anthropology have pointed to the practices of the dervish, generally considered another word for the *faqîr* among the Ammarin and in literature alike. In terms of healing psychiatric illnesses, in particular, these studies have described how trance, spirit communication, incense burning and drum beating are framed within an Islamic context with references to the Koran, and are used in ways that much resemble those of the early twentieth-century descriptions (Al-Krenawi et al. 1996; Al-Krenawi and Graham 1996, 1997).

While there may be local differences, the ethnographic sources suggest that there may be aspects of past practices that are being reformulated in the present to fit with current religious traditions. Dale Eickelman also demonstrated this in terms of the *marabout* in Morocco, when he noticed how 'Many of the Sherqawi elite dissociate themselves from the *maraboutic* interests of some of their kinsmen because such activities would open them to attack and ridicule from educated persons. Such Sherqawa seek to redefine the activities of some of their kinsmen and ancestors in light of the formal doctrines of reformist, modernist Islam' (Eickelman 1977: 15). Judging from the above, there are certain indications that much of the same taming of practices is occurring among the Ammarin, in juxtaposing in binary opposition a purist and a folk Islam. To my Ammarin interlocutors today, the *faqîr* is understood as a saint – 'a good man' who does (and did) not perform drum performances, spirit communication or ecstasy, but rather has knowledge of plants, good judgement, is poor and blessed by God. It would appear that the relationship between sainthood and shamanism is not necessarily one in which the nuances in theological terminology are as crucial as the association with any of the types (cf. Werthmann 2008). It is not, as such, the intention here to determine which interpretation of the figures is correct, or lay claims to what the past was really like. Rather, the intention is to explore the multiple gaps,

ambiguity and tensions that emerge in bringing the past into presence in the guise of the *samer*, the shaman and the saint.

Making a Shaman of a Saint

After many interviews with my Ammarin interlocutors about the *faqīr* as a renowned saint (*walī*), and having received consistent explanations of what s/he does (as indeed both men and women can become saints), surprisingly, in the webpages that promote the Ammarin Bedouin camp to tourists and elsewhere, the *faqīr* is presented as a 'shaman'. The *faqīr* is described (particularly in relation to the Bdoul tribe in Petra) on the website of the Ammarin Bedouin camp as follows:

> In Arabic, the word fuqara means literally poor people. Among Bedouins it signifies in addition, a shaman or a person endowed with supernatural powers, somewhat like the Indian Fakirs ... Part of the skills of the Fuqara is to prepare for the Bedouls [sic] talismans in the form of bracelets made of cloves, and necklaces made of Syrian Rue, which is central to their mythology.[7]

One sign in the tourist museum of the Ammarin Bedouin camp specifically describes how Salem Awwad 'had fame of having supernatural and telepathic abilities to bring news from faraway places about his tribe members. He was able to light Almond branch without matches'. Not only is the representation of the *faqīr* as possessing supernatural powers unlike anything the Ammarin recounted about their 'saint', but people from the very recent past are also presented as 'the last respected shamans' and direct descendants of Salem Awwad, and thought to have inherited some of his blessing, both in the Ammarin museum and on the webpage promoting the Ammarin Bedouin camp. While stating that 'the branch of Eyal Awwad have another claim to fame, that of having supernatural abilities',[8] tourist trekking routes are promoted as passing 'Haj Shtayyan's pool, the shaman's pool' and 'visiting the Ammarin's shaman houses'.[9] Haj Shtayyan is one of three siblings presented in the Ammarin Bedouin Museum in sepia-toned photos as shamans, although the photos were taken in the 1990s. Unfortunately, the siblings all died between 1999 and 2000.

These public statements are problematic to many Ammarin in more ways than just their representation of the past and raising awareness of alternative modes of ordering. Haj Shtayyan is the father of prominent members of the Ammarin in Beidha today. Although they may say their father was a saint (although not in the same league as Salem Awwad) and they may claim to have been hereditarily blessed by

God, they denounce all stories of supernatural abilities, performing trances or entering into states of spiritual ecstasy. This is, of course, not to say that these people do not use or recognise customary healing, such as many forms of Koranic healing – still widely used – or have knowledge of herbal medicine passed down the generations and held particularly by the elders. Quite the contrary: they are not simply shamans manipulating spirits, they are saints blessed by God.

The public representation of shamanism among the Bedouin appears to have a particular audience. The promotional pamphlets for the Ammarin Bedouin camp, produced by Rami Sajdi and Ziad Hamze, stress – in the English version – that one can learn about medicinal and spiritual therapies and how Ammarin shamans use stones and plants. The Arabic version of the pamphlets, however, explains nothing about 'shamans', saints or spirituality. Instead, it briefly states that traditional herbal medicine is displayed. The potential wildness of the past is tamed in a sanitised version. Similarly, all explanations about shamanism and supernatural abilities in the museum are in English, not Arabic. In other words, in the public English representation of the Ammarin in the museum and on the Internet, the *faqīr*, of whom my interlocutors only truly recognise Salem Awwad, is interpreted as a shaman rather than a saint. The houses and places of the recent generations of the Awwad family branch, who lived only a decade ago, are presented as shamanic tourist destinations.

As the main contributor to the public representation of the Ammarin past, Rami Sajdi explained to me how he discussed these issues with the most recent shamans (i.e. the three siblings) when they were alive, as well as elsewhere in southern Jordan. Sajdi encountered the Ammarin shamans in spring 1996 when he was investigating the spiritual properties of the Syrian Rue, Peganum Harmala. He discovered that they were using black cumin seeds:

> Burnt with certain incense 'gum-resins' [were] used for curing people possessed by the *jinn*, a treatment that often includes the beating of drums and the recitation of Koranic verses. The technique was tought [sic] by an Ammarin elder who lived in the early nineteenth century [Salem Awwad]. A man that held many sacred keys and certain ancient knowledge in relation to the spirit of the lands he dwelt in.[10]

Sajdi's homepage also has extensive information on the Bedouin, both Ammarin and Bdoul, but also New Age interests such as 'ley lines', 'energy zones' and 'sacred crossings'; and the pages concerning the Bedouin highlight the magical and healing properties of certain plants, stripped of the Koranic context. According to Sajdi, shamanic abilities

are ancient knowledge, inherited and passed on from parents to children, which allow the person not only to act as a judge and herbal healer, but also to perform exorcism, for example, to heal epilepsy.[11] Becoming a shaman, in this sense, and referring to the *fuqarā'* in Beidha, involves a change in consciousness:

> After the initiation, nothing is hidden from them any longer; not only can they see things far, far away, but can also discover souls, stolen souls, stolen objects, hidden treasures, hidden remedies and other intelligence gathering. The Fugara makes a journey during which he is spoken to by the spirits, or they may appear to him in the form of visions or even in physical form. He knows the mystery of the breakthrough in plane. This communication among the cosmic zones is made possible through his training on the techniques, names and functions of spirits, mythology and genealogy of the clan, and secret language ... All shamanic practice aims to give rise to ecstasy. Drumming, manipulating of breath, ordeals, fasting, theatrical illusions, all are time-honored methods for entering into the trance for shamanic work.[12]

Sajdi believes that these shamans (as in this description their actions would conform to most anthropological definitions of what constitutes a 'shaman') have passed on knowledge from ancient times, from even before Islam, when there were more deities, etc., and that they thus represent a sort of original spirituality that is universally shared around the globe among indigenous people.[13] As he explained to me during an interview, 'We have nothing called Bedouin shaman, we have something called Bedouin *fuqarā'*. So, to connect, what is *fuqarā'*? I used the word shaman for these people so all of the others in the world and anthropologists will realise that I am talking about shamans'.

Sajdi further stresses that, aside from being someone who contacts the spirits, the *faqīr* may also be a healer or a judge. According to Sajdi, equating 'shamans' with '*fuqarā'*' forges a connection between different indigenous populations around the world and is intended to show the authenticity of this original spirituality and close relationship that the Bedouin have with nature; it is a moral obligation to cherish and safeguard this original and somewhat pure spirituality of humankind.

I also took up the topic with Ziad Hamze (and his companion) since, aside from administering the Bedouin camp and museum, he was also responsible for the camp's website and the UNESCO nomination. He facilitates contact with tourists via the Internet and presents the *samer* to a broad audience. I asked him, 'Who is the *faqīr*?':

> *Hamze*: 'It is someone who is very much connected with God. Naturally. By blood. This is definitely a revelation, when they get the messages and intuition, without education or anything. So, they are healers,

they are good judges, they always settle problems: very wise. This is characteristic of a *faqīr*. And these guys, the guys you saw pictures of [in the museum], their grandparents were *fuqarā'*. There are some left, but it is a dying generation. Because it is blood lineage, there must be someone coming up. It is not a sect. It is not religion. It's a way of life. It is nature. The prophet was a *faqīr*. This is why he got it [the message from God]. I am not saying they are on the level of the Prophet, they are spiritual people; they are very much connected with God. They are healers, they are wise, and they are powerful. Due to that, they become powerful'.

In a sense, Hamze here takes on the blessed perspective of the figure, rather than the spirit manipulating perspective. After this, his companion interrupted with a reasoning that tunes into the New Age reasoning:

> *Companion*: 'Because they are in tune with nature. With God and nature. Not even the earth, the whole universe. They open up. Their consciousness is very open. Their awareness is open to receive. So, they become earth messengers. To give something… and God is using those people to facilitate or to give certain messages or a certain mission for the benefit of the human. Wisdom comes with awareness, it doesn't come with education. Wisdom comes with the level of maturity, and it comes from the more you are aware of things, you see things in this view. Education gives you tools in life in a way. But if you don't have wisdom … and if you have information, if you transform this information it becomes knowledge. With knowledge you are more powerful in life. So, what we are trying to tell you is, now the Bedouin have information… not information… the instinct which leads them to do whatever. We, the educated people, we want to know more, so we gather information and transform this information into knowledge, to understand why. Because we want to know: Curiosity. I read books, I study books, I read about healing, I am a healer, I know reiki, I am a pranic healer also, I study energy, I study energy for human beings. I know about earth energy. The more you become conscious and aware, the more you become "I want to know, I want to know, I want to know". But for them they just do things by nature'.

On the one hand, I was becoming aware that the Ammarin were increasingly dissociating themselves from previous practices, such as saintly intercession, but not necessarily from the saint. Yet, in presenting Bedouin heritage to tourists or in cultural performances, the spiritual aspects of a renowned figure are highlighted in ways that are not compatible with most local people's understandings of the past.

Important to note here is that these various discourses on the *faqīr* as shaman or saint and, indeed, the *ḥāshī* as shaman, run parallel with each other. While Sajdi, according to the information I have obtained, is the person who introduced the term of shamanism and indeed popularised

the New Age movement drawing on Bedouin culture, the Petra Bedouin are mostly unaware of this line of thinking. Thus, while the Bedouin are quite aware that at times they lack power to substantially influence the heritage industry in the area, the representation of the past as shamanic is beyond their attention – even if they play a central role in facilitating tourism that taps into that discourse.

This is not only a matter of presenting tourists with an 'authentic' Bedouin culture in which the Bedouin are knowingly taking part; there is more at stake, and this is where gaps begin to emerge. People like Hamze and Sajdi, in different ways, felt that the Bedouin represented an authentic relationship with nature that has kept some of them in close connection with the spirits by being gifted from God (cf. Sajdi 2007: 95). This authenticity, they find, is rapidly disappearing, however, with the spread of scriptural Islamic teachings and modernisation. People working and living in urban areas, according to this line of thought, are removed from this authentic relationship with nature.

Looking at the negotiation of the *ḥāshī* as shaman and the religious figure of the *faqīr* as a shaman or saint, the Ammarin Bedouin camp becomes a place of relaxation and engagement with nature and authenticity. This site-specific element of contemporary negotiations of spirituality is also expressed in reiki healer Susie Tamim's autobiography (2005). According to Tamim, the Amman-based owner of the Bedouin Museum, under the pseudonym of 'Sami', had advised her to visit Jerusalem, Masada and Petra.[14] In each of these places she would experience a revelation. In Petra, she explains, this came after visiting the Ammarin Bedouin Museum, where she would inhale incense and touch magical stones on display there and, finally, when walking through the mountains afterwards, she would witness the figure of the Virgin Mary with baby Jesus in her arms carved in the sandstone. The Bedouin and the mountainous desert became the vehicle for spiritual enlightenment. This is not only a phenomenon among a few urbanites in Jordan, such as the Circle of Friends[15] in Amman, who also use Petra as a location for workshops on holistic therapy, etc., often associated with the New Age movement. Even beyond Petra, desert areas in the Middle East are becoming places of such refuge, of getting away from it all in order to experience a close relationship with nature, such as the Rainbow Gathering in 2007 in Wadi Rum. Thus, while one conceptualisation is that the *faqīr* was 'a good man' – a salient saint – another conceptualisation claims shamanic practices, some more supernatural and telepathic than others, which tap into a broader New Age movement. There seem, in other words, to be gaps in the various modes of presence of the world, gaps that cannot easily be bridged.

The Uncanny Saint

In the above, we see three very different ways of presenting the past in the present. One version presents the *ḥāshī* in a male metamorphosis and the *faqīr* as a particularly good and righteous person, a saint. This version is the predominant one among the Ammarin. It is clearly enacted within the context of a growing awareness of the moral and pious obligations of being a modern Muslim. It is a moral regime that finds its source in a distant past – a 'discursive tradition' (Asad 1986), if you will – but one that also explicitly aims to discard traditions that have hitherto been understood as Islamic. Thus, rather than imputing trances and spirits to the saints, it focuses instead on piety. The saint is framed within a universality shaped in a modern (and modernising) context among the Ammarin that aims to tame the past through the potency of proclaiming ignorance of certain traditions and practices (Gilsenan 2000): that is, taming problematic knowledge through processes of not-knowing and the moral judgment of ignorance (Dilley 2010; High et al. 2012).

From another perspective, both the *ḥāshī* and the *faqīr* are framed in shamanic narratives. This version similarly employs an idea of universality, nurtured globally by indigenous populations and urban segments within the framework of New Age spirituality. The premise is that there is an original spirituality, shared across the globe, which people have detached themselves from in modern times, and no less so with the Islamic Revival. Yet some people, such as the Bedouin shamans, still have some kind of access to it. The New Age movement – or 'alternative spirituality' as the interlocutors would rather call it – is equally a modern phenomenon. Unlike the alternative Islamic universality, it aims to sustain and reclaim practices imagined to be once existing vehicles or media for communication through the trope of shamanic authenticity. It does so, however, by de-contextualising the actions, for example, by stripping healing practices of their Koranic framework. Yet, they do not see themselves as filling in the gaps of lost knowledge. Rather, they make do with what is present – or on the verge of extinction – including borrowing from what they see as related indigenous groups in the Amazon and Siberia.

It initially appears that we are dealing with two versions of the same object, which in no way can be reduced to each other. To the Ammarin, the *faqīr* cannot be both a shaman and a saint. Yet, despite the semantic transformations of the *ḥāshī*, shamans and saints, they still share some sort of link: these versions are not fragmented or isolated. Rather, they connect in the ambiguity relating to the possibility that the figure *could*

be something else. Each version partially ties to some aspect of the other version, although far removed in the long line of interpretations and processes that have taken them in different directions. As Marilyn Strathern states, these 'semantic transformations are the outcome of the way specific metaphors are elaborated, leading people's interpretations in different directions. There is no single body of knowledge any more than there is a single ... culture, but a number of small local centres' (Strathern 2004: 96).

Aside from the museum and tourist information, the main meeting point is found in the third version of the saint, the heritage version. In the universal scope of UNESCO's heritage discourse of safeguarding material and practices of 'outstanding value to humanity', the Ammarin (and neighbouring tribes) are represented as having special knowledge and skills in relation to the landscape. This discourse – like that of the New Age movement – seeks to sustain the cultural diversity of people and their heritage. This heritage trope is equally a product of modernity, and equally – although perhaps unintentionally – it seems in this case to strip the representation from its context, that is, from the fact that the Bedouin were relocated due to UNESCO tangible heritage. The problem is that UNESCO heritage is dependent on situating the heritage in a specific place within a nation state. Camel (and goat) herding skills, oral traditions and weaving skills are practiced among most Bedouin groups in the Middle East, but, by highlighting saintly veneration, Bedouin culture comes to be situated among the Ammarin and neighbouring tribes in Petra, regardless of whether other Bedouin tribes are more comprehensively living the 'Bedouin culture' that UNESCO is seeking to safeguard.

Authenticity is as much at the heart of the heritage discourse as it is in the return to a monolithic 'pure Islam', or original spirituality among the indigenous groups in the eyes of a New Age movement. Authenticity, however, is not an object but a relationship. Within a heritage discourse, authenticity becomes a tool for legitimising a particular narrative of the past through international heritage proclamations. For the shamanism trope, it is a mode of presencing both the *samer* and the saint as shamanic practices, whereby the potency of the past to transgress time is an aspiration of an urban segment for whom the Bedouin represent an original human condition.

To the Ammarin it is a relationship of taming the nature of the past. The specific feature of sainthood is multiple and remains ambivalent and undecided. The figure of the *ḥāshī* or *faqīr* performs a powerful social role as something inherited from the past yet is also simultaneously entangled in the negotiations of contemporary Islamic

moral practices. What matters is not so much the saints as the behaviour and relationship that people seek with them (or shun) (Maniura 2009: 629). To the Ammarin, the *faqīr* is ambivalently positioned between being a salient saint and a shameful shaman.[16]

While there may appear to be a gap between these versions, they also co-exist, however volatile their connection may be with the source they share. To the Ammarin, the pivotal, contemporary role of the saint Salem Awwad lies in his ability to offer social recognition of divine closeness for his descendants. To both the heritage and New Age discourse, it is crucial that the object of interest is situated 'just prior to the present' or at least threatened by the present (Clifford 1987). Certain pasts may, to the Ammarin, thus be in a state of abjection within a discourse on the past, neither too detached nor too attached to the present day. To the Ammarin saintly veneration may today belong to the Age of Ignorance, but many of the same people now denouncing the pilgrimages did themselves perform them in the past, and they still rely on the social potency of lineage and the sense of belonging that the tombs instil. The saint becomes meaningful on an individual level as both a figure of commemoration and disassociation; an ambivalence that is productive in bridging presumed gaps between the multiple versions. My Ammarin interlocutors may on initial questioning be absolutely certain of what a saint is. Yet they also accept the uncanny possibility that the saint could be something else. He is not a shaman, yet he is also not *not* a shaman – at least to someone else (inspired by Pedersen 2011; Willerslev 2004). By remaining indeterminate and ambivalent, the uncanny possibility of the *faqīr* being something other than a 'good person' allows for the continued co-existence of perspectives. The multiplicity allows for the same person to simultaneously denounce the shamanic version while also bringing tourists to the shaman's pool, or simply to be knowledgeable about alternative versions, but indifferent. This indeterminacy allows, at times, for a bridging of the gaps through partial connections between what may initially seem incompatible perspectives on the same object.

Parallel Universalities

This chapter has shown how three parallel universalities tap into the same resources from the past, where they at times overlap, at times are separate, and at times even work in oppositional directions. Yet, rather than fragmented conceptualisations of the same object, there seem to be productive gaps forged through fragile connections that have

evolved through semantic transformations that have taken different directions. To the Ammarin, the subject of sainthood is, on one level, rendered an object of shame in the guise of the shaman. This goes, too, for the representation of the *samer*, which, although in nature unlike the saint, is also framed within the same trope of shamanism by Sajdi and Hamze. Yet, simultaneously, in a community such as that of the Ammarin, where tourism, heritage, modernisation and an Islamic Revival go hand in hand, these connections allow for multiplicity, more than simply juxtaposition.

None of these three conceptualisations stand alone. The moral obligations of an emerging Islamic pious awareness are not completely detached from obligations to know and cherish one's history or make money from tourists attracted to the narratives of authenticity that the shaman affords – or take pride in being selected as UNESCO Intangible Heritage for practices no longer performed, such as the pilgrimages. The problem for the Ammarin thus lies not in deciding what the saint is, aligning oneself once and for all with either a purist or a folk Islam; the problem relies on being confronted by what the saint could also be, that is, becoming aware of this possible multiplicity. Not because it may necessarily be the case, but because of the potentiality of this happening. It is in the gaps between versions that the socially productive tension and potency of presenting the past resides. And it is in the gaps that have emerged through semiotic transformations that the question of sainthood takes on a potent, yet fragile, role of carrying with it an uncanny potentiality and sustained indeterminacy in the multiple presencings of the world. What is present through heritage, what is absent and what should have an even more substantial presence is thus at the heart of these negotiations of Bedouin traditions.

The point is that three very different universalities all seek recourse in the past to shape the future, where both the New Age and the Islamic Revival claim some sort of pure spirituality. Thus, while these conceptualisations are very different, the gaps and connections appear productive by not being completely determined. This lack of knowing is also the topic of the following chapter, in which we will go into more detail on the saint graves.

Notes

1. This chapter was previously published in an altered version in Bille (2013a).
2. Only once during my fieldwork was I aware of a woman performing the role of the *ḥāshī*.

3. Tawfiq Canaan describes many of these saints and sanctuaries, but most of them relate exclusively to the Liathneh tribe of Wadi Mousa (Canaan 1930: 71–78). He describes the tomb of Abu Hmedi in Beidha; however, to my knowledge, this is of no importance today.

4. The idea of a person being chosen as a saint, *walī*, is not used in the Koran, but is a later attribution to those people who are believed to be marked by 'a divine favor' (Radtke 2007).

5. In Doughty's account (1883) of his travels in the Arabian desert, the *fuqarā'* is a term used for a tribe, without spiritual connotations.

6. The Rwala call them sorcerers, while they call themselves 'owners of Islam'.

7. http://www.bedouincamp.net/mawasa.html (accessed 6 May 2007).

8. http://www.bedouincamp.net/fuqara.html (accessed 26 February 2007).

9. http://www.bedouincamp.net/trekking.html (accessed 5 May 2007).

10. http://acacialand.com/rami.html (accessed 15 April 2007).

11. http://acacialand.com/Hamad.html (accessed 28 January 2007).

12. http://www.acacialand.com/ndex2.html (accessed 26 May 2007).

13. The Bedouin are generally not considered indigenous but rather defined as 'original inhabitants' (*aslīyyn*).

14. This route is argued to follow the ley lines of the star sign Orion's belt, also known from some explanations of the Giza pyramids' off-axis positioning.

15. http://www.ammancircleofriends.org/ (accessed 24 January 2008).

16. The term 'shameful shaman' was coined by Geraldine Chatelard (pers. comm.).

৭⊚ 4

DEALING WITH DEAD SAINTS

Introduction

The grave of Sabah al-Sayydīyyn near Bir Hamad, south of Petra, illustrates a dilemma common to the neighbouring Muslim communities: how to deal with the dead in a proper Islamic way? As the oral tradition goes, Sabah lived in the early half of the nineteenth century. Whilst alive, Sabah was a good person, helping others and taking care of the orphans in the area. Yet he was by no means a person who was likely to live on in local history centuries later. When he died, he was buried with a heap of stones piled on top of his grave, like others at the Hamad family graveyard near Bir Hamad. Immediately after the burial, however, water flowed from the ground in this otherwise barren area. People rejoiced and washed and drank from the water. This was a clear sign from God that Sabah had indeed been bestowed with God's blessing. This blessing would now be materialised in the water flowing from the dead man's grave and encountering the grave could potentially heal a visitor. Even in death, the dead person would emit this somewhat mystical blessing from God, as a particular divine energy or presence (Brown 1981; Geertz 1968; Makris 2006; Roberts and Roberts 2003; Stewart 2001). However, this does not mean that a visitor at the grave will definitely be healed simply by drinking the water, only that the potential for healing has radically increased.

Sometime after this event, one man decided to close the spring again with an upright stone, still located at the site. This, however, caused

the man to become barren for the rest of his life. To the residents in the area, this act of disrespecting the dead was met with immediate retribution. The events at the grave, both fortunate and unfortunate, meant that Sabah came to be considered among the 'friends of God', in Arabic, *awliā'* (singular *walī*). Since then, people in need have travelled to the saint grave to seek divine blessing, by praying and offering gifts at the grave.

For an increasing number of people, saintly intermediation is considered contrary to Islamic teachings as they are currently understood in the recent Islamic revival. The social life of dealing with the dead is here shaped in terms of the moral economy of categorising time: saint intermediation belonging to 'the age of ignorance', *jāhiliyya*, before the Prophet Muhammad, rather than the age of Islamic knowledge. Dealing with the dead saints thus ties in with the emerging moral evaluation of the propriety, even piety, of doing so.

While some people dismiss the actions at the graves as heretic without hesitation, others are caught in a paradox of also finding a source of identity in the stories of saintly intercession, since the stories may concern family members, or the saint may be a forefather. The issue for those people who no longer go to saint graves, or never did, as well as the few that still do, is that they are forced to deal with the very materiality of the saint graves, the presence of elaborate material ornamentation and the stories of events that have taken place, as Hussein in the beginning of the book confirmed. Death, as well as the stories of potent blessing, forces people to take a stance on the materiality of death (Hallam and Hockey 2001; Hertz 1960; Hockey et al. 2010). In this case, it is a stance on the excess that spills over into the lives of the living with the potential actions of the dead saint. This leads one to question in what sense the dead and the material infrastructure at the grave 'produce agency', and how to deal with such potentiality of presence.

Exploring the so-called 'agency of things' will point to the intricate ways in which objects, practices and categorisations of time are ambivalently interwoven in the processes of dealing with death (cf. Hirschkind 2008). Rather than engaging with the corporeality of the dead body as such, even if the decomposing presence of the body has shaped human burial practices throughout time, or conceptions of death in Islamic theology, I will instead argue that a moral evaluation inherent in categorisations of time and the potentiality of blessing play crucial roles in shaping regimes of knowledge and pious subjects.[1]

The Agency of Things

Over the last two decades or so, debates in various branches of material culture studies have discussed whether or not things have – or, more correctly, produce – agency and, if so, on what premises (Gell 1992, 1998; Knappett and Malafouris 2008; Latour 1992). Most often these discussions are tied to the question of the role of intentionality. In one dominant perspective, agency presumes intentionality. Here, things do not have agency, as things cannot consciously choose to do otherwise; choice or will belongs to the faculty of human/animal cognition. 'Agency' becomes the 'capacity to intentionally initiate actions' (Johannsen 2012). This perspective is rarely confronted with one of the various dictionary definitions of the term from, for example, the *Oxford Dictionary of English* (2010):

> Agency: 2. [mass noun] action or intervention producing a particular effect: Canals carved by the agency of running water. [count noun] a thing or person that acts to produce a particular result: The movies could be an agency moulding the values of the public.

Naturally, a dictionary definition only illustrates how a word is used; yet it does question the tenability of the position that intentionality is a prerequisite for agency. Water cannot be said to carve the canals intentionally. In recent decades, the social sciences have also increasingly shifted away from seeing agency as 'capacity' and have begun to focus instead on 'causation'. From this perspective, things are continuously 'enacted' and produce agency as agents or actors (Gell 1998; Laet and Mol 2000; Latour 2005; Law and Mol 2008). An agent in this perspective is – in accordance with the dictionary entry – 'what causes an event to happen' (Gell 1998: 16), where 'an entity counts as an actor if it makes a perceptible difference' (Law and Mol 2008: 58).

But intentionality is still a dominant concept in the discussions. For instance, Alfred Gell (1998) makes a distinction between primary and secondary agents: a primary agent has the intention of affecting its surroundings, while a secondary agent is one that causes an effect without implying any intent, even though this agent may mediate the intention of its maker. Other ways of subdividing categories of agency have been promoted by talking about 'conscious agency' and 'effective agency' (Robb 2004: 132), while still actively dealing with intentionality. As Lambros Malafouris critically notes, most often 'intention in action' does not precede action or matter, but unfolds *with* action (Johannsen 2012: 313; Malafouris 2008: 31–35). Nonetheless, in

this perspective, things as such do not *have* intentionality, even if they may *produce* agency.

From a third perspective, things do have intentionality, but of a different kind – a technological rather than a human intentionality. The argument is that intentionality (both etymologically, and based in the phenomenological tradition) simply means 'to direct' (Ihde 1990; Verbeek 2008: 95). As a technological object, rainwater canals have intentionality insofar as they 'direct' water to other places.

When it comes to death, however, there is something bewildering about these questions of agency. On the one hand, there is the commonly held notion that the dead cannot speak or act, which is in line with the initial perspective above. Yet the dead body does, nevertheless, alter its material composition, by decomposing, smelling or attracting animals, in a way that also forces people to deal with it as both a moral obligation and bacterial phenomenon (Hertz 1960). People tend to the dead, preparing them for the last rites, carrying them to their grave and so on. Several scholars thus argue that the dead body acts within its social context, in line with the second and third perspective above (Hallam and Hockey 2001; Harper 2010; Hockey et al. 2010; Sørensen 2009).

While these discussions may have nuanced our understanding of intentionality and agency as pertaining to different realms of humanity and materiality, or even merged them, we are still left with the question of how to deal with non-mechanical responses, such as becoming barren, initiated by engagements with the non-living.

The Potential for Agency

Indeed, as the story of the events at Sabah's grave goes, and according to many other similar ones, the dead can act, even in impulsive response, to actions oriented towards their material remnants among the living. The response may not be causal or even normally possible, and the dead may not act alone, but in relation to other human and non-human agents linked up with them. God's will is channelled through the dead saint to the material remnants at the grave where the devotee's performances and material offerings may connect with the saint. While digging a grave can logically cause water to flow from arid ground, barrenness does not seem to be a direct mechanical response to stopping the water from flowing. The question of 'agency' becomes potently unclear: was it God, the saint, Satan or pure (mis)fortune? Who did it?

In this Islamic context, such post-death events are often taken as a sign of the dead person's closeness to God – in life and in death. People subsequently go to the grave to heal illnesses or change misfortunes by seeking God's blessing (Goldziher 1967: 209–38, 1971: 255–341; Kressel et al. 2014; Stauth 2004). In either collective or individual pilgrimages, people go there to offer their prayers to the deceased, light candles, burn incense, leave a coin or bead, tie a piece of white or green cloth on a wooden beam on the grave, and possibly slaughter an animal, to mediate between the divine and earthly worlds. These practices have been extensively studied in anthropology in terms of 'folk Islam', as opposed to various sorts of 'scriptural', 'fundamentalist' or 'puritan' Islam (cf. Geertz 1968; Gellner 1963, 1981; Makris 2006: 49–50). But as also illustrated in the previous chapter, there is a fertile space between such dichotomization where ambivalence and potentiality define human engagements with things through taming processes.

As a friend of God, there is simply too much human agency (to follow the distinction above) for the person to cease at death. The good deeds and actions of the person continue after death. In the above perspectives, this excess of agency encountered at the grave is neither intentional nor simply mechanical. It is not a water canal that mechanically prevents water from overflowing the cities. But neither is there an earthly living person who intentionally does something. A material analogy to this excess at the graves would be mechanical devices that should perform a simple task, but which, for various reasons, only do so sporadically to an improbable extent beyond the realms of normality, comprehension or even desire.

What I point at here is the place of potentiality in the discussions of agency. The performer of the intermediation is not guaranteed to have his or her wishes come true; that is, from the perspective of the living devotee, the capacity of the saint's grave to impact their lives is not understood in any mechanical sense. Its agency is not so much tied to questions of intentionality – what the dead saint chooses to do – as to the potentiality of what he or she could do through God's blessing emanating at the grave as a connecting force between dead saint and the living supplicant: a hope for presence of potent actuality. No one knows why it happens. It just does – on certain occasions. Emulation of practices that previously led to success is no guarantee, even if some people, such as healers, have more experience with what has been successful earlier on. The question of whether one is doing too much or too little for intermediation is hence never fully answered (cf. Geary 1994: 95–124). It is, in this case, the grave, or shrine, as a material extension of the dead saint, that works as a site for intermediating God's blessing. But

the question my interlocutors ask is not 'why', but 'if' something will happen. It is an anthropological and pragmatic experiment rather than a theological reading. Thus, the approach here is one that draws on the notion of agency as causality, while also emphasising irregularity and non-causal relations between act and reaction at the grave, through the role of potentiality.

The potency of the saint grave, in essence, relies on more than simply passing the site and being affected by God's blessing. It is a temporal actuality in the sense that the grave does not always 'produce agency' and fulfil people's needs. Instead, even if only on extremely rare occasions, the saint grave may 'eject' its intermediary potentiality onto the devotee; that is, in certain constellations of things and people the graves may indeed produce agency, but they do not emit this force all the time. One can perhaps think of the saint grave not just as a fixed, coherent 'object', but as 'enacted' – to evoke Annemarie Mol's term (2002) – by both people, things, saint and God, as an 'eject': an ejection that promotes temporality and potentiality as elements of understanding materiality.

In that sense, to the devotee, the grave is an intermediary that may influence divine powers that are beyond what the individual dares to confront directly. This follows other parts of social life in the Middle East where the concept of *wasṭa*, understood as nepotism or connections, holds a central role in mediating social relations and power, and indeed was the term used by my interlocutors to describe the nature of the mediation (Cunningham and Sarayrah 1993; Hammoudi 1997; Meyer and Moors 2006; Shenoda 2008).

Living with the Saints

Although the area around Petra is most famous for the Nabataean and Roman monuments, it is also known for its religious sites. In the mountainous landscape around Petra, there are currently around thirty saint graves, shrines and sites, such as sacred trees and rocks, which can be visited on collective or individual pilgrimages. While most of the saint graves are modestly built, such as Sabah's grave, there are a few solidly built shrines with a dome (*qubba*) for prominent historical figures. Most notable among these are those relating to biblical history, such as the shrine of Moses' brother, Aaron, the rock where Moses struck his stick to get water or, from Islamic history, the shrine of Abu Suleiman al Darani in Abu Makhtūb (cf. Miettunen 2013).[2] These shrines used to be centres of pilgrimage, and part of a broader holy geography,

in which the companions of the Prophet are particularly dominant in the Muslim world. The largest and most famous pilgrimage was the bi-annual collective pilgrimage to the shrine of Aaron on Jebel Haroun, mentioned in previous chapters (see also Canaan 1930: 74–77).

The widespread regional practice of tying knots with cloth on the grave is an example of what James Frazer called contagious magic, which, unlike magic characterised by imitation, is based on the idea that material objects that have been in contact with a person may produce a potent bond with that person and act on his/her behalf even at a distance (Frazer 1890: 11). Gilsenan further writes that 'The pilgrim hopes to obtain a direct experience of *Baraka* [God's blessing] as much through touching the tomb or cloth over the shrine ... as by the hoped-for favour' (2000: 605); that is, the hope is as equally distributed in the faculty of the saint as in the sensation of matter. Why or when it happens is unknown, but the connection the saint grave's blessing potentially offers is crucial. It is not just the saint acting; it is a connection offered through the grave.

Some of the first saint graves I was introduced to were located in the centre of Wadi Mousa. At one of the most congested places between the upper and lower parts of the town was a graveyard with a small shrine for a saint called al-Haseni. Henna was smeared on the walls as a sign of past rituals, but the green cloth covering the grave that normally denotes saintly status was carelessly discarded on the ground following a grave robber's excavation. Clearly, the grave was no longer in use for intermediation (see also Canaan 1929: 207). A second grave was barely visible under a tree called Shajarat Ataya, just 150 metres from al-Haseni's tomb.[3] The (*ephedra aphylla*) tree is so big that it conceals the grave. The fecundity of the tree acts as proof of the fact that the person was blessed.[4] While both sites also highlight the ability of the material world to tie inhabitants to their tribal history and geographical belonging, the first case emphasises the current dilapidation of the graves, as intermediation practices have stopped and grave robbers have taken over. The other case shows the continued life of the dead through the construction of a causal relationship between the fertility of the soil and the *Baraka* bestowed on a person by God, although it is no longer used for intermediation.

In understanding technologies of protection among the Bedouin, the above illustrates that a central theme is God's blessing, *Baraka*. While *Baraka* is 'one of those resonant words it is better to talk about than to define' (Geertz 1968: 33), it is more than just a blessing as commonly understood. *Baraka* is considered to be 1) prosperity and favour bestowed by God; 2) a wish, invocation or greeting asking for such

a favour to be granted to someone else; or 3) an expression of praise for God (Stewart 2001). It should not be mistaken for *mana,* a spiritual electricity of magical power, but 'rather than electricity, the best (but still not very good) analogue for "baraka" is personal presence, force of character, moral vividness' (Geertz 1968: 44). The Koran as the 'Word of God' has supremely powerful *Baraka.* As Clifford Geertz (1968: 45) further reminds us, there are two complementary ways of perceiving *Baraka;* one is the genealogical, whereby it is inherited from one charismatic person – most often the Prophet Muhammad – down the patrilineal line; the other is the miraculous, which is linked with specific events in people's lives. This double-sidedness ties a wide range of people to the graves. Some of the graves were predominantly visited by members of the deceased's tribe, such as Salem Awwad al-Ammarin's grave near Bir Maḍkur, and act both as places for divine mediation and spatial anchors of tribal and family history. Other graves, such as those of al-Fuqara at ʿAyn Amūn cited at the beginning of this book, are famous for being powerful enough to have attracted people from all over the country, even Saudi Arabia.

The saint can be seen as a person from whom the devotee wants something, even if the person granting the wish has the unusual feature of being dead (Maniura 2009: 646). The graves are, however, not only sites of benevolence, as the case of Sabah's grave attests (see also Miettunen 2013: 150–54). People who harm or destroy things at the grave of the saint are likewise prone to misfortune. The grave of the saint known as Ghannam in the area of Gerendal in Wadi Araba is a powerful example of this.[5] As elsewhere, a wooden beam is fixed to the saint's grave, from which a piece of cloth is to be hung, which materialises and creates the potential contact between living and dead. The story goes that a man took this beam and used it in his tent. The next day, this man was unable to move, paralysed, thus showing that 'to act is not to master, for the results of what is being done are often unexpected' (Law and Mol 2008: 58). He was then advised to visit Ghannam's grave and pray. He returned the beam to the grave and sacrificed an animal that his companions could eat for dinner, after which he was cured. This story works not only in a functional way to prevent further destruction of the shrines, but also to prove the potency that the graves materialise. This is not simply a potential that is initiated in the complex of rituals that combines prayer, offering and 'contact magic', but equally one that may simply flow from the grave as a constant blessing that needs to be dealt with.

The three saint graves in al-Mureibit cemetery also illustrate this point. They are the passing point of seasonal migration for some

pastoral nomads, as they move between the valley and the plateau through the mountains during autumn and spring. People lead the animals through the graveyard to graze in the area, thereby physically internalising the *Baraka*. One story goes that once there was a family who had not passed the graveyard and, when milking the goats, only blood came out. Only after returning to the site did the goats produce milk, thus showing that extraordinary events are not only benevolent actions; unlike the potentiality of the good deeds, misfortune more regularly occurs as a result of disrespect or forgetfulness. Rather than mocking of God, this is seen as mocking the potency of the saint (cf. Geary 1994: 95–115).

What matters is not the corporeality of the dead body, or even his/her actions during their lifetime, although this cannot be excluded as a mechanism in the further negotiation of evidence of sainthood. What is crucial is the interaction with the materiality of the grave to communicate between the earthly and divine worlds. Although the practices have largely stopped, some people still offer the first clarified butter (*samn*) from the goats at the saint graves, and when a new baby is born it may also undergo a form of initiation by visiting the graves. When I visited the graves at the Awwad cemetery with some of the Ammarin men – who swore by the notion that saint intercession is un-Islamic – they still insisted on bringing a goat to slaughter at the cemetery. Better safe than sorry, as they said.

The saint graves offer what Giorgio Agamben has called 'the hardest and bitterest experience possible: the experience of potentiality' (1999: 178). The saint grave is a potential in the sense that it has, in a generic sense, transformed the person from an ordinary deceased person into a saint, through extraordinary events, but also with the potential to not actualise wishes. Extraordinary events may take place at the grave; death, it seems, is not the end. To Agamben, potentiality is thus the very possibility of not actualising. It is this potentiality of acting, not acting or acting differently, that survives in oral histories among the tribes, rather than a notion about healing every pilgrim, or questions of the intention of the saint, God or whatever. As Maniura aptly states, 'The characteristics of saints are to be sought not in the inherent qualities of a category of persons, but in the behaviour of those who interact, or attempt to interact, with them' (2009: 629). Through such practices, it is also a potentiality that people in the area are forced to deal with: an agency that cannot be easily ignored.

This question of potentiality has previously been explored through the concept of affordances (Gibson 1979; Ingold 2000; Knappett 2004). The concept of affordances leaves it up to a (living) person to establish

what an object is used for within the potential framework of the design; for instance, a chair can be used as a ladder, but not as a computer. Viewed through this perspective, the 'functionality' of a thing is not the issue; rather, the question is the potential ways in which its form may be applied to a task. My point with potentiality here is, however, that the question of what an object potentially does is placed at the object end, at the grave, with all its attributes and connections to divine influence. It is thus the potential of a dead saint and the grave to act (or not act) in seemingly extraordinary ways, rather than people who define what a thing can actualise for certain.

The excess of agency encountered at the saint graves becomes a powerful uncertainty that is encapsulated in Agamben's notion of 'the experience of potentiality'. It is this potentiality of agency that is unsettling to both the religious scholars and people in the area, whether they visit the graves or not – things happen, have happened and can happen.

New Regimes of Knowledge

Yet excess provokes excessive response, either of worship or of persecution (Meltzer and Elsner 2009: 377). Thus, it is also an 'excess' that should be handled with care. Since the 1990s, the pilgrimages have largely disappeared. I interviewed several Islamic scholars in the area, such as one of the official Jordanian *mufti* (Islamic jurist qualified to give authoritative legal opinions, *fatwas*) who resides in Wadi Mousa, and two of the *imām* (worship leader in the mosque) directing prayer in the mosque in Beidha, on the topic of pilgrimages. According to these Islamic scholars, the pilgrimages to Jebel Haroun, in particular, were clear proof of the religious ignorance of people in the area; by relying on the saint for blessing, people were associating others with God. This was 'folk Islam' that should be replaced by an original and pure Islam, as they saw it.

However, when interviewing some of the people who still visit them, the interlocutors argue that the many stories of success testify to the potency of the graves. Others neither believe nor disbelieve in the power of the saint and the graves, but rather abstain from judgement, suspending the whole question to God's will (cf. Marcus 1985: 456). Even in the cases where people no longer visit the graves, they are highly critical of the new scholarly regime, as life has deteriorated since the pilgrimages stopped; there is an uncanny feeling of the saints' retaliation. This demonstrates how being offered blessings by

the dead is also a dangerous debt that may become an obligation. In other words, the clear-cut opposition between purist and folk Islam may be less clear under closer ethnographic scrutiny. One interlocutor, defining himself as an adamant Muslim, performing his prayers, and going to the mosque and fasting, expressed this ambivalence towards wholesale adherence to scriptural teaching in the area by saying:

> They [the saint worshippers] visited and came back with a pure purpose. Religion and scholarship has increased today. They say that visiting the tombs is forbidden and people started visiting them less and less. But when people started visiting less, things changed. How did things change? It rained less, life became harder, and the animals didn't find anything to eat. People had more faith then, than today. Nowadays, faith is weak … They say that visiting the tombs is forbidden, visiting the sanctuary of Prophet Aaron is forbidden. Is it forbidden to read the fātiḥa [opening verse] for the dead? No! Some experts say that it is forbidden. It's forbidden to visit the tombs of your parents to read the fātiḥa! This is wrong! My father is dear to me dead or alive and it is my duty to visit his tomb. The most important thing is the consciousness between myself and God. I don't defy God, but for my consciousness it is important for me to visit my father's tomb. And God knows that I don't disbelieve in him.

The *imams* and *mufti* I interviewed were not against reading the opening verse at the grave, as such, only the intermediation. The interlocutor above does, however, describe a general sentiment, particularly among the elderly interlocutors of both genders, of how things have deteriorated since the pilgrimages stopped. For the pilgrims, the saint is 'a living presence and active agent in the world, existing between God and his believers and as a go-between' (Gilsenan 2000: 605) – a presence offered by the excess ejecting from the grave.

But saints are also contested figures, as they interfere with structural powers. Gilsenan notes that, 'To the state and to those attempting to regulate the spaces of power and citizenship, that person is above all a source of disorder and the illusory forces of magic' (2000: 605). One such powerful place of 'illusory forces' is located in the graveyard variously known as ʿAyn Amūn – after its location next to a spring – or al-Fuqara, after four graves belonging to a category of people known as *faqīr*, associated with spirituality, poverty and divine blessing. The graves at ʿAyn Amūn are positioned between Taibeh and Wadi Mousa, and have a clear view of Aaron's tomb on Jebel Haroun in the far distance. Although everyone knows of it, it is not one that the Ammarin visit. On one side of the asphalt road that cuts the graveyard in two, three of the graves have small heaps of stones, where the only signs of the special status of the deceased are the marks from incense

burning and the occasional gifts.[6] On the other side of the road is one of the most elaborate demarcations of saint worship in southern Jordan.

A large square wall surrounds several graves in the centre of the walled area.[7] A great number of objects are left at these graves for healing and good fortune, such as the remnants of candles and coins; there are darkened patches on the wall from the burning of incense and the ubiquitous pieces of cloth tied to a stick, placed in-between the stones of the wall.[8] As elsewhere, stories abound of the healing successes, including stories of sick people who would sleep inside the structure until they were healed.

In light of the Islamic revival, these practices have mostly ceased, particularly in densely populated areas, although proof that they continue to some extent is still evident. This revival entails a more purist understanding of Islam and is spreading through mosques, televisions and schools, particularly inspired by the Gulf countries and Saudi Arabia. Saintly intermediation is considered *bid'ah* – an innovation – but, contrary to the English word, it has predominantly negative connotations. In this line of religious thought, veneration of the saints is equal to polytheism, *shirk*, and should be abandoned. Praying for the dead in the afterlife is permissible, but not for the sake of healing, which is to associate others with God. It is important to note here that my interlocutors rarely judge the status of the deceased as a saint, but rather those who performed the practices in the past and who continue to perform them today. Thus, the question is not so much whether the saint grave offers blessings; rather, it is to assess the engagement with this excess (although the clergy of course may question the saintliness of the person whose grave it is).

Knowing Ignorance

The disdain with which the venerating people are met is framed through the notion of *jāhiliyya* – belonging to the age of ignorance. The term *jāhiliyya* generally has two connotations: an historical epoch when pre-Islamic Arabs were primitive barbarians, considered to be ignorant; and any conduct which goes against Islamic culture, morality or Islamic ways of thinking and behaving (Goldziher 1967: 201–209; Shepard 2001). Up until the twentieth century, *jāhiliyya* mostly referred to the former, a time of ignorance, of superstition and polytheism. This understanding stresses the religious state of unawareness of the guidance from God. The second understanding emerged in popularised form during the twentieth century with the rise of a

more politically oriented Islam. This political turn may be central to the Islamic revival and the emphasis on a scriptural understanding of Islam, but only inspires the political developments around Petra –where the theological implication and inspirations are clearer – to a limited extent. One of the main inspirations for this Islamic Revival is the Egyptian author Sayyid Qutb, who describes the understanding underlying the changing perception of religious practices as follows:

> When a person embraced Islam during the time of the Prophet – peace be on him – he would immediately cut himself off from *Jāhilīyah*. [The state of ignorance of the guidance from God.] When he stepped into the circle of Islam, he would start a new life, separating himself off completely from his past life under Ignorance of the Divine Law. He would look upon the deeds of his life of Ignorance with mistrust and fear, with a feeling that these were impure and could not be tolerated in Islam! (Qutb 1981: 31)

On a general level, categorisations of time periods are integrated into social life and often emerge as ruptures in the slipstream of new religious movements. The categorisation of time with social, even psychological, implications of guilt and morality is also entangled into social life in Petra. Death may offer a different status to a person, such as sainthood, but it is the practices of the people at the saint grave that lead to the moral judgements by those who believe that they are practising a properly informed Islam. By finding their recourse in the past at the time of the Prophet, the adherents of the Islamic revival seek to 'rid the world of magic' – a disenchantment project that this revival shares with the advent of modernity and rationalisation, but which, nonetheless, as Gilsenan (2000) notes, relies on its own enchantments.

However, the power of agency represented in oral stories seems to linger with people, especially the elders, who are not fully convinced by the prescriptions arising from a solely scriptural understanding of Islam, but neither are they not adhering to them. While many of my interlocutors explicitly ridiculed people practising saintly intermediation, stories of retribution are still quite common. One oft-told story about the graves at 'Ayn Amūn is about a soldier returning from Taibeh, who visited the graves to read the opening verse of the Koran. He was accompanied by a friend who called him ignorant for believing that reading to some stones would help him in any way. The next day, the friend's son died, and he became convinced of the retaliatory power of the saint and returned to the grave to slaughter a goat.

Even though the clergy have been very successful in persuading people through the Koran and Sunnah (the practices of Prophet Mohammed) to abandon these intermediation practices, most people

also recognise that 'ignorant practices' still occur to a limited extent at the margins of the heavily populated areas. The problem is that most people who scorn saintly intermediations recognise that there are indeed deceased people in this area that can be characterised as 'saints', and that it is dishonourable to accuse people of lying about the deeds of these people and events at the graves. They distance themselves from belief in the potentiality of the dead by categorising such practices as belonging to a particular time – a time of ignorance. But, by accepting the stories of success and retaliation, they also have to deal with the human and material causation through which these stories are formed. Sainthood, it seems, is dealt with and articulated with a high degree of precariousness (Bandak and Bille 2013; Kressel et al. 2014). Most often, the adherents to this new regime of Islamic knowledge deal with the saints through indifference, treating the graves as places of tribal identification, and otherwise abstain from judgement by leaving it up to God's will. A few others deny the potentiality of the graves and accuse the saint worshippers of apostasy.

One consequence of this stance has been an animosity towards the graves of the dead saints. Some of the signs of veneration of the graves are currently being destroyed, such as the excavation of Hamad's tomb at the Hamad cemetery, where the two other graves of Ghadi Mohamed and Sabah still stand, but without the beams with knotted cloth.[9] At other places, the knots and other marks of veneration are simply disappearing, as they are no longer performed and the wind tears them down.[10] Places like the shrine at Janeb ibn Janeb, where light was said to glow at times even though no one was there, are now in rubbles, and at the shrines of Nusha bin Nusha in Abu Makhtūb or Jebel Karoun, there are only a few remnants of the elaborate structures left. Other sites for intercession only exist through oral traditions, rather than in material traces, and may not be centred on graves. These include Zegnat Eshrūr in Wadi Bodha near Taibeh, which was a shrub next to the grave of a female saint, the tree called Shajarat al-Minjeh with elaborate knots of cloth tied to it, and another tree called al-Tameemah near two saint graves at al-Arja cemetery (for more details on holy sites, see Miettunen 2013).

The issue at stake here thus essentially concerns the negotiations taking place between various regimes of knowing, or rather not knowing, in Petra. In his work on nescience and ignorance, Roy Dilley notes that ignorance 'is not a simple antithesis of knowledge … It is a state which people attribute to others and is laden with moral judgement' (2010: 188). In this sense, the designation of a particular category of time in relation to how people deal with death becomes a

moral mark of knowledge and piety – or lack thereof (High et al. 2012). Dealing with the deeds of a dead saint becomes subject to a social and pious positioning through claims of knowledge and ignorance.

Among the younger population, only a few have substantial knowledge of the saint graves, but they often ridicule those who practice intermediation. As Dilley eloquently notes, ignorance 'is an absence that has effects in terms of what is construed as knowledge, and of what social relations of learning are established in order to address the consequences of absence' (2010: 188). I will elaborate on the social impact of claiming ignorance in Chapter 6, but what we see is thus a particular kind of taming absence that is not simply about forgetting. It is also about taking a stance on the immediacy and presence of the material world. In this case, it is a social relation of Islamic knowledge that centres on the scriptural sources of the clergy, either physically present in the area or televised. This clergy – and, more importantly, the way in which their message enters the social life of people with less Islamic education – seeks to purify the Islamic practices from innovations, enchantments and the agency of a particular kind of material tradition of seeking providence against misfortune.

It is thus in the formulation of sainthood that the potential agency of the dead spills into everyday life and becomes a contested field of knowledge and practice (Meltzer and Elsner 2009: 375). This returns us to Gilsenan's point above that the agency of saints needs regulation and taming, so as not to become a source of religious, and by effect, social disorder (2000: 605).

Taming Excess

The point of this exploration of extraordinary events around graves in the Petra region has been to show how places and stories of the potential agency of the dead are part of healing practices, tribal history and contestations in religious life – regardless of whether the events actually took place in any historical sense. The physical life of the saint has ended, undoubtedly, but his or her deeds are sustained, even enhanced, through the agency of the material remnants at the grave, which the devotee may – or may not – be blessed by: people never know the intentions of the saint, but they know of the potentiality of the grave to cause events to happen. It is the potential power of a mediating presence that is under contestation through the reformulation of a universal Islam. As Dilley argues, while 'knowledge provides a sense of certainty about things, and has a reassuring effect regarding our

place in the world, ignorance, by contrast, can suggest uncertainty and a discomfort about the world' (2010: 188). This uncertainty, I argue, is countered by the experience of potentiality that an enchanted world of saint graves offers in acting as a bridge between the dead and the living, between the invisible and the seen (Brown 1982: 6; Goldziher 1971: 259). This is a question of the affecting presence of matter at the grave and evaluating causation and potentiality in the stories by those people who still practise or know of saintly intermediation. It is not about a particular logic based on scriptural readings. Leaving these stories of excess behind is, in a practical sense, a distancing from specific tribal history, from belonging and from a sense of cultural heritage, and is thus not unproblematic for those who have stopped going to the graves or who reject their power (Schielke and Stauth 2008: 15). In the everyday life between juxtaposing purist and folk Islam is the role of ambivalence, ambiguity and potentiality.

The very materiality of the saint graves offers an excess of agency. It is not a human agency related to questions of intentionality. But neither is it solely a non-human agency based on causal, mechanical relations. Rather, it is an excessive agency that spills over into life among the living by offering a potentiality. While some have rightly suggested that the question 'who did it?' should be replaced by 'what is happening?' (e.g. Law and Mol 2008: 74), I suggest here that the question in this case is rather, 'could it happen again?' and 'how to deal with it?'. There is a need to tame matter, but the taming should be done in particular ways, and local adherents to the Islamic universality of one *umma* have their logical reasonings, while others are dealing with the potentiality of a mediating presence.

Notes

1. This chapter builds upon Bille (2013b).
2. Many of the graves are known by different names, stories or tribal affiliations, depending on the interlocutor; one interlocutor, for example, called it the grave of Sheikh Ibrahim al-Khasheibi. This is perhaps an important characteristic as it enables different people to infer different meanings from the graves and thus sustain their relevance.
3. The same name is also given to another, now disappeared, tree in the village (Al-Salameen and Falahat 2009: 190–91; Canaan 1929: 207). Some places are known by different names depending on tribal association, such as the site al-Bawwat; according to my interlocutors from the Sayydīyyn tribe, it is located in Taibeh and visited by the inhabitants, but the interlocutors in Taibeh had no knowledge of it. Most sources indicate

that al-Bawwat is another name for al-Fuqara at 'Ayn Amūn (Canaan 1930: 179). Furthermore, other sites are presented in the literature on saints in the region, particular Tawfīk Canaan's pioneering work, which mentions the grave of Abu Hmeid in Beidha but which no one in the area, even the Hmeid branch of the Ammarin, has any knowledge of.

4. According to oral tradition, there is a cave full of gold nearby, which will open when a man named Abdullah bin Hamad al-Naimi arrives.

5. As the story goes, there was a socio-political conflict about who would lead a tribe between 150 and 200 years ago. People decided to go to Ghannam, who had previously acted as an honourable judge, to find a solution. Ghannam was not supported by a big strong tribe, while the other people were strong and tough fighters. While Ghannam heard their claims, one person showed no respect for him as a judge. When Ghannam realised this, he held up a piece of goat dung. He asked the audience: 'What is this?' They answered: '*Ba'ar*' (goat dung). He crushed it between his fingers, and said: 'What is this?' They said: 'Pieces'. Ghannam added: 'I will crush you like this if you keep behaving in the same wrong way'. One of the audience members then mocked Ghannam, saying: 'Do you think you are saint?', to which Ghannam replied: 'Oh… Please God if this secret is given to me from God… I ask you God to send the answer to what you hear and what you see'. After Ghannam had made his judgement, the man rode his horse back but accidentally touched the gunlock or trigger of his gun. The bullet killed him, thus proving that Ghennam had close ties to God.

6. These graves are mostly attributed to the E'yeanat tribe.

7. Some say that the main grave there is the grave of al-Kheisi, from whom people from the cities of Dana and Tafila claim ancestry. The story I heard most often was that it was the grandfathers of the Sāidat tribe, Salman Sāidat and Salim Sāidat. According to one story, when people stopped visiting the graves, they would hear stones being thrown at their houses all night, without finding the culprit. It only stopped after they visited the grave again.

8. Outside the cemetery is yet another grave called *khbaybi* where incense is burned. This grave is not considered to belong to a saint, but rather to a cheerful person who was always spreading good humour. In hagiographies, this distinction between saint and 'fool' is not always so clear-cut.

9. This is also the case at the Abu Khiribe cemetery between Jebel Haroun and Wadi Mousa, where the sticks at the grave of *faqīr* Salame were intentionally crushed beneath stones. Similarly, the beams of one of the three saints' graves at the graveyard at al-Muraibit have been removed; the beam is still standing by the grave of Farraj bin Mufarraj and Mohammed Sweilim Farraj.

10. Another place where intermediation practices are performed is at the stone of Umm Mathhur, where people crawl into a small hole underneath; this allegedly has the capacity to heal physical illnesses. Lastly, there is Mentar al-Dakheeirah, which is a large stone, also known as Mentar al-Dabusah. It stands several metres over the sloping ground on a hard compact pillar of soil that (miraculously) has not been washed away by the yearly floods.

᭞◉ 5

The Allure of Things

Introduction

One of my good friends, Ibrahim, ran his car off a mountainside on the road from Beidha to Wadi Mousa. Ibrahim is in his late twenties, has no education, and a small family to take care of. Like most of the other men in Beidha, he works with tourists and has the occasional short-term job, such as participating on the archaeological excavations in the area. He had bought the used car the very same day: a typical white Mitsubishi Japanese pickup truck from the early 1990s. While he only suffered minor injuries in the accident, the car was damaged beyond repair. His injuries were no doubt made worse by the fact that he did not wear a seatbelt, as he considered such protective measures a sign of weakness and lack of faith in the will of God. But such reasoning does not entirely work when we are dealing with the misfortune caused by what is widely known as the evil eye ('ayn al-ḥasūd, more correctly translated as 'the envious eye'). People like Ibrahim decorate their cars extensively with amulets and Koranic verses as apotropaic technologies. The accident still raises a fundamental question about what material logics undergird the ways in which people protect themselves against risks.[1]

The evil eye rests on the idea that a look of envy, even unintentionally, can cause harm and misfortune to a thing or person, and everybody is potentially capable of giving the evil eye (Abu-Rabia 2005a; Harfouche 1981; Musil 1928).[2] Beautiful women, successful people and children

are particularly vulnerable and exposed to the evil eye. Abu-Rabia (2005a) has argued that it is a widespread social mechanism of morality, and sanctions people not to desire the possessions of others, while also explaining misfortune, bad luck and illnesses (cf. Abu-Rabia 1983, 2005a; Al-Sekhaneh 2005: 155–60; Drieskens 2008; Dundes 1981). The symptoms of a person being harmed by the evil eye are described as sickness, anxiety, worry and uneasiness, as well as dramatic changes in personal character.

The evil eye has a very physical nature since it 'touches' in a haptic sense by looking. An interlocutor explained that 'when you have a beautiful glass, and they just keep looking, you are afraid the glass may break' (cf. Al-Sekhaneh 2005: 158; Drieskens 2008: 70–79; Nippa 2005: 544–45, 568). Protective technologies against the haptic vision of the evil eye were found in abundance in Ibrahim's car. Hanging from his rear-view mirror, he would have amulets with Koranic calligraphy, as well as a cloth bag that he considered to be protective against the envious eye. The little cloth bag contained black cumin seeds and is a very common prophylactic item. According to Ibrahim and many others among the Ammarin, the cumin literally absorbs the envy and physical decomposition from the evil eye, and the bag would thus have been physically marked had the accident been caused by envy. I asked Ibrahim about his understanding of the cause of the accident, hinting about whether it had been caused by the evil eye or by technical problems exempt from divine or malicious human intent like the evil eye. He answered: 'There is nothing that doesn't get damaged, but it is not from envy. Maybe a part gets broken, the engine gets damaged, but this is normal. But the black cumin bag protects from envy. It is impossible that this damage came from envy'. The improbability had a physical reference: the substance of cumin acted as evidence for an unlikely relation between the invisible evil eye and the physical harm to the car. In other words, the cumin would have lured the invisible danger of the evil eye into its matter. Knowing relies on an interpretation of causality in material responses. Since the black cumin bag had not yet broken to the point of inefficacy – i.e. with all the seeds broken into bits – the accident was clearly caused by a technical problem. The protective object had been efficacious – automobile technology had not.

The efficacy of the black cumin is more than just that of a physical decomposition, but also connected with religious references. According to a *ḥadīth*, Prophet Muhammad said that 'there is healing in black cumin for all diseases except death'. Besides, it was an old car; the technical deterioration and the ageing of the brakes caused the

accident. It had been the will of God for him to survive a technological fault. One may consider ideas of evil eye causality as imaginary, but to the person affected, they do indeed have consequences, and a physicality within the ontological realm.

The cumin bag is part of a larger complex of objects that are used among the Bedouin to protect themselves against evil and harm. These objects are also held in particular esteem in representations of Bedouin culture in museum displays. Whenever one enters a museum with a section on the Bedouin, one inevitably sees a wide range of stones, necklaces and amulets used for protection against envy and the attraction of good luck. In that sense, things are not only used to protect against envy or attract luck or fertility, but also to lure in tourists and museum visitors in a display of cultural roots and traditions.

How come, then, did I later find myself sitting in a tent and witnessing a heated debate between a young man from the village and an elder local sheikh about the appropriateness of using the black cumin bag? The young man, who like many of the other young men in Beidha based their knowledge on what they saw in religious guidance programmes on television or from the religious scholars in the area, kept blaming people who used objects like the cumin bag for being ignorant, heretic and un-Islamic. His argument was clear: 'humans always have to ask God to protect him from the Devil, and mention God (by praying and reading). In the past people were ignorant. All of them ignorant'. However, the sheikh, who under normal conditions would be treated with respect, sustained his support for the black cumin bag, saying that people should not just throw the baby out with the bathwater because they suddenly read a book on Islam. Ibrahim and many other young people among the Ammarin concurred. He argued that the bags and various other stones work and besides they encapsulate Bedouin traditions and heritage, and there are abundant religious references to cumin as a healing matter.

So why was the young man so repulsed by the things that saved people from the evil eye? If for some reason he knew something that, to him, was an obvious violation of Islamic teachings, why did others not know, or not care? Can there be a productive role for ignorance? And what kind of materiality is at work in the moral realms of negotiating appropriate technologies of protection? Raising these questions highlights two issues in this and the following chapter. One issue is the particular kind of presence that make things work to prevent harm. Another issue is how can we understand how different regimes of knowledge, some of which claim to be universal, are employed in technologies of protection.

The Moral Judgment of Ignorance

Since the 1980s, the use of things like the black cumin bag, stones of various kinds and amulets, has decreased amongst the Ammarin, and in the Muslim world in general. Some have vanished completely, others are only used by a few people, and items such as the black cumin bag are not as popular as before. There can be little doubt that the religious practices of Muslims in Jordan have become more homogenous and orthodox as part of the Islamic revival. In this context, protective practices such as the cumin bag are looked upon by some with embarrassment and disliked as un-Islamic and ignorant.

The notions of *jāhiliyya* – belonging to the age of ignorance – and *jāhil* (ignorant) are often used in Beidha today in reference to things and practices such as amulets, talisman and saint intercession, as also discussed in the previous chapter. This does not mean that the risks of the evil eye or harm have decreased, only that 'whatever objective dangers may exist in the world, social organizations will emphasize those that reinforce the moral, political or religious order that holds the group together' (Rayner 1992: 87). The new order is shaped in particular by the educational system presented in schools and mosques. In terms of education in Jordan, the Muslim Brotherhood has been influential in determining the understanding of Islam in school textbooks. Since the 1950s, and particularly during a brief period from 1991 when a Muslim Brotherhood leader, Abdallah ʿAkaylah, became minister of education, they have pushed to Islamicise education (Anderson 2007: 76–77). Schoolbook authors overwhelmingly come from Islamist organisations, and they produce texts that promote family values, particularly women's domestic duties, and, according to Betty Anderson (2007), hatred against the Other – particularly Jews and Western cultural imperialism. These entities are framed as a threat towards Islam. While socio-economic change impinges on people's lives, the schoolbooks neglect this completely. Education, in other words, seems to be one way of countering the authority of the Hashemite regime by establishing a religious authority that emphasises family values in particular. Until recently, the school and mosque were the main sources for answers to Islamic questions. Through these structures, the government and religious authorities have been able to spread a more homogenous interpretation of Islam.

The availability of satellite television has also accelerated the changing understandings and knowledge of Islam, and thus also the means of protection and seeking providence. This is particularly the case for women, who often stay in their houses with the television on,

listening to prayers and Islamic Q&A programmes. Through these more readily available sources, whether education, mosques or television programmes, more homogenous understandings of how to deal with invisible powers, and most notably how not to, are thus widely spread.

One question raised when interlocutors openly judge other people as ignorant for using amulets is what role knowledge plays in the social realm. Here I take my cue from Roy Dilley's work on ignorance:

> Knowledge and ignorance must be regarded as mutually constituting, not simply in terms of an opposition by means of which one is seen as the negation of the other, but also in terms of how a dialectic between knowledge and ignorance is played out in specific sets of social and political relations ... If knowledge is transmitted, communicated, disseminated, or exchanged through social relations, it is given form and process by the potentiality of ignorance, of not-knowing, either as an absence in and of itself, or as a willed and intentional stance towards the world. (2010: 176–77)

Thus, more than simply being about the Bedouin not knowing, ignorance may also be a deliberate stance, so as not to commit to any particular current. To venture a bit more into the study of ignorance – or agnoiology, as James Frederick Ferrier (1854) calls it – it is important in this case to follow Dilley's insight: 'Ignorance is not a simple absence, a plain lack of knowing. It is an absence that has effects in terms of what is construed as knowledge, and of what social relations of learning are established in order to address the consequences of absence' (2010: 188).

The interesting point here is to see ignorance as a particular kind of absence. Firstly, we may find people who really do not know that there even is a debate about the use of cumin bags as a sign of ignorance. Secondly, there may be people who disagree with the interpretation that they reflect ignorance; and thirdly, there may be those people who are just indifferent. In all cases, the question of ignorance is enmeshed in moral judgements. Piers Vitebsky (1993: 101) has for instance argued that knowledge and ignorance are less cognitive than evaluative terms – i.e. they are used to assess other people. Ignorance is not only something used (negatively) to characterise other people, but also a stance that may be deliberately adopted, since by claiming a position of ignorance, doubt or uncertainty, one may also claim not to know any better, and so avoid over-committing oneself to any particular social current (Gershon and Raj 2000; High et al. 2012; Proctor and Schiebinger 2008). Ignorance is not only about knowledge of something, or its lack. It is also shaped through things, when objects do the memory work for us, or when people use things in wrong ways.

The Malicious Forces

Bedouin cosmology incorporates different invisible powers – good as well as evil powers that at any given time could cause prosperity or harm to a person or his/her family. Most notable of these invisible powers are the evil eye and the *jinn*. In response to such potent powers, different material means have been adopted to construct the most powerful devices. These combine with practices such as saint worship and utterances of protective formulas in order to extend the protection offered by the magical stones, coins, amulets, talisman and saint shrines (for early studies, see Canaan 1914; Kriss and Kriss-Heinrich 1960a, 1960b).

There are two basic causalities when it comes to accidents, misfortune or illness: those caused by 'evils' and those caused by 'natural' circumstances. The former is the work of other people, their envious eyes, or the *jinn*, but they are also determined by the will of God and one's abilities to protect oneself. The latter are technical, as we saw with Ibrahim when he wrecked his car due to bad brakes.

The *jinn* belongs to the spirit world. It may be either Muslim or infidel, and is believed to possess both good and evil powers, as well as the ability to mediate between the invisible world and humankind (Al-Sekhaneh 2005: 137–60; Drieskens 2008). They are also believed to haunt certain spaces, such as the Soldiers Tomb in Petra, and places where people travel through. According to Tawfiq Canaan (1930: 78), they should be fairly recognisable, as they appear in human shape, yet have larger stature, elongated pupils, perpendicularly running eyes and mouth and cow-like hoofs.

Whether they are actually present in Beidha or not is sometimes questioned, and there may be a good reason for this, as a younger interlocutor explains:

> The *jinn* are a fact, and the *jinn* were there at our fathers and grandfathers' times. But because there is more research, education and the Koran, every person who reads one verse from it will keep the *jinn* away. The *jinn* don't like to hear God's words. They'll go. 'Allāhu akbar' (God is great), when called from the mosque, the *jinn* will go far away in order not to hear it. They hate it. When the call is finished, they return, so if in every house the Koran is read then the *jinn* wouldn't come near.

Another elder interlocutor was a bit more uncertain: 'I never saw the jinn. But God said in the Koran: "I only created humans and jinn to worship me". From this verse, we learn that the jinn exist'. However, other interlocutors are less positive towards the belief in the *jinn*: 'In my opinion, believing in the jinn is a lack of faith'. Another interlocutor

has an even stronger resentment towards both the *jinn* and the evil eye: 'These are myths and magic. Everything that happens to you is from God'. It is important to note here that while some practices can be seen to be based on generations – elders go to saint graves, while younger people do not – the other practices and opinions cited here are not a matter of elder versus younger generation.

Nonetheless, there is generally an awareness of the powers the *jinn* may have to harm people if one stumbles upon their resting place. Most people would claim that the *jinn* exist, at least as a Koranic fact, although they did not know of anyone who had actually witnessed them. Many people in Beidha perform acts that may well be interpreted as protection against the *jinn*, such as burning incense. Like Barbara Drieskens' interlocutors in Cairo, 'for some these practices are just a habit, and the connection with the invisible is often not even conscious. When asked, they do not even know why they do it. Others are aware of the different possible meanings of these rituals' (2008: 47).

Several techniques have been used to avoid the evil eye or the *jinn*, particularly jewellery. Bedouin jewellery is popular in museum displays, and while the jewellery may be visible on the people wearing it, they are not considered to be objects of public exposure, admiration or judgement. As Annagret Nippa comments: 'if jewellery is a means of communication, it communicates with the invisible. It attracts positive powers and rejects those that are negative' (2005: 553). Geometric and other pictorial symbols, such as triangles, crescents and 'the hand of Fatima', are often used to provide protection from the evil eye (Topham et al. 2005: 66). Cloves are also used as protection, either in conjunction with other protective materials or in necklaces.

One particular category of jewellery is the amulet. The amulets can be divided into two main groups: firstly, scriptural amulets with Koranic verses on them, some of which serve specific purposes, for instance, as talismans. These are made by magico-religious specialists who include the name of the wearer or purpose, as addressed in the following chapter. They work through symbols and supernatural influence (cf. Canaan 2004). Secondly, there are non-scriptural amulets, dealt with here; as Birgit Mershen argues, these 'work through the material, colour or form of an object's inherent power' (1987, my translation).

The materials used, particularly for the latter type, are selected in part due to their colour and in part due to their shiny, glittering and delicate surfaces. Blue is used as protection against the evil eye; red is used to assure fertility and love; and white is used to increase breast lactation.[3] For the Bedouin, it is often not the stone material as such that matters, but the quality of the surface, i.e. the colour and the dim light

from the glazed stones, or amber, which has a light and softly shining appearance.

Protection against the *jinn* is becoming less widespread in Beidha, since many believe that the noise, lights, traffic and soundscape of prayers on loudspeakers scare the *jinn* away. As Charles Hirschkind (2006) has also eloquently shown, the soundscapes created by cassette sermons and calls to prayer establish an ethical space – not only for people, but also for spiritual forces. The move away from remote desert areas into villages has led to a decrease in protective efforts against the spirits, although they still largely occur among the desert-dwellers I have interviewed. The evil eye, on the other hand, is present as both a social and physical force.

A constant answer to my questions concerning the existence of the evil eye ('ayn al-ḥasūd) was with the play of words: 'it's present!' (*fī mawjūd*). As such, the question is thus not so much whether the evil eye risk exists, but rather what to do about it. Below I will concentrate on the objects used for seeking blessing and protection, since the specific physical properties of the object are considered preventive and blessing.

The Physics of Prophylactic Items

Despite religious declarations that objects should not be used to protect people, places and things, and that they are un-Islamic in character, some still remain in Beidha. The most influential objects are the blue stone (*ḥajar al-'ayn* – 'the eye stone'), the *kbass*, the black cumin bag and the guard (*ḥerz*). The most common stone used to protect against the evil eye is the blue stone. It is a light blue stone in a necklace. Though the stone looks different from the common multi-coloured stones in white, black and blue mimicking an eye, found in Amman, Istanbul or other major cities in the Mediterranean, it performs a similar protective function. It can also be implanted in architectural spaces, or it can be used decoratively in different contexts – including as charms on mobile phones – but this is rarely the case in Beidha. Among the Ammarin, it is mostly women who use it in necklaces, and while the stone, no larger than two cm in length, comes in different shapes, the common denominator of the various forms it takes is the bright milky blue colour. The stones are also often coated with shiny varnish. It is this blue colour and surface that both attracts and deflects the evil eye through the physical presence, colour and brilliant properties of the stones. It is hidden under the veil and as such is not visible to a casual viewer, but it will still attract the malicious evil eye. They are purchased in the

cities or from travelling merchants and passed on from generation to generation. They are not supposed to be admired either, and, as with most things, if you are thought to be staring at an object without the proclamation of it being the will of God, the owner will potentially give it to you in order not to cause harm to either the object or the family.

Another similar type of protective stone is the *kbass*. The *kbass* is a green, heart-shaped stone, coated in varnish, which is used on newborn babies (Abu-Rabia 2015: 94; Mershen 1987).[4] When a child is born, it is customary for the mother and child to have visitors come to the house during the first two weeks and give a small gift; the family in turn would offer candy. During the first two weeks, the child is seen as particularly vulnerable to the evil eyes of the guests, and the *kbass* is used as protection against both the evil eye and also the touch of 'impure' people.[5] It works by deflecting the evil eyes of the viewer through the attraction of the gaze. I only witnessed it twice out of the five newborn babies I visited during fieldwork. Some families claim that they have not used them for twenty years, while others claim that all newborn babies in hospitals in Amman get one.

The cumin bag is called *al-ḥabba al-sōdā'* (literally: black beads, also called *al-ḥabba al-samra* or *ḥabbat al-baraka*), a term used for the black cumin beads,[6] as well as a collective term for the small bag of cloth (figure 5.1). Aside from the black cumin, the bag contains seven pieces

Figure 5.1. Cumin bag around camel's neck. Photo by the author.

of flint, pieces of either salt or alum (*shabb*) and sometimes a piece of shell from the spur-thighed Mediterranean tortoise (*kurka'*) (for a different combination, see Musil 1928: 409).[7]

Pieces of flint are used because they are considered 'hardest', and therefore better able to sustain and ward off the evil eye. The proverb 'use flintstone against the eyes of women' (Bailey 2004: 94) encapsulates how flint is related to protection and the idea that women in particular are the cause of envy. Seven pieces of flint were used as material correlation to the saying that if one feels the touch of the evil eye, the utterance '*saba'ak*' ('your seven') will return the evil eye to the sender seven times.[8] Three pieces of alum (*shabb*) are used for its curative properties if one is affected by the evil eye. Salt has a similar consistency and physicality and can thus be used as an alternative. As for the use of tortoise shell, no reason was given other than tradition and previous efficacy.

Like the blue stone and *kbass*, the black cumin bag is still used, especially for protecting means of transport. In the case of my interlocutor Ibrahim, it was in his car, but walking around Petra one also notices that many camels used for tourists have a black cumin bag around their neck. The black cumin bag is placed somewhere visible as decoration. It works, it is argued, by capturing and absorbing the evil eye, thereby converting the envious viewer into a harmless person. It also has the curative function of absorbing the effect of the evil eye. As argued in the beginning, the black cumin bag, unlike the other protective stones mentioned above, is materially affected by the evil eye, since the black beads decompose as part of the protection process and thus need to be replaced.

This complexity of the various material registers within the same protective object – the hardness of the flint to deflect, the softness of the cumin to absorb, and the curative properties of the alum – creates a composite efficacy that centres on the multiple physical registers of the evil eye, and the need for the malevolent person to see the evil eye object (cf. Manning and Meneley 2008). Unlike many of the other items that are bought from traders, all ingredients in the black cumin bag except the tortoise are readily available in any household. This availability, together with Prophet Muhammad mentioning cumin, act as a moral authentication of its appropriateness.

Aside from the healers, people generally have a basic knowledge about healing. The most common everyday uses of herbal medicine, not just among the Bedouin but more generally in Jordan, involve *qaysōm* (archillea fragrantissima), *ja'īda* (teucrium polium), *shīḥ* (Artemisia herb-alba), *za'tar* (majorana syriaca), *na'na'* (mentha

longifolia), *baʿytharān* (artemisia judaica) and *bābūnij* (matricaria aurea), used in various ways as carminative, depurative, anti-cough and stomachic medicine. The plants are washed and put in sweet tea. Other plants used are *ḥanẓal* (citrullus colocynthis) as cathartic, and *ḥarjal* (peganum harmala), to be inhaled for relief, and for increasing the sexual activity of animals (cf. Abu-Rabia 1983; Sincich 2002). The most common healing stones used are *ḥabunnieh*, an egg-shaped stone used against swollen necks or other parts of the body by simply being placed near the inflicted area. The *khaliaʿ* or *ruwaʿ* is a cone-shaped, dark, soft-worked stone type, which is scratched against a glass. The dust grinded off is then consumed with water if a patient has been scared, particularly if he wakes up at night. Lesser known methods are the *ḥawaieh*, which is an oyster used to 'suck' out snake and scorpion poison, and *terfeh*, a small round red stone used against pain in the eyes. Other healing stones that people mention are *enfas* and *kurhamman*, and many more exist, or existed but are no longer in use in Beidha. It is considered somewhat ill-conceived to sell these, while those that go into the tourist economy are considered normal stones without effect, yet similar in form. Thus, unlike non-Koranic amulets of protection like the blue stone or cumin bag, which were replaceable, the efficacy of the healing stones are often inalienable objects, whose biographies are pivotal for their efficacy.

Extending beyond the personal sphere, the tent and, in fewer cases, the houses are often protected by what is called a *ḥerz* ('guard') (figure 5.2). The guard is an object made of beads (*ḥarjal*) from the Peganum Harmala plant (*ḥarmala*). It has a long-held tradition, as one interlocutor explains: 'It has a story from prophet Muhammad's time! When you make it into a necklace, it is not like the Koran, but it is a guard (*ḥerz*)'. The *ḥarjal* beads are collected during summer and put on strings by women. The inner part of the guard is made of three pieces of wood creating a triangle. In the museum in the Ammarin Bedouin Camp, this part is called 'vesica' and represents the 'eye' or 'void'. The wood is covered with pieces of cloth, most often red or green. Longer strings with *ḥarjal* are fastened within the triangle, forming a net. This is the centre of the item, while long lines of string with beads and colourful pieces of paper hang down from it and create a larger triangular feature. The guard should hang in the reception area of the tent (*shiqq*) or on the back of tents to protect against the evil eyes from afar. They are still in some cases put on the wall in reception rooms in Beidha. At times, the *ḥarjal* are simply put on a string in a simpler form, rather than the more elaborate and time-consuming triangular form.

By positioning the guard in the reception area, it is noticed by the guest, and his potential evil eyes are absorbed and enter the guard, where they are destroyed. According to the local Bedouin doctor, the guard, as such, is not harmed by this, and may be used for several years depending on the condition of the beads. Therefore, like the other items discussed above, it is the interaction between the potential perpetrator and the guard that protects the house from the evil eye. At the same time, the *ḥarjal* beads are also thought to increase social harmony in the room they are placed in.

The practice of using the guard is slowly vanishing and is most commonly seen in tents and in tourist areas with shops run by Bedouin. In the village, only three houses had the triangular guard, while a few others had a smaller decoration using the *ḥarjal*, likewise for protection. Many of the tents in the region had them either in the reception area or readily reachable in the private or women's area. The justification for the continued use of the guard and the black cumin is that Prophet Muhammad also mentioned the plants, and so they are Islamically 'legal' for this purpose. I mention this to highlight that what may be seen as folk Islamic practices by more 'purist' Muslims also draw explicitly on Islamic theological tradition.

What emerges from the above material strategies is the fact that some things are seen as ontologically 'more' material than others, while others are seen as less so. This highlights one of Tim Ingold's

Figure 5.2. The guard in the reception room. Photo by the author.

(2007) pleas that we should concentrate more on the material properties rather than simply looking at the social network in which they act. In this case, it is the very material capacity of the object to absorb and deflect that is the key point. Despite their continued use, the Ammarin are aware of the problems of these various practices in relation to current understandings of Islam. These practices are therefore not only a matter of protective efficacy, but also function as potent social markers of religious knowledge and position.

Centrifugal Efficacy

While the above methods of protection are still practised to some extent, the practice of saint worship has largely disappeared, as illustrated in the previous chapters. It is a topic that my interlocutors were very hesitant to accept as a present-day practice, even if they did admit that they themselves had done it once, not so very long ago.

However, as I moved around the area, it became apparent that such practices do still occur on a minor scale – if not by the people living in Beidha, then by others in the vicinity. Saint intercession does not, as such, specifically relate to the notion of the evil eye caused by another person – even if it may be used as a healing strategy – but to the relationship between invisible powers and a person. Saint intercession is more a kind of providence-seeking practice that aims at blessing (*Baraka*) and that thereby shun harm and misfortune, rather than through the physicality of the absorbing or deflecting items above.

Tawfiq Canaan has described *Baraka* as a 'benevolent power which radiates from the holy place to everyone who comes in contact with it' (Canaan 1927: 99). *Baraka* can radiate from living or dead people, such as the 'friends of God' (*awliā᾿* or *fuqarā᾿*) among the Ammarin, or the *sayyeds* in Lebanon, the herbalists and *marabouts* in north-western Africa, or even their descendants. Within a broad continuum, some are considered to have a lot of *Baraka*, others only a little (Canaan 1927; Geertz 1968; Gilsenan 1982; Rasmussen 2006). *Baraka* is in this sense centrifugal – an emanating force, securing providence for people, places and things in the vicinity of its material medium. Contrary to the physical presence of the amulets, this mode of seeking providence through intercession relies on an existential sense of presence understood as 'being-in-touch' emotionally: an intimate, immediate and passionate closeness with God through the *walī*.

Baraka takes part in many aspects of everyday life, most commonly in everyday expressions and greetings such as '*Allāh yubārik fīk*' ('God blesses you'). During pilgrimages to sanctuaries and shrines of saints, a more celebratory and ritualised pursuit of *Baraka* is obtained by touching the tomb, its cloth or the like and then passing the hand over the face and body, whereby the blessing is transmitted through the hands to the body. This practice is also seen when a Muslim takes his or her Koran, lets it touch his or her face and gives it a kiss (see also Donaldson 1937: 254). The most common form of blessing in relation to pilgrimages is through offerings, e.g. a goat, to a dead saint or prophet.

The Petra region has many saint tombs and sites that are – or were – visited by the local Bedouin, as illustrated in the previous chapter.[9] As 'spiritual representative', the saint is considered close to God and able to influence Him (Marx 1977). The two main places for saint worship among the Ammarin were Jebel Haroun[10] and Awwad cemetery.[11] The pilgrimage to the shrines could be done individually or collectively, some in a seasonal way, like the pilgrimage to Jebel Haroun, where prophet Aaron (Nebi Haroun, the stepbrother of Moses), is allegedly buried.[12] Other pilgrimages are more individual events or are tribally oriented. Offerings are made and rituals performed at the tombs of the saint who is thought to have special properties, such as curing particular diseases, reversing infertility or increasing prosperity. The purpose of a pilgrimage to a shrine is therefore to seek providence and healing through divine blessing by offering and honouring the saint as intermediator (Abu-Rabia 2007; Canaan 1927; Kressel et al. 2014; Kriss and Kriss-Heinrich 1960; Lane 1986; Meri 2002; Miettunen 2013).[13]

As shown earlier, most Ammarin dissociate themselves from this sort of intercession, also called *tawaṣṣul*, because the participants would ask Aaron for blessing, and therefore commit heresy by worshipping him instead of God.[14] In other words, the idea that the saint works as an 'efficacious intermediary in securing God's blessing (*Baraka*)' (Eickelman 2002) for the believers is currently contested and attention has shifted towards more direct blessing-seeking strategies between individual and God. While these latter ritual practices of seeking blessing, cure and fortune are largely discarded as un-Islamic, they are still to some extent continued by very few individuals, mainly elders. To most people in the village there was little doubt that the continuous practice of saint intercession must be by the tent-dwelling Bedouin in Wadi Araba, such as the Sayydīyyn, or by elder people in the Petra region, who do not have the same access as the Ammarin in Beidha to formal religious teachings, thus tapping into discussions of the role of ignorance in social hierarchies.

These practices are, however, also socially potent as efficacious knowledge passed on from their forefathers, and part of Bedouin heritage and respect for the past. The pilgrimages to saint graves link a place with the family ties of the Awwad branch of the Ammarin, the social economy of being descendants of a highly respected people, and the objects left on the grave are material proof of the long tradition of saint intercession and efficacy.

In many other places in the Middle East, such as Syria, the practice of *tawaṣṣul* is often justified with reference to a *ḥadīth* which refers to a blind man performing intercession through the Prophet Muhammad, and even within the *Shāfiʿī* school of thought that the Ammarin adhere to, there are arguments for the practice. Following this, not everyone in Beidha is convinced that visiting the saints is a display of ignorance. Yet they find it difficult to stand up against those whose knowledge and authority in Islam is seen as greater than their own, and the insistence on saint veneration practices could be interpreted as disbelief. These interlocutors clearly felt that saint veneration, and visiting graves more broadly, were part of their heritage. Yet, they acknowledge the potentiality of contestation of the practice, and thus often displayed ambivalence towards what they considered heritage.

The practice of tying a knot of cloth on a sacred place, like Salem Awwad's grave (in figure 3.2) or trees, is an old tradition in the Middle East. The knots are tied by visitors to show that they have visited the sacred place and fulfilled their religious duties; the cloth is also a material reminder for the saint not to forget the visitor and their wishes. The material understanding of the interaction between person, cloth, practice and place is that of 'contact magic', where the biography of a thing is inherently manifested in it. Therefore, the cloth embodies the person tying it and reminds the saint of the wishes of the visitor (Canaan 1927: 103–106).[15]

The pilgrimages are becoming increasingly rare because they rely on seeking blessing and providence through material practices of mediated closeness by knot tying or saint mediation. It is thus a mediated presence rather than a direct one (cf. Engelke 2004) that relies on materials as efficacious mediators of divine *Baraka* from God. As a practice of leaving personal items or offerings as material reminders, it establishes a connection of *being-in-touch* between a diseased saint and a person and asks for a future blessing. It is precisely because these practices employ mediation of divine blessing, revering the dead, elevating certain people from others, that they are contested in current 'reformist, modernist Islam' (Eickelman 1977).

In the Presence of Irreducible Materiality

Evaluating material efficacy is in some cases a physical property *inherent* in a protective object, and, in other cases, a reliance on *Baraka* conveyed *through* a place or thing. With the initial four methods (the blue stone, the *kbass*, the black cumin bag and the guard), in contrast to the *Baraka* obtained by pilgrimages, the key concern for them to be effective is the 'physics' of the material, their proximate presence as *being-in-place*. By 'physics' I imply that the material efficacy of the protective objects is found in their abilities to physically deflect, reflect or absorb evil, as Ibrahim explained of the decomposing cumin beads. The physical properties of things are thus highlighted, e.g. flint is hard, beads absorb, mirrors reflect, brilliance deflects, etc. These various material registers confront a phenomenon – the evil eye – capable of breaking things in an equally physical manifestation of material presence. The protective powers of these objects, I argue, are inherent in their 'irreducible materiality' to use William Pietz's term (1985: 7); that is, deriving from the object's physicality itself, such as the decomposing cumin (Ingold 2007; Nakamura 2005; Pels 1998).

The material properties of the amulets need to be 'there' to be efficacious; their efficacy relies on their unambiguous physical presence to confront the evil with the physicality of the protective matter; the matter strikes back (Pels 1998). These objects are 'satellites' that lure the evil eye towards them precisely because of their physics and spatial proximity. In that sense, unlike the centrifugal *Baraka* emanating from the grave, these objects work by being centripetal, sucking in all evil to their materiality. Flint is hard. Cumin absorbs and decomposes. Also, unlike the saint mediation, which relies on the interconnectedness of person and God through cloth, grave and offerings – all stationary markers of the potentiality of closeness to God[16] – the four initial items are highly mobile, and thus act as appositional strategies to the immobility of saint mediation. Again, the key concern of the various strategies is to protect against the physicality of the evil eye on the one hand, and the providence offered by saintly mediated *Baraka* on the other.

Likewise, the prophylactic items are considered part of a heritage, where most people still have different kinds of stone in their home – although they may not necessarily use them. They are still materials of the past, at times passed on for several generations, if not in specific material form, then in transmitted knowledge of efficacy.

The Power of Material Presence

While the various registers of protection against the evil eye may not perhaps appear to be fundamentally different in that people simply employ different objects, I have argued above that such an approach misses the point of the irreducible materiality of some things to absorb the evil. Envy, among the Bedouin, is a physical force, rather than a magical one, and the particular kind of presence that objects employ offers to engage materially with this physicality. The prophylactic items thus rely on their 'proximate presence' of *being-in-place* to engage physically with the threat, more than in terms of values and meanings the objects have obtained through their biography or exchange value. It is a question of efficacy, rather than history.

However, another protective technology, saint intercession, relies on a mediated presence of protection through *Baraka* emanating from the grave. In essence, there are two different modes of presence – presence as *being-in-place* and *being-in-touch* – that work either centripetally or centrifugally. The protective objects and amulets are alluring – they tempt the evil eye and centripetally gather the world of evil into their physical nature. The way of being present is thus also radically different from the ecstatic nature of the saint grave to emanate *Baraka* in centrifugal ways. This is alluring in quite another way, by spreading, rather than gathering, the blessing of a saint.

These diverse strategies are, as we have seen throughout the book, increasingly contested. In this chapter, we have dealt with reference to local traditions competing with the more universalist claims of the immorality of such conduct of material reliance. As we shall now see, an emerging understanding of the very materiality of protection is spreading in a way that not only reconceptualises notions of 'efficacy' and 'presence', but indeed emphasises the immaterial qualities of efficacy of the Koran as 'the Words of God', even if materialised.

Notes

1. Parts of this chapter were published in Bille (2010).
2. Some claim a distinction between the evil eye of the *jinn* and of people (Abu-Rabia 2005a; Al-Sekhaneh 2005: 157). My interlocutors however, did not articulate or recognise the distinction.
3. This could explain the dual function in the use of cowry shells in decorations by many Bedouin groups (although not the Ammarin in Beidha), to increase milk production, and to protect against the evil eye as they resemble eyelids.

4. A piece of gold is also often put on the baby either in relation to the *kbass* or as a replacement, still called *kbass*. In one case the interlocutor had a blue bead, which he referred to as *kbass*, but the general understanding is that it is a green, heart-shaped, varnished stone.
5. I.e. those who have not washed after sex, women during their menstrual period, or non-Muslims.
6. Nigella sativa, most often called black cumin (Abu-Rabia 2005b: 406).
7. This is the only terrestrial tortoise in Jordan (see also Ruben and Disi 2006). Many consider the tortoise shell itself as protection against harm.
8. While I never received an explanation from my interlocutors as to why the exact number should be seven, there are several stories where seven is a sacred number, e.g. in the story of the seven sleepers and their dog Qitmir, also recorded in the Koran (*Sūrat al-kahf*, Q 18:9-26), which may work as protection through recitation or written on objects (Porter 2007). Tawfiq Canaan also points to the preference of the number seven, for example, in the opening verse of the Koran, *al-fātiḥa*, which is composed of seven sentences, corresponding with the seven heavens, seven earths, seven planets, seven days of the weeks (Canaan 2004). See also Musil (1928: 390) for a discussion of the use of specific colloquial words for 'seven', which may attract the evil eye.
9. This is in contrast to Alois Musil (1928: 417–18) who argues that among the Rwala there is no saint worship, and never has been.
10. It should be noted that another shrine of Aaron, the brother of Moses, is located near St Catherine monastery in Sinai (see also Marx 1977: 46–47; Muhammad 1998).
11. Some stories also tell that Jebel Karoun (a Roman/Byzantine archaeological burial site on a mountain top on al-Fersh) was perhaps once used for rituals by the Ammarin but this could not be verified.
12. One of the stories of the monument on Jebel Haroun is that after Aaron's death in the western part of Wadi Araba, his soul flew from place to place, only to be disturbed by camels drinking water, until he finally found Jebel Hor (now Jebel Haroun), where he lay himself to rest, and where the camels could not reach. Moses saw his brother's spirit there and built a cenotaph, and hereafter the mountain became known as Jebel Haroun (Canaan 1930: 73-74 – a different Bdoul version of the story is also told here).
13. See also Padwick's (1961: 235–44) descriptions of prayers and purposes of saint worship.
14. This is an argument put forward throughout Islamic history (Meri 2002: 126–38) and recently by Islamic reformists seeking a more puritan orthodoxy, particularly by *salafi* and *wahhabi* scholars (Lewis 1986: 95; Renard 2008).
15. Aside from shrines and sanctuaries, there are other places around Petra where knots are tied, such as north of Petra, near Ras al-Nemele, where knots are tied of the branches on a *ratum* (White Broom). The explanation for this practice is two-fold. One is that the ritual would prevent the traveller from developing a sore back and body on the long walk down to the desert; the other is that it is used to signal that someone had walked down to Wadi

Araba and Palestine, before the advent of the mobile phone. According to my interlocutors, it was a very old practice, and is still occasionally used. South of Petra, in the area *al-Minjeh*, is a large Atlantic Pistachio (*botum*) tree with green and white strings of cloth tied to its branches. It is believed to be a sacred tree. It is a large and very old tree and the only one on that hilltop. My interlocutors in Beidha did not recognise it, nor had they even heard about it as a sacred tree, as it was far to the south of the Ammarin territory.

16. It could be argued that the actual movement to the shrine is also an important element of pilgrimages, at least in terms of social negotiations of territory and identities (Marx 1977).

ꥇ⑨ 6

AMBIGUOUS MATERIALITIES

Introduction

Ibrahim eventually got a new car after he crashed the first one and, as so many times before, I ride with him from Beidha Housing towards Little Petra. I use the time to ask him about the elaborate merchandise hanging from the car's rear-view mirror (figure 6.1): 'What is this for?' Ibrahim answers:

> This one is the black cumin bag. It is put in the car as decoration. If you have a beautiful car some people might envy it. The black cumin will take the attraction to it instead of the car. The evil eye will not affect the car, it will affect the black cumin; they will break. As little as the seeds are; they break. The other is 'There is no god but God, and Muhammad is the Prophet of God'. This is Islam!

As illustrated in the previous chapter, the black cumin has a presence that works by *being-in-place*. But I am still puzzled by the use of both items against the evil eye. So I ask, 'but how is this different from the black cumin?' He answers, 'These are God's and Muhammad's names. When anyone sees the car or a house, he will say "in the name of God" and he won't envy'. Not really feeling that his answers address my question, I continue, 'If you already put the names of God and Muhammad, then why do you need the black cumin?' Ibrahim explains:

It is not a must to have the black cumin. You have to put God's names and 'God blessed upon Muhammad'. The black cumin has been known for a very long time. The elders say that it is good against envy. But, 'There is no god but God' is better. When you put the black cumin, it will protect the whole car. God protects, but the black cumin is a tradition.

Figure 6.1. Protecting the car. Photo by the author.

I am reminded of a similar conversation I had with Ahmed – a young, single male Bedouin in his late twenties with a government job. Unlike most of the others in the village, Ahmed is well educated and well versed in Islam from his own reading and studies, compared to most other residents' reliance on oral transmission. Ahmed and I discussed the different types of prophylactic items I had seen during my fieldwork. Ahmed frowned and, unlike Ibrahim, said, 'Twenty years ago if you said this stone doesn't work, they would say, "you are crazy! This stone protects me". But now they discovered that the stone doesn't work. The stone is a stone – nothing more'.

Clearly, protective stones and black cumin must in some way have seemed efficacious in the past, and indeed still do to Ibrahim and many others. So I ask Ahmed how did the black cumin and stones work? Would people have to perform certain initiation rituals with them? Ahmed replied, 'No, no, just put it and it protects you', and he started laughing: 'This is what people think, but not me! Don't hang it here or anywhere, because that means you don't believe in God. You worship two Gods if you put it here, because you think it helps you. No. Just depend on God and forget all the materials. That's the summary'.

As illustrated in the previous chapter, there is an irreducible materiality to some of the prophylactic objects, yet still, there is a problem of presence. It is a question about *how* things are present or absent. What is needed is a protective strategy that instantiates God in mind, not the physical protective efficacy of materials. As Ahmed would argue, the protective measures to ward off the evil eye resemble acts of polytheism (*shirk*). Instead, the protective materials should be replaced by an intentional absence of objects relying on an irreducible materiality. The absence of certain kinds of materials shifts one's attention to the superiority of seeking providence in immaterial sources: a providence that involves preparation and anticipation of divine support for future eventualities, even if these are not immediately apparent to the believer. The efficacy of such 'absences' instead relies on the contiguity of God through *Baraka* (blessing) or *dhikr* (remembrance of God).

Although people among the Ammarin are gaining increased access to material goods, asceticism and relying on the uncreated Words of God presented in the Koran are increasingly perceived as a superior means of seeking providence and protection to that of non-Koranic amulets. In a dichotomy between elite and folk Islam, it appears that the former is now dominant. But it is not unequivocal, as illustrated by Ibrahim, and the Koran holds a central part in legitimizing both positions, highlighting that the positions are perhaps not about an either/or, but about when and how it makes sense.

However, Ahmed's position still raises a pertinent question: how can one experience God when the absence of material form presumably is the ideal? Daniel Miller has aptly argued that 'the passion for immateriality puts even greater pressure upon the precise symbolic and efficacious potential of whatever material form remains as the expression of the spiritual power' (2005: 22). In this chapter,[1] I will investigate this paradox of immateriality as it unfolds in conceptualisations of presence, absence and efficacy. The aim is to continue the previous chapter's unravelling of what cultural logic is at stake in the shift in notions of protective efficacy.

Embracing Islam

I had many formal and informal discussions with interlocutors concerning these changes in religious and protective technologies, caused primarily by settlement. With the increasing availability of satellite television, the inspiration and guidance the community receives is not just limited to the teachings of the imam in the mosque and missionaries from nearby cities. Nor are they limited to the particular versions of Islamic teachings that the Jordanian educational system promotes. Instead, people also become influenced by Islamic interpretations from the Emirates, Saudi Arabia and Egypt that they see on satellite channels during the day.

The influence of the television is particularly clear with regard to women's religiosity. With few exceptions,[2] the women (particularly the unmarried ones) in Beidha spend most of the days in their own houses or with other female friends in the village. Today they are the main recipients of the vast amount of media input from the satellite television during the day. As an illustration of the influence of different Islamic traditions, the *niqāb*, the full face-veil that only leaves the eyes exposed, is increasingly used by the women in Beidha, and the theological arguments for wearing it are predominantly linked to Islamic guidance programmes from Saudi Arabia and the Gulf.[3]

The changes in protective strategies are characterised by a shift away from the perceived physical protection of the amulets discussed in the previous chapter and the mediating presence of the saint intercession, towards those that focus on the blessing and protection of God and the Koran as the 'Word of God' (*kalimāt-u-llāh*). The use of the 'Word of God' is by no means a new invention, but simply the intensification of one strategy over the other. As seen with Ibrahim, some of the customary technologies of protection and seeking providence are still

used in conjunction with the 'Word of God'. The diverse, material protective technologies employing the 'Word of God' conform to a variety of beliefs about their efficacy. People have faith that God will protect and bless the spaces wherever God's words are present, which means that one does not need materials at all, but can, potentially at least, instead rely entirely on one's ability to remember God (cf. D'Alisera 2001; Starrett 1995). The issue here is to comprehend what is at stake with the different understandings of materiality employed in the various registers of protective objects, which, for some, stand largely in opposition to another. For others, like Ibrahim, they are complementary means of protection. This highlights the complex engagements the Bedouin have with evaluating protective efficacy and determining the use and materiality of the 'Word of God'.

The Ambiguous Materiality of the Koran

The change in perception of what to use as protection was not simply a generational matter of younger versus elder people. To illustrate, I was finally allowed to record an interview with Mashal, an unmarried man in his early fifties. He and I had spoken several times informally about the changing life of the Bedouin. Mashal is particularly interesting because he was released from prison during my fieldwork after twelve years' incarceration for murder as part of an honour feud involving a neighbouring tribe. I wanted to interview him on his perception of returning to Beidha, and the changes he had experienced while trying to settle in. Among the many things we talked about were the changing traditions of protective amulets against misfortune that have a prominent role in museum representations of Bedouin culture:

> There is a stick from a tree that they cut and put into their head rope and say that it is against envy. There are certain areas of the land, which people believed were good (shrines, sacred trees). The Bedouin had habits: they used the [blue] stone, the stick and so on. But they didn't know! They didn't have the education of today, the mosques where they hear the *ḥadīth* and learn right from wrong ... When people got to know that this is against Islamic law and they don't benefit, they went to the Koranic healer and to the Koran verses. Prophet Muhammad said that the Throne verse and the opening verse of the Koran – if you read them correctly – is, as if you have read the whole Koran.

It was clear from our conversations that he had also changed his perception of protective traditions, and he recognised that a more purist Islam had taken on a much more important role in the lives of people. Instead of stones, people now turn to Koran verses for protection, since

they now consider themselves to 'know better' what is effective and what is not – and more importantly, what is effective in the proper way. You could say that more people are turning towards Ahmed's purist Islam than Ibrahim's simultaneous embrace of both local traditions and Islamic Revival.

Despite his anti-materialist position Ahmed still had a few protective amulets, although much fewer than other people, and they only had the Word of God written on them. There was a Koranic verse built into his father's car near the ignition, put there by the previous owner, which he often used, thus reminding him of God as he used the ignition key. He had none in the reception room of his house, and only one small tin miniature of the Koran in his own new car. I had previously asked Ahmed about his perception of the shift in protective practices that Mashal also described and, specifically, about the more prominent role of the Koran in this:

> If you asked me this question in the past, at least 40 years ago, or before, I would answer 'I use the amulet to protect me' because I am uneducated, but now even if I use the amulet, I use the Koran to protect me, it is God's words I use to protect me. In the past they believed that the amulet would protect them, but now they use the Koran and Koran verses in the house so that God will protect them if they have his words in the house. We do not exactly believe that the Koran as a book, or as a material in our house, protects us. We use the words from the Koran to connect with God; our senses, our soul, directly with God.

The two interviews with Mashal and Ahmed pinpoint one of the religious developments that have taken place since the mid-twentieth century among the Ammarin – and in Jordan at large – but which has rapidly increased within the last few years. For Mashal, reading one Koranic verse was metonymic of reading the whole Koran. For Ahmed, the book, as such, is not exactly protective, relying on a presence as *being-in-place*, but somehow affords a connection with God by shaping a presence as *being-in-touch* through reading or remembering. For both Ahmed and Mashal the protective traditions with blue stones, black cumin and Peganum Harmala, discussed in the previous chapter and forming part of the museum and heritage industry, were an expression of ignorance and un-Islamic materialism.

But if this is the case, how do Koranic words actually work, since they, like the amulets, are located in the same places? What notions of materiality undergird these Koranic objects? These questions draw attention to an ambiguous and contiguous relationship between presence and absence that almost imbricates yet avoids this by conceptualising particular sensuous engagements with things. If people should 'forget

all the materials', since they signify polytheism and religious ignorance, then how are we to understand the persistence of material objects in Ibrahim's rear-view mirror, and indeed with Ahmed? This paradox, I argue, suggests that we need to be careful not to conflate absence with 'the immaterial', or as oppositions to presence and empirical matter, as all are subject to ambiguous classifications and experiences. This is particularly so in the case of defining the nature of the Koran.

As in standard Islamic thought, the Ammarin understand the Koran as God's own words. They were passed on to the Prophet Muhammad by the archangel Gabriel. Hence, it is the foundation of religious thought in any Muslim community and is the message and guidance from God to humanity. The Koran consists of 114 chapters (*sūra*, plural *suwar*), which are composed of verses (*āya*, plural *āyāt*). These guide Muslims in all aspects of their lives. The relationship between the words, text, material of the Koran and the practitioners' senses is described in the preface of the Encyclopaedia of the Koran as follows: 'to hear its verses chanted, to see the words written large on mosque walls, to touch the pages of its inscribed text creates a sense of *sacred presence* in Muslim hands and hearts' (McAuliffe 2001: i; my italics).

The most important part of Islamic praxis in everyday life is prayer. There are three different types of prayers: *ṣalāt* (the five prayers a day), *du'ā'* (a personal prayer) and *dhikr* (remembering God). It is believed that God literally speaks to human beings through the Koran, and human beings reciting the Koran address themselves to God by chanting the essence of God. As Clifford Gertz notes, 'the point is that he who chants Quranic verses … chants not words about God, but of Him, and indeed, as those words are His essence, chants God Himself. The Quran … is not a treatise, a statement of facts and norms, it is an event, an act' (1983: 110). Each in its own modality, *dhikr*, *du'ā'* and *ṣalāt*, returns the word to God in the thought of recollection, the word of invocation and the action of ritual worship (Böwering 2004).[4]

The Ammarin maintain that the transcendental origin of the Koran as God's words is evidenced in the content of its knowledge about the past and future, and in the text's inimitable written style (e.g. Q 2:23). It is believed that the Koran is the eternal uncreated utterance of God, and that it had a previous existence in Paradise (Zayd 2002: 95). Therefore, as a venerated object, as the literal 'Word of God', originating in Paradise, one should have performed ablution before reciting or touching it.

Koran literally means 'recitation', but the Koran as a material book is termed *muṣḥaf* (from the word *ṣaḥīfa*, singular for 'page'),[5] suggesting

that through different categorisation of (from an empiricist position) the same object, the immateriality of the one and materiality of the other are emphasised. In this way, despite being historically written down after the life of the prophet, 'the character of the Quran as a book in the Western sense is far less pronounced than its identity as a recited "word" ... the quintessential Muslim "book" denies its writtenness' (Messick 1989: 27–28).

The Koran is believed to contain the most powerful *Baraka* (blessing). Hence, aside from guiding humanity, material artefacts with Koranic verses also protect the believer against misfortunes and malevolent forces. The most powerful protection is offered by the commitment of the Koran to memory, which creates an affective nearness to God (El-Tom 1985: 416); that is, its internalised nature creates a sense of immediacy and what I have termed *being-in-touch*. In this way, acts of recitation and remembrance (*dhikr*) of God shape a contiguous relationship that offers safeguarding and comfort. The words themselves in materialised or verbal form impose the remembrance on people, as a pervasive 'affecting presence', to invoke Armstrong's terms (1971), whereby the Koran is 'both the occasion or catalyst for *dhikr* as well as what should be recalled, the object of *dhikr*' (Madigan 2001: 372).

Inherent to the Koran is both a tension and a connection between the physical (*mushaf*) and the immaterial (*Qur'ān*: recitation). This relationship is continuously creating social tensions through allegations of misconduct and misunderstandings of the divine. The Koran offers a sense of 'closeness' to God through remembrance of his words, on the one hand. It is important to note here that the Koran only exists in Arabic, and translations are, in that sense, not the Koran, but precisely a translation of the Koran. On the other hand, there is the theological obligation not to worship the Koran as a material book in itself, despite its powerful *Baraka*. Protection through the 'Word of God' therefore becomes a socially potent question of the proper understanding of presence and absence of material efficacy. Thus, the issue addressed here also extends beyond questions of the effects of objects, to a question of the ability of the objects to cause those effects in a suitable way – both in terms of social life and protective efficacy.

Recitation and memorisation of the Koran are important parts of everyday life in terms of blessing and protection. Utterances such as '*bismillāh*' (in the name of God), '*mā shā' Allāh*' (what God wills), '*in shā'Allāh*' (God willing), '*al-ḥamdu lillāh*' ('Praise be to God'), '*subḥān Allāh*' ('Glory be to God'), reciting the opening verse of the Koran,

'bismillāhi l-raḥmāni l-raḥīm' ('in the name of God, the compassionate, the merciful', also known as the *basmala*), are all ways of relating to the words and will of God in everyday life, which then offers protection. Reciting Koran verses (particularly Q 1:1-7, 2:255, 113:1-5 and 114:1-6), often a certain number of times (mostly three, five or seven), becomes a means of protection against envy and misfortune. Likewise, when entering a house, a car, starting dinner, killing a goat, accidentally breaking a thing, etc., people would immediately utter *'bismillāh'* (in the name of God). Importantly, however, they would not do so when entering impure places, such as toilets, as this would be to disrespect the words. When seeing something that may be admired, such as a telephone, car, jewellery, etc., the words *'mā shā' Allāh'* (what God wills) should be uttered as a self-reflexive mechanism, in order not to harm the owner by casting the evil eye. As a consequence, such words are also often printed on houses, cars and objects.

While the Koran as a tangible book obviously has different qualities, different sizes and materials, these all equally represent the 'Word of God', and as objects they are also used, worn and damaged. Discarding the 'Word of God' has traditionally been done either by burning it or burying it deep in a place where the animals would not dig for it. In Beidha, they would either burn the Koran (and thereby physically dematerialise it), or they would give them to the mosque to deal with. This also includes individual pages, which, once worn out, would cause the whole Koran to be cremated or disposed of in a pure place, so no disrespect, impurity or incompleteness befalls the 'Word of God'.

This material nature of the Koran, as 'Word of God', often became a catalyst for discussions during my fieldwork. The evening before *ʿīd al-aḍḥā*,[6] I was in a discussion with a young man, who a few days earlier had begun to reconsider his life after getting a job. He had replaced alcohol and getting into trouble with prayers and seeking knowledge on proper ways of Islamic behaviour. The change in lifestyle, however, only lasted about a week more (cf. Schielke 2009). Our discussion started when, during dinner with his family, I asked questions about the meaning of specific parts of the Koran, which I had in my room. At first there was a great satisfaction for the family to see that I was seeking more knowledge about Islam. They acknowledged that they, for their part, had informed me on issues of Islam,[7] and it was therefore now a matter between me and God; and besides, they knew that for the past six months I had had other people talking to me every day about the issue of conversion to Islam.

Surprisingly, however, it then turned into a discussion about how I – as a non-Muslim – should deal with the Koran in my room. While the rest of the family was less strict on the subject, the newly revived young Muslim insisted that it should be on top of all my other books, and that I should wash myself before reading it, facing Mecca. While I could have gone along with this and agreed, I chose to take up the discussion, stating that I would respect the Koran as a book revered by Muslims, and treat it as my other books, which I did not intend to harm. It took the best part of an hour to come to an agreement. The agreement was not, however, what I initially would have assumed: that we should respect our differences, and not intentionally seek to harm the other person's religious feelings or sacred objects, etc. Rather, the discussion ended when it became clear to the young man that it was a Danish translation without the Arabic letters in it, and hence not the 'Word of God'.

This example illustrates not only the temporary nature of spiritual awareness, and its increasingly dogmatic understanding, but also how the 'Word of God' is manifested materially and dealt with practically in everyday life. Thus, one very important point for the argument here is that the Koran is only considered the 'Word of God' in Arabic. Muslims consider translations of the Koran into languages other than Arabic to be interpretations, hence no longer the 'Word of God' (McAuliffe 2001: ii).

By applying the Arabic 'Word of God' to things, people can claim to stay true to worshipping God's immaterial qualities and thereby avoid allegations of materialism. The local Islamic preacher would happily have blue stones and cloves hanging in his car in a decoration with Koranic words, and yet he would fiercely denounce the use of the blue stone alone. The application of the 'Word of God' re-classifies a thing into something ontologically entirely different. The propriety invested in dealing with the 'Word of God' is contingent upon recognising how the material and immaterial aspects are adjacent, never overlapping or separate, but linked together by comprehending its ambiguous materiality: more than immaterial and less than material. To make sense of the conceptualisations of it in Beidha, I will argue that as the literal 'Word of God', the Koran is an 'immaterial thing', although the Ammarin do not refer to it in these terms. To make this conceptual leap, I must emphasise that the physicality of the book – as *muṣḥaf* – is at times acknowledged, but what matters about the Koran is its *Baraka*, recitation and *dhikr*: externalisation and internalisation. Its physicality is downplayed (or avoided), even if the words of God throughout history have been elaborately materialised – for example

in calligraphy. Yet, in the immediate, everyday engagement, discourse and perception of the 'Word of God', it is less than material: an 'immaterial thing'.

In my discussion above with the young man who was reconsidering his religious life, the Koran had thus transformed from being the 'Word of God' – an 'immaterial thing' – into an object: a book with the translation of the 'Word of God', which did not have the same power, nor did it generate the same position or respect by its user.

Materialising the Word of God

In the past, the illiteracy level in Beidha was much higher than today. Many people from the older generations in the village are still functionally illiterate. The words of God, or at least those most important for protection, are thus memorised and orally transmitted, rather than recited from a text. The Koran and names of God are increasingly made materially manifest in a wide range of mass-produced product lines, though ontologically its materiality as the 'Word of God' has not changed. A picture frame with the 'Word of God' on it *is* the 'Word of God', not a representation or common object.

Precisely because the Koran is considered the literal 'Word of God' and a 'reminder', many *suwar* and *āyāt* are applied to other physical objects, to extend the agency of the Word. These applications are a result of the increased availability of mass-produced items, economic surplus, as well as the increased ability to read, watch television and attend mosques. Particularly popular and effective are any one of the ninety-nine names of God, *al-fātiḥa* (the opening, Q 1), *āyat al-Kursī* (the throne verse, Q 2:255), the light verse (Q 24:35, in which the nature of God is compared to the nature of light),[8] and a conjunction of *sūrat al-falaq* (Q 113) and *sūrat An-Nās* (Q 114) called *al-mu'awwidhatān* ('the two cries for refuge and protection'; Campo 1991: 102–104; Zayd 2002: 87). With few exceptions, every house had Koran verses, the *shahāda* (testimony of faith) or the name of God in some form in the reception room (figure 6.2). Around half had 'The Throne Verse', while the others had a compound of the *al-mu'awwidhatān* (Q 113-114), the *basmala*, a written prayer (*du'ā'*), or one of the names of God (each of these may of course also complement the other).

Application of the 'Word of God' to physical things takes many shapes, and throughout history it seems to have been applied to many types of objects around the world. *Baraka* may be transmitted to food through the application of Koranic verses to brass platters used to

serve communal meals. Koran verses are also placed on the inside of drinking cups, which would then cure or bless the recipient (Starrett 1995: 57). Yet in Beidha, it seems that only a few items such as car stickers, picture frames, clocks, wall calligraphy and coins have them. Utilitarian objects such as pans, tools or knifes would not have Koranic verses, as they would be exposed to fire, and so users would potentially be performing blasphemous acts (Starrett 1995: 56–57).

My interlocutors argued that Koranic calligraphy protects the physical space and members of the household from external evils by framing a blessed space (cf. O'Connor 2004: 175). The names of God, verses or parts of the Koran are set in gold or silver laminated frames (*barawāz*) that are mostly bought from Wadi Mousa.[9] They are often moved between rooms, depending on the social contexts, though they usually hang in the reception room, in a high position. While they do not contain the complete text from the Koran, a verse is 'presencing' the full Koran, as Mashal described earlier – reading one part is like reading the whole Koran in terms of instantiating divine closeness. Like the Koran, if they are worn out or if one wishes to dispose of them, they should be burned.

Within the last few years, a new fashion has been evolving with the writing of the words and names of God directly on houses. As

Figure 6.2. Protecting the house with the Word of God. Photo by the author.

well as one of the ninety-nine names of God or the name of Prophet Muhammad, or *dhikr* – such as the *basmala* – some had more elaborate proclamations, including 'My prosperity is only from God' and 'Enter it safely in peace', over their doors. An even more elaborate case was the application of different coloured tiles in the kitchen of one house, arranged into man-size high letters spelling '*Allāh*', or on the wall as part of the decoration.

Sometimes the protective properties of the Koranic frame were not for (potential) reading since the elaborate calligraphy or the level of literacy made doing so impossible. Instead, such items became the material instantiation of the presence of God, while simultaneously causing the person in its presence to remember God. To understand this, one needs to see how these objects 'are not the mere letters or mere words. They are the twigs of the burning bush, aflame with God' (Graham 1987: 109), and beyond the written word, even if this is not understood.

Such material manifestations have a dual function: on the one hand, they are reminders (*dhikr*) of the 'Word of God'; on the other hand, their mere presence seems to be beyond that of reading or reciting. Instead, they relate to the words of the Koran as part of a protective strategy in itself. Furthermore, the use of a miniature Koran, so small that reading is impossible, is still considered the complete Koran. So too are stylised miniatures in gold alloy, with one page open, often hung in automobiles, which transfer the full presence of the words of God through a relation of presence in absence.

At times the calligraphy itself even renders the text difficult to read, whereby 'the letters and words are only elements that form the entire piece of art and are no longer meant to be read' (Zayd 2002: 95). Thereby, the presence of God is indicated by the image of a few words, whether readable, complete or not (Dodd and Khairullah 1981: 17).[10] That is, rather than a semiotic understanding of a contingent, indexical relation between one entity and another (the material relation of smoke to fire, or the symbolic relation of the crown that refers to the queen), the understanding in play here is the 'presence in absence', which implies a literal transfer of presence. There is no gap in indexical relation.

To return to the question of materiality, the protective properties of the Koran are ambiguous for interlocutors. Despite the stress on the power of immaterial remembrance, some believe a house is not safe unless it has a Koran inside it. As one interlocutor explains: 'people know that the Koran is God's words. And we keep it! When you put the Koran verse, it is to protect you from the devil and the evil. When

a house has a Koran in it, no harm will enter it'; therefore, a house needs a Koran. Many of my interlocutors, like those of Gregory Starrett (1995: 53), would thus:

> Attribute the protective value of Qur'anic verses to their innate power as utterances of God, who will benefit those who display His word in their residences or places of business ... God has promised to protect His word, and so will protect it wherever it is found. When invoked in this way, divine action is assumed to take one of three forms: the conferral of success and prosperity; the prevention of misfortune; and protection from the envy of others.

The Koran in and of itself, as God's own words that contain strong *Baraka*, acts as a protective technology for believers, by being ecstatic – transcending its own physical borders as a centrifugal power (cf. Owusu-Ansah 1991: 31). But for other believers, this is a problematic position. As another interlocutor in Beidha explains:

> If the Koran isn't in your heart and you only put it on walls then it is of no use. Some people believe that putting these verses on walls means that you worship it! Others say that it is Gods words and they remind you of your belief in God. If you don't have the Koran in your heart then hanging it on the walls has no use! The benefit is in reading it. When I see the Throne verse on a wall, I remember the words of God! It makes me say Gods words.

This stands in contrast to the previous interlocutor's idea that the mere presence of the Koran is enough to protect the house. Thus, while Geertz's argument that in Morocco people are 'taught to regard the Koran not merely a fetish radiating baraka but as a body of precepts to be memorized, comprehended, and observed' (1968: 73) also applies in Beidha, it appears that in some cases the relationship between instrumentality of protection (through *Baraka*) and protection via remembrance is more complex. Therefore, it can generally be said that the Koran, as a physical mnemonic, protects through its ability to make people think about God, while also protecting believers in its immediate proximity through its innate ecstatic powers as the essence of God.

Such particular material presence is illustrated by Armstrong when he claims that things are part of a 'Perpetuating, affecting act – a near-being, with its unique "personality" continuously asserting its own existence, though it is known only in transaction. It is independent of any source of "meaning" or energy external to itself; being a self-sufficient entity, it is its own "meaning" and provides its own energy' (1971: 29). Previously, the application of the word of God was predominantly used on jewellery among female Bedouin.[11] The jewellery differs

considerably among the Bedouin depending on geography: e.g. the historical abundance of coins and jewellery among the Bedouin in Negev, compared to Jordan. Today, only a few of the women in the village have silver coins (*'umla*) with some sort of inscription on them, which would usually be worn around their necks. They also told me that they did not have many before either, mostly due to the poor economic situation. I was shown two silver coins during my fieldwork. They were very small and very worn. The Arabic letters had almost been rubbed away and could not be read, but my (illiterate) interlocutor still described her coin as the 'Word of God'.

The Powers of Amulets

As argued in Chapter 5, amulets can be divided into two main groups in Jordan. There are non-scripture amulets, and scripture amulets with Koranic writings on them that work through symbols and supernatural influence. This latter type of amulet and talisman is also known as *ḥijāb*.[12] One can further distinguish between two different kinds of Koranic *ḥijāb*. One is the amulet or charm with the words of God on it, and the second, which I call here a talisman, is used to address a specific purpose. These are often produced by a special healer writing a passage from the Koran, a prayer or invocation on a piece of cloth or

Figure 6.3. Talisman consisting of nonsensical word meant for the spirits. Photo by the author.

paper (figure 6.3). While religious or spiritual knowledge in the Middle East is often seen as being strictly gendered – with, for instance, Islamic knowledge being dominated by the male sphere – this is not the case with the herbal healers in the Petra region, who can be men or women.

I met many such healers and one in particular was one of the very few people in the area to practise fortune telling. The most common form of fortune telling in Jordan is reading the coffee cup, but this woman used another method. She threw ten molluscs on the floor and judged their position, sometimes interpreting from one she caught when throwing. For most people in the area, such practices are associated with mysticism, lies or tricking ignorant people for money. Nonetheless, the fact that she performed many different kinds of healing, some more theologically consistent than others, points to a practice in which things mediate between past and present, the seen and the unseen, where clear-cut Islamic and non-Islamic practices are difficult to discern.

In this battlefield of revealing and concealing, a common artefact is the talisman. The talisman is prepared by a healer, generally known as a *khaṭīb*, who can contact the spirit world. Again, every healer has his/her own particular method, but it generally includes reciting words from the Koran, and then entering the realms of spirit contact, where the healer and the summoned spirits communicate to decide which treatment should be advised to the ill person. The healer then starts writing the communication that s/he has had with the spirit with a pen on a piece of paper. When a healer made a talisman for me, he would write 'in the name of God' followed by eight lines of incomprehensive words and letters, ending with 'in the name of God'. He then copied the communication on another piece of paper with a coloured water-dissolvable pen. While the first piece of paper was to be put under my pillow at night, the second was to be put in a glass of water, with a lid on top, so the letters could be dissolved but the power would not disappear. The next three nights I should wash myself in the water. These papers are called *ḥijāb*, meaning veiled, concealed or hidden. They mediate between the spirits and the world of the humans to protect against harm. Other healers suggest that the pieces of paper be put in a necklace or sewn into clothes.

Non-scripture amulets, such as the blue stone, as well as scripture amulets such as the silver coins and *ḥijāb*, are controversial. Some Islamic scholars argue that a reliance on amulets and talismans as protective technologies is heresy, since these objects' efficacy is based on magic (Owusu-Ansah 1991: 25–40). This is the view often taken in Beidha today, particularly among the men; however, this is a recent development. Many women still persist in using such items.

Amulets with Koran inscription are intended to assist Muslims in daily life; on its own, the inscription is often considered a preventive material form (e.g. blue stones, cloves, silver, mirrors, etc., or combinations of different healing stones). The inscription increases the protective powers of the object. The effectiveness of the amulet and talisman relies upon the reifying power of Koranic speech and the physical transmission of Koranic blessing (O'Connor 2004: 164).

Talismans, on the other hand, are produced to fulfil a specific temporary function, such as curing an illness, creating success in a transaction or causing good fortune. They are in a sense more temporary than other scriptural objects, since the paper they are written on quickly tears or wears out. The paper is normally either put in a pocket or sewn into clothes. One example of a talisman's perceived powers from my fieldwork was a young man who suspected another man of using such an amulet to make a girl fall in love with the other man instead of him, as she had suddenly changed in her feelings towards him.

In Beidha, almost all interlocutors publicly denounced such talismanic practices as illicit magic and polytheism (*shirk*). Most people considered the Koranic talisman illicit magic (*siḥr ḥarām*). Sometimes interlocutors denoted the maker of such objects as *musha'widh*, or sorcerers, and so part of past ignorance and heresy. And yet, there are many healers that one can visit, particularly in Wadi Mousa, who create talismans. Thus, displaying or adhering to certain protective strategies is socially potent since such practices can ostracise and exclude people, but at the same time, may also be a fairly normal practice, even if not publicly announced. At the extreme end of the allegations of black magic are the kind of practices that make no claim or reference to Islamic tradition, but are directly considered as black magic, even by the healer, who calls upon spirits to do harm. This is a much more delicate matter, and I only heard of one person practising it in the area. When I interviewed him, he was not proud of it, and claimed that he had now abandoned the practice, even if he could still explain how to do it in detail.

The problem with the Koranic talisman, according to interlocutors, is that its use is instrumental, and such items rely on the material instead of upon remembrance of the 'Word of God'. In other words, the problem is not that the words are on objects worn or associated with the body, as 'repositories of power' (Tambiah 1984: 335), but that they could not be read and thus actively remind one of God.

Another problem for the interlocutors is that the words of God were perhaps altered in the process, cut short or taken out of context, or even worn in impure places such as toilets, which shows disrespect

for God. A recent episode illustrates this point: a *fatwā*, or religious ruling, by the Islamic Jurisprudence Council in Saudi Arabia, in collaboration with several Egyptian religious leaders, prohibited the use of verses from the Koran as ring tones on mobile telephones. The sudden interruption of a verse, or recitation (ringing) in impure places, 'harms' the Koran.

Both amulets and talismans are thought to rely on the proximate presence of the materialised 'Word of God' as *being-in-place* in order to protect, and not upon the affecting presence of the word of God as *being-in-touch*. Thus, at least to the degree the interlocutors wanted to talk about it, Koranic talismans and amulets are considered un-Islamic, even at times illicit magic, and so they do not use them – or at least they will not state that they do. They know such objects exist, however, and they know that a *sheikh* in Wadi Mousa makes them and that such items were once employed in the area.

The Ambiguous Materiality of Koranic Healing

As illustrated above, when it comes to healing, the Ammarin do not just 'throw the baby out with the bath water', just because modern medicine is readily available or because religious authorities have their solutions to healing. Most interlocutors recognise that modern medicine has certain advantages over other healing practices in controlling adverse or counterproductive effects through measured dosage. On the other hand, Koranic healing may, for example, be efficient for some illnesses, particularly when concerned with mental problems (cf. Al-Krenawi and Graham 1996, 1997, 1999).

While some of the healing practices presented here are only practiced marginally today in the villages around Petra, they are still part of the collective memory. Many interlocutors still rely upon common knowledge of the healing properties of certain animals, plants and stones that have been passed down for generations, when their illness is not too severe. The knowledge of how these things were used in the past is considered an important aspect of their specific cultural heritage of interacting in the landscape. A statistical study of the impact of tourism in the Petra region (Nasser and al-Khairi 2003: 104)[13] includes one section on medicine and illness. Presented with the question: 'If you or your family were sick where would you go?', the answers show to what extent age-old local practices persist, and how they are used in combination with new ones:[14] 100 per cent in Beidha, and 85.2 per cent in Wadi Mousa would go to the hospital; 37.5 per cent in Beidha, and

2.6 per cent in Wadi Mousa would use local (herbal) medicine; 6.2 per cent in Beidha, and 0.3 per cent in Wadi Mousa would use a sheikh/clairvoyant; no one in Beidha, and 22.5 per cent in Wadi Mousa would use a private doctor. Thus, there is a clear difference in use between the city of Wadi Mousa and the village of Beidha. People in Beidha are more open to using customary healing methods.

The Bedouin doctor in Beidha is a woman aged around sixty.[15] She is the one who knows most about herbal medicine and other Bedouin skills relating to nomadic life, such as weaving, storytelling and animal husbandry. While she is highly respected for her skills and knowledge, her reputation among some people is somewhat dubious, since men will also come alone to her house at night for healing. She is unmarried, has been divorced once and one of her sons has shamed the family by having been in prison for the wrong reason (the 'right reasons' may include for securing the honour of the family, even if illegal). Furthermore, she uses many, if not all, of the non-Koranic protection strategies discussed in Chapter 5. Her public position is thus ambiguous. She falls between being a highly respected elder with extensive knowledge of self-reliant Bedouin practices, and also part of the older generation of people who are less educated in the Koranic scriptures. Yet she is also respected in that she does not accept money for her healing as she considers these skills a manifestation of divine blessing.

Most patients come for treatment against the evil eye or because of her extensive knowledge of herbal medicine. For example, people come to her for her expertise in treatment with fire, and for treatment against the evil eye using black cumin and alum. To heal against the evil eye or harm from the *jinn*, she heats a nail in the fire, takes a small bowl with cold water and turns it around the head of the patient three times while reciting the opening chapter of the Koran; she then places the nail in the bowl with water, it apparently makes a loud sound, at which point she utters '*al-ḥamdu lillāh*' and the evil disappears. Another way is to burn incense (*bakhūr*) to prevent the *jinn* from harming you; this also works as a cure and relief if suffering from illness. In some cases, people would still burn incense at the place where they accidentally fell. Incense can also be burned in front of a house, by taking lit charcoal, putting incense on it and then throwing salt on it to eliminate all magic. It is sometimes believed that in the afternoon, when children run around and accidentally fall, they have upset the *jinn*, and so thereafter some interlocutors would put incense on the fire to promote healing. Today, however, my interlocutors would argue, the use of incense is fairly limited in comparison to earlier times.

One of her specialities is called *kawī* (meaning: iron, also *kayy*; see Sincich 2002). *Kawī* is treatment against the evil eye, diseases and pains, with fire. The techniques and purposes resemble Chinese moxibustion. She uses *qreʿ*,[16] or a heated nail for cauterisation. She argues that it 'cuts' inside the body, and it leaves a scar on the place of burning, usually the stomach. If the pain continues after treatment, it should be repeated. She collects and dries the *qreʿ* in spring and rubs it until it becomes like cotton, and then places a small pellet on the stomach and ignites it, uttering '*al-ḥamdu lillāh*' (the will of God), thereby once again linking herbal medicine and fire with the powers of God.[17]

Another act of scarring and piercing the skin is 'getting the bad blood out' (called *ḥujāma*). When a person is continuously tired, a small hole is cut in the neck of the person to get 'thick' blood out. When a small cut is made behind the earlobe to remove the 'old' blood, it is called *Umm al-ḥalūq*. With reference to the acts of Prophet Muhammad, it was argued that it should be done twice a year. It is considered potent medicine to leave scars, to pierce the skin and to 'get the bad blood out' by using fire-heated nails on specific places, and most men and women will have several scars on their body.

However, the most practiced way to deal with a patient suffering from the evil eye is to use alum (*shabb*). The act of using alum is called '*tunquth*' (curing) and is used to diagnose whether a person has been touched by the evil eye and what the source of the evil eye might be. The healer listens to the symptoms, which are usually weakness, tiredness, headaches and concerns about everything. The many healers around Petra make use of objects, plants and minerals, many of which gain their power from their particular material composition and the resultant material transformation, proving efficacy. I met one such healer, a blind Bedouin woman, in her home around Petra for an interview about treatments against the evil eye. She started her treatment of the evil eye by breaking a piece of alum into three, designating 'this is for the man, this is for the woman, and this is for the land'. She then positioned them in front of my forehead, moving them in circles while invoking God:

> The hand of God is faster than my hand. By the name of God. One by the name. Two by the name. Three by the name. Four by the name. Five by the name. Six by the name. Seven by the name. Hitting you back all month. From female or male. By the name of God. (Opening verse from the Koran) In the Name of God, the Most Beneficent, the Most Merciful. All appreciation, gratefulness and thankfulness are to Allāh alone, Lord

of the Worlds. The Most Beneficent, the Most Merciful. The Possessor of the Day of Recompense. You we worship, and You we seek help. Direct all of us to the Straight Path. The Way of those on whom You have bestowed Your Grace, not of those who have earned Your Anger, nor of those who have lost their way and are astray.

This practice would remove the bad energy from my body caused by the evil eye. Quite physically, the alum would absorb the envy. Then her daughter took the alum pieces and put them in the fireplace, only to return a short while later. They had completely altered shape and the healer now took them in her hands and started judging their shape: one represented a woman, one a man and one my land. The land, she said, had no problems, but there was a woman who had given me an envious look, as well as a man sitting in a chair, as she deducted from the alum piece. After this the stones were crushed – completely pulverised, whereby the malevolent energy contained within the mineral after their contact with my forehead would disappear. After treatment with black cumin, the patient will recover. Attribution of general responsibility is thus materialised in the interplay between fire and alum. This treatment is not based on her personal skills, as such, but more on the ability to invoke God through recitation in order to effectuate the materiality of the alum to contain the envy.

Another oft-used healing practice in Beidha is *al-ruqiyya*: 'drinking the Word of God'. Some come to the doctor, while others do it themselves. The cure consists of a glass of water, which may also contain black cumin or honey. Someone would then utter verses from the Koran immediately on top of the glass or bottle of water, which the patient is then prescribed to drink from a number of times the following days, effecting a cure. This is one of the clearest examples of how matter is spiritualised and spirit materialised in Beidha. This cure finds legitimacy in the practices of Prophet Muhammad, who performed this with good effect on an ill man. In the Ammarin museum, it is described as a verse from the Koran written on a piece of paper, which is then put in water and drunk. It is also referred to in many other places in the ethnographic literature, where many of the above-mentioned practices carried out throughout the Middle East and Northern Africa, are described, although at times under different names. One example is in Abdullahi Osman El-Tom's (1985) study of the Berti religious practices in Sudan, where it is described as 'erasure' (*al-mibaya*). The justification in Beidha is the same:

> The Koran is regarded as containing divine power; thus, to possess the Koranic texts renders an individual powerful and protects him

against misfortunes and malevolent forces. The highest form of the possession of the Koran is its commitment to memory, which amounts to its internalization in the head, the superior part of the body, whence it can be instantly reproduced by recitation. But the Koran can also be internalized in the body by being drunk. Although drinking the Koran is seen as being far less effective than memorizing it, it is superior to carrying it on the body through the use of amulets. (1985: 416)

These types of practices have been described as 'Koranic tincture' – as the infusion of Koranic content and methods of discourse (O'Connor 2004: 176). In other words, 'drinking the Word of God' relies upon the materialisation of the *Baraka* achieved by recitation, where water becomes a physical 'residuum' of Koranic *Baraka* (O'Connor 2004: 174). In Sudan, such Koranic practices include thrashing the patient with palm leaves inscribed with Koranic scripture; *al-bakhra* (incense burning, and inhaling while reciting the Koran); *al-ʿazima* (the spitting cure) where a *faki* (healer) recites the Koran and spits or distribute his spit mixed in water on the patient (see also Warnier 2006: 188–89 on practices among non-Muslims); the *al-ruqiyya* (drinking the Koran); and the *al-mibaya* (erasure). Similarly, Beth Donaldson describes that, by pouring water on the cover of the Koran and by letting it drop into a bowl from each corner, the water is transformed and will possess the divine power to remove evil (Donaldson 1937: 266).

The various registers of healing described above show how they, like other protective traditions, apply various ranges of material logics: from the infusion of herbs, to physically cutting the skin or scarring the body, to ephemeral properties of incense, to internalisation by drinking 'words', or combinations of aspects of the above. The logic of efficacy relies on the perceptions of materiality and the recognition that each strategy affects in a different way that does not require overlap in the understanding of material efficacy with another practice.

By retaining this knowledge, the healer becomes the personification of Bedouin skills in a setting that only bears a remote resemblance to the traditional tent life. For the healer, the potency of her healing is in the internalisation, either by drinking the Koran, scarring or by reading causation in the alum. She is not considered a magician, as she does not write talismans, but her practices teeter on the border between emblazoning a Bedouin heritage and reproducing un-Islamic practices, since she uses blue stones, guard, *kbass* and many other problematic items described in the previous chapter, both for herself and others. Thus, inherent in the practice of healing is an ambivalence in finding a balance between what is healing or protecting, and what is considered the socially approved way of healing or protecting.

Relative Materialities

The point of this chapter has been to explore the problematic processes of matter being spiritualised and spirit being materialised. Together with the previous chapter, the aim has been to show how that which is proclaimed heritage by some is practiced, contested or adapted to new contexts among the Bedouin. The materialisation of divine words is used in many different aspects of the everyday material infrastructure to bless and protect people and spaces. By focusing on the perception of the 'Word of God' in everyday life and practice, it is possible to observe how 'as Islam's most religiously authoritative, rigorously liturgical, and legally conservative source, the Koran also comes down to the present as Islam's most intimately negotiated, vernacularly creative, and magically effective venue of religious action' (O'Connor 2004: 166).

Classifying, transforming and using ideas of whatever constitutes 'matter' as a protective strategy is not only ambiguous in this context; it is also a way of showing and reaffirming alternative identities and religious awareness. Perhaps even more importantly, by partly denying the physical properties of the 'Word of God' (at least in terms of any binary opposition between materiality and immateriality), people are reaffirming their reluctance to rely on materials for protection by transforming a thing into something conceptually 'less material' through the application of Koranic scripture. The anti-material ideals of divine presence through material absence are thus achieved by a cultural reformulation of what constitutes matter and efficacy.

For the Ammarin, the question of the materiality of protection is thus one of understanding various modalities of presence and absence. The socially entangled nature of the diverging strategies of protection has led to current attempts to dissociate oneself from materialism in order to avoid allegations of backwardness and heresy on account of the perceived superiority of immateriality. To Ibrahim, the black cumin was complementary to the Words of God, indeed legitimised by the Prophet as efficacious, as they fulfilled different modalities of presence. The use of the black cumin was based on knowledge of what his Bedouin forefathers had been using for generations with Islamic reference, and a way of life and cultural identity that Ibrahim and others like him feel increasingly alienated from today. The objects are markers of cultural identities. More than this, through the very properties of the materials, he is convinced of the efficacy of the amulets by the physics of absorption and the deflective properties of the flint against the physicality of the evil eye.

On the other hand, a different solidarity and way of belonging as a modern enlightened Muslim is presented by the efficacy of experiencing the presence of God through 'immaterial things'. The Koranic frames and merchandise are also markers of identity, but rather than marking Bedouin roots, they mark solidarity with a moral and religious identity which focuses more on being Muslim, in a very distinct matter. Ibrahim wanted both, and to him the two ways of materialising protective efficacy were not mutually exclusive. Ahmed, on the other hand, would have none of this and wanted instead explicitly to 'forget all the materials'. From a material perspective, obviously, he did not fully comply with this, but in an emic perspective, he did so by making use of Koranic objects classified as 'immaterial things'; not exactly a thing, but not immaterial either, rather both – conjoining material and immaterial, a presence through the absence of a certain kind of material efficacy.

Rather than describing a result of social change, the protective objects are mechanisms of change. The objects both describe and act as a social display of the means of coming to terms with vulnerability, physicality of envy and experiencing the divine, as well as part of negotiating a post-nomadic identity through links to traditions. Thus, in terms of achieving *Baraka* through reciting, remembering and surrounding oneself with things, the words of God, as immaterial things, suffice. Hence, investigating everyday conceptualisations of presence and absence reveals how such seemingly oppositional concepts, as a cultural phenomenon, have both ontological and epistemological implications, as well as confirming the sense of nostalgia relating to a rapidly changing Bedouin culture.

The 'Word of God' facilitates a continuous manifestation of the protective efficacy of divine speech by actively inspiring remembrance, and by instantiating the inherent *Baraka* of the words. However, the applications of the words, particularly to architecture, could be understood as a potential mechanical abuse, because the 'Word of God' is being used instrumentally rather than for remembrance and reflection. If one were to follow the interlocutor's words, that 'When a house has Koran in it, no harm will enter it', it could simply be seen as a different version of presenting the efficacy of the blue stone. Yet there is a marked difference, even for that interlocutor, in that the non-scripture amulets, such as the blue stones discussed in the previous chapter, are 'centripetal'. Their efficacy relies on their ability to make the evil eye move towards the protective object. The words of God, on the other hand, have powerful *Baraka* that is 'ecstatic' or 'centrifugal'. Their efficacy relies on moving or spreading away from the object.

The Koran verses protect by rendering it impossible for the evil eye (or the *jinn* for that matter) to 'touch' within the space the 'Word of God' inhabits, either physically or mentally. The 'Word of God', in any form, emanates *Baraka* and divine power. Thus, the efficacy of the 'Word of God' relies on the words' ability to transcend themselves. In their repetitive applications to the houses in Beidha, they become significant parts of daily life and enhance feelings of security. Repetition conveys an understanding of the continuous presence of God, and through an ocular (Koran frames) and audio-centric (public prayer) sensorium, they are constant reminders of God. Through the *Baraka*, presenced by the 'Word of God', they create an intimate sense of *being-in-touch* with and close to God.

This particular strategy of protection applies an ecstatic material register of efficacy by centripetally spreading its presence onto the world, thereby continuously asserting its own existence. This register of efficacy employs objects and events that 'in any given culture are accepted by those native to that culture as being purposefully concerned with potency, emotions, values, and states of being or experience – all, in a clear sense, *powers*' (Armstrong 1971: 4, emphasis in original). Yet, as much as such assertions of affecting presence of protective objects are culturally invested with potency, they are also material manifestations entangled in social negotiations of reputation and religious awareness.

In other words, the clear separation between what is materially and immaterially manifest, particularly in terms of the 'Word of God' as an efficacious protective strategy, is indeed a matter of perspective. The Arabic Koran is – and not just represents – the 'Word of God'; it is an 'immaterial thing' that instantiates God in hearts and minds. The 'Word of God' is used to invoke divine power, blessing and protection by applying it on other things, such as decorative frames that then become imbued with divine presence by either emanating *Baraka* or by being a catalyst for remembering through the shaping of a presence in absence. The Koranic frames and the application of God's words therefore do not only transfer meaning; they also presence divine essence.

The notion of 'relative materiality' developed by Mike Rowlands (2005) suggests, in this case, that technologies of seeking providence highlight how some things are 'more' (and irreducibly so) or 'less' material, and how these may be complementary protective strategies depending on the perception of the propriety of using materials against envy. As Bill Maurer (2005) argues, the words are neither considered material nor ideational, but 'both and neither'. The application of the 'Word of God', I argue, transforms an otherwise mundane object into

an 'immaterial thing' and in terms of its relative materiality emphasises an immaterial source of protection (cf. Buchli 2016). The notion of 'immaterial thing' is thus not just a conceptual riddle of oxymoronic classifications, as the 'both and neither' statement may insinuate. Instead, it relates to the sensuous engagement with the ontology and adjacency of things and their affecting presence 'asserting their own being' (Armstrong 1971: 25). The riddles are real: 'Drinking the Koran', the use of the word 'Koran' as 'recitation' to describe a book, or as with Ibrahim, who, instead of saying 'decoration with written Koranic words', describes his car decoration as 'There is no god but God'. These are examples of the cultural practice and reality of such oxymoronic classifications.

Knowing the Modalities of Presence

As well as drawing our attention to ignorance and the social evaluations it takes part in, Dilley (2010) also points out that we need to distinguish between 'ignorance' and 'nescience' – even if the word ignorance today covers both meanings. Ignorance, Dilley argues, from its etymology means 'not knowing by the senses'. In contrast, nescience etymologically means 'not knowing by the mind'. Being protected by the words of God is not conceived in sensuous terms, but in terms of an internalised and affecting presence as *being-in-touch*, whereas the deflection and absorption are precisely sensuous encounters – corporeal encounters of *being-in-place*.

By following this strategy, Ibrahim can simultaneously use the black cumin bag in his car and indicate adherence to the authority of the past Bedouin knowledge and practice, as well as using the 'Word of God'. What is important for these strategies to co-exist is that they employ appositional modalities of presence, i.e. there are no imbrications between the centripetal physics of the blue stone and the centrifugal 'Word of God' emanating *Baraka* as an 'immaterial thing'. However, saint intercession overlaps by instantiating ecstatic *Baraka* through intermediary personages, relics and graves. Such practice is problematic, given the spread of a universalising Islamic teaching, and has mostly been abandoned. Understanding these different strategies of taming presence is thus a matter of understanding the appositions and imbrications of their efficacy. This highlights a clear juxtaposition between an elite and folk Islam that in everyday life is a bit more blurred and which offers fertile grounds to negotiate

social and religious identities. The relationship between materiality and immateriality discussed here thus points to the way in which, in practice, they employ a wide spectrum of conceptualisations that may materialise, or shape, an intentional absence that lies at the forefront of the definition and public exposure of the performance of 'Bedouinity' and religiosity.

Notes

1. Parts of this chapter were published in Bille (2010).
2. Such as the four or five girls who go to Wadi Mousa or Umm Sayhoun for secondary schooling or the four or five women who sometimes work in the shops in the tourist area, if the men have other appointments.
3. Interestingly, the use of the veil is not exclusively explained in terms of religious prescriptions. For the three female interlocutors I spoke to about wearing the veil, two of the three reasons given were in a sense 'non-religious'; to protect the skin from a suntan; and to protect their honour from other Arab men. The first reason could be explained in terms of suntanned skin being a symbol of having to do hard work, such as herding the goats all day, hence showing that the husband was not prosperous and successful enough for his wife not to work. The second reason, related to honour and the role of sexuality in the public sphere (Abu-Lughod 1986), was striking in a tourist area, where a woman may sit for half a day with the face-veil lifted above the head when only other Ammarin and non-Arab tourists were around, but as soon as an Arab family came, she would pull down the *niqāb*, so as not to expose her face.
4. One particular prayer among the Ammarin is the prayer for the dead. When *samn* (clarified butter) is made from goat's milk in any of the households, it is customary to invite people for the first meal. After this meal people perform a prayer for the souls of the dead.
5. A note here is that the Koran talks about itself as *kitāb*, meaning 'book', but this does not necessarily imply a material form, as even in its immaterial form in Paradise before its revelation, it was a 'book'.
6. One of the major religious festivals celebrated as commemoration of Prophet Ibrahim's (Abraham) willingness to sacrifice his son Ismael to God.
7. *da'wa*: the religious duty for every Muslim to spread the word.
8. An example of the material and liturgical connections could be the enamelled and gilded glass lamps from Mamluk buildings inscribed with the light verse (Soucek 2004: 311).
9. The normal *barawāz* cost about 3–5JD, while more elaborate and expensive ones are rare in Beidha, and can mainly be found in the local Sheikh's house.
10. Erica Dodd and Shereen Khairullah argue that Koranic citations are a way of coping with the prohibition of the image. Rather than being a remnant

of Bedouin superstition, or a reflection of Jewish or Christian influences, they argue, it is the outcome and reflection on a long tradition of pagan, Christian and Jewish scholarship (Dodd and Khairullah 1981: 18; see also Starrett 1995: 60–61).

11. The historical use and design of jewellery and amulets are discussed in detail by Sheila Weir (1976) and Annagret Nippa (2005) with material that extends up until the mid-twentieth century.

12. Coming from *ḥajaba*, meaning to veil, disguise, to be hidden, used for both the veil and the amulet.

13. Based on 16 people in Beidha, and 216 in Wadi Mousa.

14. A question, however, that is vulnerable to cultural understandings of what counts as illness.

15. The Ammarin consult five types of healers: 1) the doctor with a modern university education in medicine; 2) the Bedouin doctor (*ṭabīb/ṭabība*) who uses medicine from herbs and animals, cauterisation and healing stones; 3) the *faqīr*, a person (dead or alive) considered to be particularly blessed by God, whose healing properties are based on Baraka (blessing) emanating from him; 4) the *khaṭīb* (sometimes referred to as sheikh), a Koranic healer who uses knowledge from the Koran; and 5) the *musha'widh* ('clairvoyant' or 'sorcerer'), a highly controversial person, who uses the Koran in the 'wrong way', contacts the *jinn* or uses illicit magic in his/her practices. Depending on the context, the *khaṭīb* is known by some as *musha'widh*. Three of these are present to some extent among the Ammarin in Beidha. First, there is a medical clinic, which is attended by a nurse. It has an ambulance that comes to the village a few times a week to take the ill to a medical doctor in Wadi Mousa. Second, most people who live in Beidha claim descent from the deceased saint Salam Awwaḍ, who was considered a *faqīr*. People would visit his grave near Bir Maḍkur in Wadi Araba. Third, the village has a local Bedouin doctor. She married into the Ammarin tribe, although she was born into the Bdoul.

16. It was unclear which plant was actually used. I showed one of my healer interlocutors a picture from a field guide to plants (Ruben and Disi 2006: 60); she recognized it as African Fleabane, Phagnalon rupestre. However, Rami Sajdi lists it as coming from 'the Artemisis moxa plant' (Sajdi 2007: 221), i.e. from the wormwood family, of which only Artemisia herba-alba and Artemisia judaica grow in the area.

17. However, neither she, nor anyone else in the area, performs the ritual of *bisha'a*. Most people know that it was used to prove innocence, if someone was accused of misconduct or lying about it. The practice is now illegal in Jordan, but when disputes cannot be sufficiently resolved by the official legal system, people will in rare cases travel to Egypt to turn to *bisha'a*. A specially trained person, the *mubisha'*, heats a metal spoon, and puts it on the tongue of the accused. He then inspects the tongue to look for burn marks – which indicate guilt – and the case is solved. As one can perhaps guess, this is also a matter of showing courage and honour.

৯◉ Conclusion

Introduction

As a Bedouin saying goes, 'Protection is a way to gain honour' (*ad-dakhāla dawwārit ʿizz*) (Bailey 2004: 175). This is more than simply a saying; this book illustrates how the Ammarin frame everyday life – and how their lives are framed – through protection practices that in effect connect everyday life with formal, informal, Islamic, national and international notions of heritage and its contestation. One of the points of protection, it is argued – and that includes international heritage protection – is to announce (threats to) possession of objects of cultural value, while publicly displaying the propriety of being a 'care-taker' in the right way. Nation states across the Middle East – as everywhere else – have persistently sought to shape their legitimacy as 'modern' states through links to particular conceptions of 'traditional', 'authentic' and 'original' (Diaz-Andreu and Champion 1996; Eriksen 1993; Kohl and Fawcett 1995; Massad 2001; Mitchell 2001; Silberman 1989). Yet simultaneously, as Gilsenan (2000) argues, modernising authorities, scholars and devout believers also seek to 'rid the world of magic', as magic and enchantment are seen to mark the boundaries of modernity. This process of modernising Jordanian citizens, materialised in the settlement of the Bedouin in Beidha, is also a political project of destabilising the tribal power structures; e.g. through the implementation of government laws and officials in rural areas. Heritage, aside from cherishing and protecting cultural diversity, thus also become a vehicle for identity development and state formation.

As a product of modernity, the quest for heritage reveals a gathering of what in reality are diverse conceptualisations of the traditional, the authentic and the past. Here, the Ammarin, with their history and position in Petra, have become prime proponents for an authorised

heritage discourse. This quest for heritage finds its resources in a Bedouin past which often lacks specificity, but which encompasses camel herding, tent dwelling, raiding, and support of the royal family in establishing the state – regardless of whether that was actually the case for the specific tribes tapping into this image.

What is fascinating about the case of the Bedouin in Petra is that it is not simply a matter of top-down, or bottom-up heritage conflict or construction. Rather, the very definitions of terms such as traditional and modern are construed through the processes of taming Bedouin pasts as heritage (or not), whether it be UNESCO, Islamic, Jordanian, Bedouin, New Age or any other notion of heritage, which may not mutually exclude one another. Where the UNESCO conceptualisation of heritage aim for physical presence, the Islamic one aims for evaluating the particular quality of presence established. Formal and informal heritage recognitions, in this sense, become a quest for imagining, desiring and taming possible presences of the past. The universality of the UNESCO conceptualisation of heritage is thus not undisputed. Rather, it is situated among parallel and at times competing universalities, such as the Islamic Revival or New Age Movement, resting on questions about the role of the past and material objects in people's lives. Heritage processes here involve tackling the particular character of figures from the past and present. Is it a shaman, a saint or a sorcerer? Is the Bedouin an empirical category of nomadism, or a skill?

There is rarely a single narrative or one line of intentions and premises when it comes to the announcement or celebration of heritage. If there is, there is a good chance that alternative versions have been actively silenced. In Petra, we saw how the justification for heritage was a chance for 'reconciliation' of former injustice, or an 'effective tool to strengthen and to rebuild a wider Jordanian national identity', or to link people to allegedly ancient knowledge. What some heritage processes can achieve is to gather the gaps and overlaps of such diverse interests into a successful, yet not unproblematic, heritage nomination. That is, even though there may be contrasting intentions, they may each see their version being justified by the final announcement, even if the people in question – here the Bedouin – are in large part oblivious to both the intentions and the proclamations. The process we have seen in Jordan has been about establishing a specific presence of the Bedouin that makes sense to a wide range of actors with parallel or competing intentions. It is about justifying why these particular Bedouin are exemplary, rather than merely examples of a culture likely to be found elsewhere (cf. Højer and Bandak 2015).

The various registers of materiality and protection represented in the ethnographic accounts have illustrated how protection and the sense of being safe is not just the absence of harm, but also an active practice of employing objects, discourses, practices and histories to achieve authority and efficacy. While risk, as Douglas noted, is about blame, protection is about the duality of exposure, which creates impenetrable ties between social propriety and the objects or subjects of veneration. It is a dual sense of exposure to danger and the ability to define and deal with it in an appropriate way that unfolds, while balancing one's doubts, insecurities and ambivalences in the process.

Parallel Universalities

Two very different paradigmatic universal processes, drawing on the same temporal perspectives, dominate the case of Bedouin heritage and Islamic pasts. Since the mid-twentieth century, modernisation processes have sought to settle, educate and integrate nomads across the world into the government systems. One of the effects of this, paradoxically, was to produce a modern moral incentive to display caretaking through UNESCO for past material and cultural traditions by fiercely struggling against the effects of such modernisation processes in defending localities, spirituality, the past or indeed the universality of heritage of value to humanity.

Another universal process – likewise a product of the modern condition – seeks to abolish what is perceived to be un-Islamic acts of 'magic' occurring, for instance, through saint veneration or reliance on materialism. This is done to restore and purify the moral conditions and regimes of knowledge, to 'return' to supposedly original Islamic teachings. Contrary to UNESCO, this latter process seeks to wipe out what are seen as innovations to Islam (*bid'ah*) which have evolved since the first Islamic caliphs. The aim here is not a theological discussion of the possibility of such purification. Rather, it is an anthropological endeavour to understand what is going on. Even if 'Islamic' is written in singular, the process of purifying Islam is by no means homogenous and uncontested, as illustrated by the many discussions between members of the Ammarin tribe on what kind of knowledge counts as legitimate.

Both UNESCO and the emerging Islamic Revival thus organise the present with a reference point solidly planted in a more or less nebulous past, and thereby through political processes tame the present and the future as much as the past. Both these strategies

seek to conquer different universalities. They make other less dominant universalities come to life, as a by-product, such as the neo-shamanistic approach to linking indigenous populations across the globe through an allegedly original spirituality. Thus, throughout the book one can follow a discussion of the role of protecting, preserving or denouncing the past in the present and the way in which these processes are socially constituted and materially practiced through commitments, production, contestation and representations of certain kinds of knowledge and ignorance.

The parallel and competing claims between the Islamic revival in the rural areas, the New Age tendencies in the urban areas and the desire through UNESCO to safeguard the intangible heritage that in many ways are presenting the past rather than the present, point to an interesting reversal. It is a reversal away from what has been discussed (and critiqued) as a dichotomy between the urban elite's 'high' Islam and the rural, folk and 'low' Islam (Geertz 1968; Gellner 1981; Goldziher 1967; Lukens-Bull 1999). The Ammarin have largely dissociated themselves from 'folk Islam', which had previously characterised many rural areas, and adhered to more scriptural versions that are often associated with the educated segments of urban centres. But this is not a movement between a monolithic local Islam and a monolithic universal Islam. Rather, I have shown how the transformation displays fertile gaps between past traditions and contemporary knowledge, by highlighting the power of the presence of things. While individuals in the area may be found to personify each position in the dichotomy, there also seems to be much more room for navigating practices, each legitimised with reference to a universal source in the Koran or *ḥadīth*. Ambivalence, potentiality and ambiguity is thus filling the space between the two positions.

Furthermore, segments from the urban elite are actively trying to protect and present 'folk Islam' as authentic through Bedouin spiritual practices and relationships with nature that taps into a universal spiritual source of indigenous people, in opposition to Western influence and more dogmatic Islamic teachings. What we are seeing is the impact of spreading claims of universality at times amalgamating, at times conflicting, but most often simply running parallel with each other. Such focus oscillations between amalgamation, conflict and parallelism also offer to contribute to our understanding of the Islamic revival by highlighting how, particularly in the rural areas, the piety movement is spreading fast, with consequences in everyday life spanning from how to deal with things and the past, to how people have to position themselves in such social currents. In such a process of

more active reformulation of one's relationship with the past, there is a high degree of ambiguity and uncertainty. The material world plays a crucial role here, if only by demanding attention for people to take an active stance. This process of ridding the world of magic seeks – like settlement policies – to reformulate existing power structures of knowledge, authority and spirituality, particularly with regard to the saints. One can only protect the particular against the universal, through the very universal claims presented by UNESCO, it appears.

Rami Daher and Irene Maffi have rightly argued that cultural heritage 'cannot be divided into two separate realms – one intangible and one tangible – without losing its complexity and its internal logic' (2014b:34). While the distinction between tangible and intangible cultural heritage may act as practices of 'translation' and 'purification' (Latour 1993: 11) and thereby reaffirm a critical project of modernity, the various ethnographic accounts addressed here show that the image of being modern is only developed by ignoring the proliferation of hybrid forms – such as 'immaterial things' – or the interdependence of oral and material practices with the specificity of place – such as Jebel Haroun. The complexity also unfolds through the commitments between incompatible imaginations of spirituality, traditions and cultural identities, with the aim of producing heritage that renders multiple identity formulations possible. Even the emerging puritanical Islam could be argued to work through the same processes of purification in terms of constructing times of ignorance (*jāhiliyya*), by 'ridding the world of magic', and seeking a modern epistemology about the world – although, in the shape it is taking in Jordan it is based on different premises and objectives than Western modernity.

It is in these hybrid forms that the overlaps and gaps between the various parts show the untenable commitments to oppositions of object-subject, material-immaterial and presence-absence. While the distinctions may produce clarity in what may otherwise appear messy, they are nonetheless more entangled than separated. However, in such clearly distinctive form – at least as enforced through UNESCO – the separate orders of heritage produce effects, such as settlement as an effect of tangible heritage protection, or the reconceptualisation of the notion of Bedouin as a skill with the intangible heritage safeguarding. Like the development of an 'antimodern' puritanical Islam, a paradox emerges when the international institutionalisation, employed in efforts to protect 'the traditional' and intangible, is confronted with the results of ridding the world of magic which came about through its own efforts to protect tangible heritage.

The Meaning of Presence

One of the arguments pursued in the book is that protective practices, whether about heritage or about how to connect with God, are not only a contained, local phenomenon. It is global in the sense that international concerns over religious conduct, heritage, not to mention terror, increasingly influence and frame local ways of living. Claims to a specific morality of engaging with saint graves, along with the UNESCO wishes to safeguard these practices and places, are mixed with the emergence of new technologies such as cars, mobile phones and television, which have had a profound impact on constructing new risks. To this end, it appears that it makes little sense to create a sharp division between the particular and the universal, since they seem to feed on and feed into each other.

Furthermore, it is also ill conceived to shape a hierarchy between the different claims to universality at play. They are at times parallel, at times competing, and at times people may adhere to both, even when they seem incompatible. This is exactly the point of seeing how regimes of knowledge and ignorance are not simply about cognitive absence of knowledge, but likewise about exploring the evaluative measures they partake in. It is in the overlaps and gaps between inscribing oneself to a specific current that the productive role of ambiguity rests, which led Ibrahim to use both the existentially irreducible materiality of the cumin bag as *being-in-place*, and the elaborate Islamic merchandise resting on a different kind of affecting presence as *being-in-touch*.

Heritage protection increasingly valorises people's life-worlds by documenting, administrating and representing what are considered valuable cultural traits. Pronouncing something as cultural heritage 'always entails protecting a specific idea of the past and excluding other pasts' (Daher and Maffi 2014b: 35). According to this line of reasoning, the material world (including the paper trails, websites and museum exhibitions emerging from intangible heritage proclamations) becomes the means of defining and asserting identities, wherein heritage representations produce a certain sense of order for the past (Buchli 2002: 14). This sense of order is entangled in other processes of legitimisation of policy production and claims to roots and identity. These processes are oriented towards the future, rather than the past. In that sense, heritage is a 'metacultural production' in that it produces something new (Kirshenblatt-Gimblett 2004, 2006), which forces us to look closer at what heritage does, how it is practiced and how it materialises (see also Smith 2006).

Highlighting the various ways of dealing with protection shows how the imbrications, contiguity and adjacency of modalities of presence and absence have a strong bearing on the conceptualisations of protection and materiality. The power of the immaterial – in this case God – is often presented through things, but by emphasising the conceptually immaterial nature of the specific object, as the literal word of God, the image of not relying on materials is preserved. Ahmed's inclination to 'forget the materials' issued forth a conceptual leap to avoid 'materialism' through a break with non-textual protective strategies that utilised the physical qualities and irreducible materiality of the things. The emanating *Baraka* of the word transgresses any clear distinction between materiality and immateriality to Ahmed. God is present through the materialised words, but its efficacy relies on invoking an affecting presence that internalised and embodied remembrance.

Yet, not all were like Ahmed. The non-textual techniques that past generations had known as efficacious gained their protective properties exactly because of their physicality that effectively avoided the very tactile and physical impact of the evil eye by *being-in-place*. Thus, while one could claim that it was sufficient to rely on God alone through remembrance and the absence of materials, more was at stake in abandoning the old ways, even if they only act as a secondary means of protection. The irreducible materiality is a manifestation of links with the past and Bedouin identity; their continued use was a way of engaging with the presence of the past. Seeing presence as (at least) an existential, affecting or mediating force offers an analytical lens to explore how things are constantly tamed and framed to constitute socio-political and religious needs.

To summarise, how, and why Islamic pasts and Bedouin heritage shape identities in Jordan, this book investigated how parallel universalities are shaping and are shaped by everyday processes among the Bedouin in Petra. These universalistic ideals of how things should be present are tamed by naturalising the duality of exposure – acknowledging vulnerability and displaying propriety. While this taming process of establishing what is heritage (formal/informal, tangible/intangible or Islamic/un-Islamic) may rest on parallel universalities at a macro level, they often diverge or conflict in everyday material practices where certitude, ambiguity and ignorance are part and parcel of coping with risks. Rather than creating an *a priori* distinction between the universal and the particular, I have shown how locality and universality are performed and materialised in the process and effects of heritage proclamations. Many of these processes

rest on defining the particular way in which people, places or things are present or absent, including the uncertainties and ambivalences that erupt when seeking an ontological reduction of a messy, illogic or irrational world. What emerges is a plethora of ways of presencing the world, from identifying with and tolerating the existence of things, to ignoring or obliterating them. This has taken us from the way in which desires for presence and absence inform preservation politics and emerging post-nomad Bedouin identities, to the assembling and multiplicity of presence established by different actors in a heritage process. It has ended in a distinction between how things work by being either physically present or offering an affecting presence. In all these different kinds of presences, absence is ever lurking, since even absence may install a presence in people's lives that will need taming.

A Future for Bedouin Pasts

Although there are clearly still Bedouin living nomadic pastoral lives, any nostalgic image that would define the Bedouin as having a traditional, largely self-sufficient, nomadic way of living without modern technologies is at odds with a current life of settlement, tourism and general absorption into a modern system with taxes, cars, smartphones, electrical bills and jobs in Jordan. However, this nostalgia, present among Bedouin themselves, Westerners and Arabs alike, often adheres to the banality of difference (Kirshenblatt-Gimblett 1991: 433), wherein the Bedouin in Petra have been living semi-nomadic lives, moving over a fairly short vertical distance from the plateau to the valley rearing goats, while living in caves, houses or tents. It is important to note that settlement may not be a one-way process, as people also at times, either for economic, climatic or personal reasons, move into the desert in tents again – even if only temporarily – a few hundred metres from the villages. There is no doubt that in the last few decades the very notion of being Bedouin has changed and has become a term used to describe both primitive behaviour, as well as the backbone of a national heritage. The place of the Bedouin in the national narrative has long been debated and contested, and the particular form of representation has continuously changed (Al-Mahadin 2007a, 2007b; Daher 2007b; Maffi 2002, 2011, 2014; Massad 2001). The broader question remains of how the figure of the Bedouin (rather than their actuality), their objects and practices, are employed in narratives of identity, and in that very process, become important to some and contested by others.

A final word of more speculative character perhaps needs to be added on the future role of the Bedouin in Jordan. Since the Arab uprising, southern Jordan has been balancing on a fine edge. The more Saudi-friendly tribes around Maʿan have been under intense surveillance, as they have often previously challenged the ruling powers to promote a more Islamic agenda. With the economic challenges increasing as tourism drops, people in southern Jordan are becoming increasingly frustrated about the lack of possibilities. Changes to the economic privileges have, among other things, resulted in great distrust towards the government.

In 2011, many of the Bedouin tribes in Jordan were frustrated that the government sought to privatise territories that the Bedouin had had the right to use since Ottoman times: the so-called *wajihat*. This was seen as a degradation of the privileges of the Bedouin as part of political and economic reforms. But, while the uprising and frustration seemed to be directed at both the government and the Royal family, particularly Queen Rania, other Bedouin have also insisted that there was no need to swear loyalty to the king, since this loyalty was never lacking to begin with. The link between the Bedouin tribes and the Jordanian monarchy is thus reasserted, even if it is balancing on a fine edge. The question, however, is how far the uprisings in Syria and expansions or effects of the so-called 'Islamic State' are able to destabilise Jordan, either by threatening the tribes at the borders, or by convincing people of their call to join. In either case, the destruction of heritage sites in light of the spread of the so-called Islamic State only confirms that, indeed, there is more than one notion of heritage at play, and the particular presence or absence of the material world is at the heart of defining what it is.

ᚱ References

Abu-Khafajah, S. 2010. 'Meaning-making and Cultural Heritage in Jordan: the Local Community, the Contexts and the Archaeological Sites in Khreibt al-Suq', *International Journal of Heritage Studies* 16: 123–39.

Abu-Lughod, L. 1986. *Veiled Sentiments: Honor and Poetry in a Bedouin Society*. (1999th edition). Berkeley: University of California Press.

———. 1993. *Writing Women's Worlds: Bedouin Stories*. London: University of California Press.

Abu-Rabia, A. 1983. *Folk Medicine among the Bedouin Tribes in the Negev*. Sede Boqer: Ben-Gurion University of the Negev, Social Studies Center, Blaustein Institute for Desert Research.

———. 1994. *The Negev Bedouin and Livestock Rearing: Social, Economic and Political Aspects*. Oxford and Providence, RI: Berg.

———. 2001. *Bedouin Century: Education and Development among the Negev Tribes in the Twentieth Century*. New York: Berghahn.

———. 2005a. 'The Evil Eye and Cultural Beliefs among the Bedouin Tribes of the Negev, Middle East', *Folklore* 116: 241–54.

———. 2005b. 'Herbs as a Food and Medicine Source in Palestine', *Asian Pacific Journal of Cancer Prevention* 6: 404–407.

———. 2007. 'Nabi Musa: A Common Weli between Bedouin and Fellahin', in E.J. van der Steen and B.A. Saidel (eds), *On the Fringe of Society: Archaeological and Ethnoarchaeological Perspectives on Pastoral and Agricultural Societies*. Oxford: BAR International Series, pp. 9–18.

———. 2015. *Indigenous Medicine Among the Bedouin in the Middle East*. New York: Berghahn.

Abu-Saad, I. 1991. 'Towards an Understanding of Minority Education in Israel – the Case of the Bedouin Arabs of the Negev', *Comparative Education* 27: 235–42.

Abu-Zahra, N. 1988. 'The Rain Rituals as Rites of Spiritual Passage', *International Journal of Middle East Studies* 20: 507–29.

Addison, E. 2004. 'The Roads to Ruins: Accessing Islamic Heritage in Jordan', in Y. Rowan and U. Baram (eds), *Marketing Heritage. Archaeology and the Consumption of the Past*. Walnut Creek, CA: Altamira Press, pp. 229–47.

———. 2005. 'Political Effluent: Implementing Wastewater Re-Use in Wadi Musa, Jordan', *Arid Lands Newsletter* 57.

———. 2006. 'Documenting Deforestation at Sidd al-Ahmar, Petra Region, Jordan'. Unpublished master thesis, University of Arizona.

Agamben, G. 1999. *Potentialities: Collected Essays in Philosophy*. Stanford, CA: Stanford University Press.

Ahmad, Y. 2006. 'The Scope and Definitions of Heritage: From Tangible to Intangible', *International Journal of Heritage Studies* 12: 292–300.

Al-Amaren, T. 2015. 'Safeguarding 'Cognitive Heritage': Case Studies in Bedouin Heritage in the Petra Region, Jordan'. Unpublished master thesis, Cottbus, Germany.

Al-Hasanat, S.A. and A.S. Hyasat. 2011. 'Sociocultural Impacts of Tourism on the Local Community in Petra, Jordan', *Jordan Journal of Social Sciences* 4: 144–58.

Al-Krenawi, A., J.I. Graham and B. Maoz. 1996. 'The Healing Significance of the Negev's Bedouin Dervish', *Science* 43: 13–21.

Al-Krenawi, A. and J. R. Graham. 1996. 'Social Work and Traditional Healing Rituals Among the Bedouin of the Negev, Israel', *International Social Work* 39: 177–88.

———. 1997. 'Spirit Possession and Exorcism in the Treatment of a Bedouin Psychiatric Patient', *Clinical Social Work Journal* 25: 211–22.

———. 1999. 'Social Work and Koranic Mental Health Healers', *International Social Work* 42: 53–65.

Al-Mahadin, S. 2007a. 'Tourism and Power Relations in Jordan: Contested Discourses and Semiotic Shifts', in R.F. Daher (ed.), *Tourism in the Middle East. Continuity, Change and Transformation*. Clevedon: Channel View Publications, pp. 308–25.

———. 2007b. 'An Economy of Legitimating Discourses: the Invention of the Bedouin and Petra as National Signifiers in Jordan', *Critical Arts* 21: 86–105.

Al-Salameen, Z. and H. Falahat. 2009. 'Religious Practices and Beliefs in Wadi Mousa Between late 19th and early 20th Centuries', *Jordan Journal of History and Archaeology* 3: 175–204.

Al-Sekhaneh, W. 2005. *The Bedouin of Northern Jordan: Kinship, Cosmology and Ritual Exchange*. Berlin: Wissenschaftlicher Verlag Berlin.

Albera, D. and M. Couroucl (eds). 2012. *Sharing Sacred Spaces in the Mediterranean:Christians, Muslims, and Jews at Shrines and Sanctuaries*. Bloomington: Indiana University Press.

Alivizatou, M. 2012. *Intangible Heritage and the Museum New Perspectives on Cultural Preservation*. Walnut Creek, CA: Left Coast Press, Inc.

Anderson, B. 2005. *Nationalist Voices in Jordan*. Austin: University of Texas Press.

———. 2007. 'Jordan: Prescription for Obedience and Conformity', in E.A. Doumato and G. Starrett (eds), *Teaching Islam: Textbooks and Religion in the Middle East*. London: Lynne Rienner Publishers, pp. 71–88.

Angel, C.C. 2012. 'The B'doul and Umm Sayhoun: Culture, Geography, and Tourism', in D.C. Comer (ed.), *Tourism and Archaeological Heritage Management at Petra: Driver to Development or Destruction*. New York: Springer, pp. 105–11.

Antoun, R.T. 1989. *Muslim Preacher in the Modern World*. Princeton, NJ: Princeton University Press.

Armstrong, R.P. 1971. *The Affecting Presence: An Essay in Humanistic Anthropology.* Chicago, IL: University of Illinois Press.

Asad, T. 1986. *The Idea of an Anthropology of Islam.* Washington: Georgetown University.

Ayad, C. 1999. 'Petra's New Invaders', *The UNESCO Courier* July/August, 40–42.

Bailey, C. 2004. *A Culture of Desert Survival: Bedouin Proverbs from Sinai and the Negev.* New Haven, CT: Yale University Press.

Bailey, C. and A. Danin. 1981. 'Bedouin Plant Utilization in Sinai and the Negev', *Economic Botany* 35: 145–62.

Bandak, A. and M. Bille. 2013. 'Introduction: Sainthood in Fragile States', in A. Bandak and M. Bille (eds), *Politics of Worship in Contemporary Middle East: Sainthood in Fragile States.* Leiden: Brill Publishers, pp. 1–29.

Banning, E.B. and I. Köhler-Rollefson. 1992. 'Ethnographic Lessons for the Pastoral Past: Camp Locations and Material Remains near Beidha, Southern Jordan', in O. Bar-Yosef and M. Khazanov (eds), *Pastoralism in the Levant: Archaeological Materials in Anthropological Perspective.* Madison, WI: Prehistory Press, pp.181–204.

Baumgarten, J. 2011. *Die Ammarin: Beduinen in Jordanien Zwishen Stamm und Staat.* Würzburg: Ergon Verlag.

Bendix, R. 2009. 'Heritage Between Economy and Politics: An Assessment from the Perspective of Cultural Anthropology', in L. Smith and N. Akagawa (eds), *Intangible Heritage.* Abingdon: Routledge, pp. 253–69.

Bienkowski, P. 1985. 'New Caves for Old: Bedouin Architecture in Petra', *World Archaeology* 17: 149–60.

Bienkowski, P. and B. Chlebik. 1991. 'Changing Places: Architecture and Spatial Organization of the Bedul in Petra'. *Levant* 23: 147–80.

Bille, M. 2010. 'Seeking Providence through Things: The Words of God versus Black Cumin', in M. Bille, F. Hastrup and T.F. Sørensen (eds), *An Anthropology of Absence: Materializations of Transcendence and Loss.* New York: Springer Press, pp 167–84.

———. 2012. 'Assembling Heritage: Investigating the UNESCO Proclamation of Bedouin Intangible Heritage in Jordan', *International Journal of Heritage Studies* 18: 107–23.

———. 2013a. 'The Samer, the Saint and the Shaman: Ordering Bedouin Heritage in Jordan', in A. Bandak and M. Bille (eds), *Politics of Worship in Contemporary Middle East: Sainthood in Fragile States.* Leiden: Brill Publishers, pp. 101–126.

———. 2013b. 'Dealing with Dead Saints', in D.R. Christensen and R. Willerslev (eds), *Taming Time, Timing Death: Social Technologies and Ritual.* Surrey, UK: Ashgate, pp. 137–55.

———. 2017. 'Ecstatic Things: The Power of Light in Shaping Bedouin Homes', *Home Cultures* 14: 25–49.

Bille, M., F. Hastrup and T.F. Sorensen (eds). 2010. *An Anthropology of Absence: Materializations of Transcendence and Loss.* New York: Springer Press.

Billig, M. 1995. *Banal Nationalism.* London: Sage.

Bocco, R. 2000. 'International Organisations and the Settlement of Nomads in the Arab Middle East 1950–1990', in M. Mundy and B. Musallam (eds), *The Transformation of Nomadic Society in the Arab East*. Cambridge: Cambridge University Press, pp. 197–217.

Bourdieu, P. 1966. 'The Sentiment of Honour in Kabyle Society', in J.P. Peristiany (ed.), *Honour and Shame: The Values of Mediterranean Society*. Chicago, IL: University of Chicago Press, pp. 191–241.

Boym, S. 2001. *The Future of Nostalgia*. New York: Basic Books.

Brand, L.A. 2001. 'Displacement for Development? The Impact of Changing State–Society Relations', *World Development* 29: 961–76.

———. 2007. 'Development in Wadi Rum? State Bureaucracy, External Funders, and Civil Society', *International Journal of Middle East* 33: 571–90.

Brown, P. 1981. *The Cult of the Saints: Its Rise and Function in Latin Christianity*. London: SCM.

———. 1982. *Society and the Holy in Late Antiquity*. Berkeley: University of California Press.

Buchli, V. 2002. 'Introduction', in V. Buchli (ed.), *The Material Culture Reader*. Oxford: Berg, pp. 1–22.

———. 2016. *An Archaeology of the Immaterial*. London: Routledge.

Burckhardt, J.L. 1822. *Travels in Syria and the Holy Land*. London: John Murray.

Butler, B. 2001. 'Return to Alexandria: Conflict and Contradiction in Discourses of Origins and Heritage Revivalism', in R. Layton, P.G. Stone and J. Thomas (eds), *Destruction and Conservation of Cultural Property*. London: Routledge, pp. 55–74.

———. 2006. 'Heritage and the Present Past', in C. Tilley, W. Keane, S. Küchler, M. Rowlands and P. Spyer (eds), *Handbook of Material Culture*. London: Sage, pp. 463–79.

Böwering, G. 2004. 'Prayer', in J.D. McAuliffe (ed.), *Encyclopaedia of the Quran*. Washington DC: Brill, pp. 215–31.

Campo, J.E. 1991. *The Other Sides of Paradise: Explorations into the Religious Meanings of Domestic Space in Islam*. Columbia: University of South Carolina Press.

Canaan, T. 1914. *Aberglaube und Volksmedizin im lande der Bibel*. Hamburg: L. Friederichsen & Co.

———. 1927. *Mohammedan Saints and Sanctuaries in Palestine*. London: Luzac & co.

———. 1929. 'Studies in the Topography and Folklore of Petra', *Journal of Palestine Oriental Studies* 9: 136–218.

———. 1930. 'Additions to "Studies in the Topography and Folklore of Petra"', *Journal of Palestine Oriental Studies* 10: 178–80.

———. 2004. 'The Decipherment of Arabic Magic', in E. Savage-Smith (ed.), *Magic and Divination in Early Islam*. Aldershot: Ashgate Variorum, pp. 125–77.

Chadha, A. 2006. 'Ambivalent Heritage: Between Affect and Ideology in a Colonial Cemetery', *Journal of Material Culture* 11: 339–63.

Chatelard, G. 2003. 'Conflicts of Interest Over the Wadi Rum Reserve: Were They Avoidable? A Socio-political Critique', *Nomadic Peoples* 7: 138–58.

————. 2005a. 'Tourism and Representations: Of Social Change and Power Relations in Wadi Ramm', in S.Latte-Abdallah (ed.), *Représentation et construction de la réalité sociale en Jordanie et Palestine*. Beirut and Amman: Institut français du Proche-Orient (IFPO).

————. 2005b. 'Desert Tourism as a Substitute for Pastoralism? Tuareg in Algeria and Bedouin in Jordan', in D. Chatty (ed.), *Nomadic Societies in the Middle East and North Africa: Entering the 21st Century*. Leiden: Brill, pp. 710–36.

Chatty, D. 1986. *From Camel to Truck: The Bedouin in the Modern World*. New York: Vantage Press.

————. 2000. 'Bedouin Economics and the Modern Wage Market: the Case of Harasiis of Oman', *Nomadic Peoples* 4: 68–83.

————. 2014. 'The Persistence of Bedouin Identity and Increasing Political Self-Representation in Lebanon and Syria', *Nomadic Peoples* 18: 16–33.

Chatty, D. and R. Jaubert. 2002. 'Alternative Perceptions of Authority and Control: the Desert and the Ma'moura of Syria', *The World Geographer* 5: 71–72.

Clifford, J. 1987. 'Of Other Peoples: Beyond the "Salvage" paradigm', in H. Foster (ed.), *Discussions in Contemporary Culture no. 1*. Seattle, WA: Bay Press, pp. 121–30.

Cole, D.P. 1975. *Nomads of the Nomads: the Al Murrah Bedouin of the Empty Quarter*. Chicago, IL: Aldine Pub. Co.

————. 1981. 'Bedouin and Social Change in Saudi Arabia', *Journal of Asian and African Studies* 16: 128–49.

————. 2003. 'Where Have the Bedouin Gone?', *Anthropological Quarterly* 76: 235–67.

Cole, D.P. and S. Altorki. 1998. *Bedouin, Settler, and Holiday-makers: Egypt's Changing Northwest Coast*. Cairo: American University in Cairo Press.

Comer, D.C. 2001. 'Enhancing Site Management at Petra Archaeological Park, Jordan', *Cultural Site Research and Management*.

————. 2012. *Tourism and Archaeological Heritage Management at Petra. Driver to Development or Destruction?* New York: Springer.

Corbett, E. 2011. 'Hashemite Antiquity and Modernity: Iconography in Neoliberal Jordan', *Studies in Ethnicity and Nationalism* 11: 163–93.

Cunningham, R.B. and Y.K. Sarayrah. 1993. *Wasta: The Hidden Force in the Middle Eastern Society*. Westport, CT: Praeger Publishers.

D'Alisera, J. 2001. 'I ♥ ISLAM: Popular Religious Commodities, Sites of Inscription, and Transnational Sierra Leonean Identity', *Journal of Material Culture* 6: 91–110.

Daher, R. 1999. 'Gentrification and the Politics of Power, Capital and Culture in an Emerging Jordanian Heritage Industry', *Traditional Dwellings and Settlements Review* 10: 33–47.

————. 2005. 'Urban Regeneration/Heritage Tourism Endeavours: The Case of Salt, Jordan "Local Actors, International Donors, and the State"', *International Journal of Heritage Studies* 11: 289–308.

————. 2007a. 'Reconceptualizing Tourism in the Middle East: Place, Heritage, Mobility and Competitivness', in R. Daher (ed.), *Tourism in the*

Middle East: Continuity, Change and Transformation. Clevedon: Channel View Publications, pp. 1–69.

———. 2007b. *Tourism in the Middle East: Continuity, Change and Transformation*. Clevedon: Channel View Publications.

Daher, R. and I. Maffi. 2014a. *The Politics and Practices of Cultural Heritage in the Middle East: Positioning Material Past in Contemporary Societies*. London: I.B. Tauris.

———. 2014b. 'Introduction', in R. Daher and I.Maffi (eds), *The Politics and Practices of Cultural Heritgae in the Middle East*. London: I.B. Tauris, pp. 1–52.

Deeb, L. 2006. *An Enchanted Modern: Gender and Public Piety in Shi'i Lebanon*. Princeton, NJ: Princeton University Press.

DeLanda, M. 2006. *A New Philosophy of Society: Assemblage Theory and Social Complexity*. London: Continuum.

Denny, F.M. 1988. '"God's Friends": The Sanctity of Persons in Islam', in R. Kieckhefer and G.D. Bond (eds), *Sainthood: Its Manifestations in World Religions*. Berkeley: University of California Press, pp. 69–97.

Diaz-Andreu, M. and T. Champion. 1996. *Nationalism and Archaeology in Europe*. Boulder, CO: Westview.

Dilley, R. 2010. 'Reflections on Knowledge Practices and the Problem of Ignorance', *Journal of the Royal Anthropological Institute* 16: 176–92.

Dinero, S.C. 1997. 'Cultural Identity and Communal Politicisation in a Post-nomadic Society: The Case of the Negev Bedouin', *Nomadic Peoples* 1: 10–23.

———. 2002. 'Image is Everything: the Development of the Negev Bedouin as a Tourist Attraction', *Nomadic Peoples* 6: 69–94.

Dodd, E. and S. Khairullah. 1981. *The Image of the Word: A Study of Quranic Verses in Islamic Architecture*. Beirut: American University of Beirut.

Donaldson, B.A. 1937. 'The Koran as Magic', *Moslem World* 27: 254–66.

Doughty, C.M. 1883. *Travels in Arabia Deserta*, vol. 1–2. London: Jonathan Cape.

Douglas, M. 1992. *Risk and Blame: Essays in Cultural Theory*. London and New York: Routledge.

Drieskens, B. 2008. *Living with Djinns: Understanding and Dealing with the Invisible in Cairo*. London: Saqi Books.

Dundes, A. 1981. *The Evil Eye: A Folklore Casebook*. New York and London: Garland Publishing.

Eickelman, D.F. 1977. 'Ideological Change and Regional Cults Maraboutism and Ties of "Closeness" in Western Morocco', in R.P. Werbner (ed.), *Regional Cults*. London: Academic Press, pp. 3–28.

———. 1998. 'Being Bedouin: Nomads and Tribes in the Arab Social Imagination', in J. Ginat and A.M. Khazanov (eds), *Changing Nomads in a Changing World*. Brighton and Portland: Sussex Academic Press, pp. 38–49.

———. 2002. *The Middle East and Central Asia: An Anthropological Approach. Fourth Edition*. Upper Saddle River, NJ: Prentice Hall.

El-Tom, A.O. 1985. 'Drinking the Koran: The Meaning of Koranic Verses in Bertu Erasure', *Africa: Journal of the International African Institute* 55: 414–31.

Eng, D.L. and D. Kazanjian. 2003. 'Introduction', in D.L. Eng and D. Kazanjian (eds), *Loss: The Politics of Mourning*. Berkeley: University of California Press, pp. 1–25.

Engelke, M. 2004. 'Text and Performance in an African Church: The Book, "Live and Direct"', *American Ethnologist* 31: 76–91.

Eriksen, T.H. 1993. *Ethnicity and Nationalism: Anthropological Perspectives*. New York and London: Pluto.

Fabian, J. 1983. *Time and the Other*. New York: Columbia University Press.

Farajat, S. 2012. 'The Participation of Local Communities in the Tourism Industry at Petra', in D.C. Comer (ed.), *Tourism and Archaeological Heritage Management at Petra: Driver to Development or Destruction*. New York: Springer, pp. 145–65.

Ferdinand, K. 1993. *Bedouins of Qatar: Carlsberg Foundation's Nomad Research Project*. London: Thames & Hudson.

———. 2003. 'Material Culture of Pastoral Nomads: Reflections Based on Arab and Afghan Materials', in R. Tapper and K. McLachlan (eds), *Technology, Tradition and Survival. Aspects of Material Culture in the Middle East and Central Asia*. London: Frank Cass Publishers, pp. 172–204.

Ferrier, J.F. 1854. *Institutes of Metaphysic: The Theory of Knowing and Being*. Edinburgh and London: William Blackwood and Sons.

Fontein, J. 2000. *UNESCO, Heritage and Africa: an Anthropological Critique of World Heritage*. Edinburgh: University of Edinburgh, Centre for African Studies.

Frazer, J.G.S. 1890. *The Golden Bough: a Study in Magic and Religion*. Ware: Wordsworth.

Frembgen, J.W. 2006. *The Friends of God: Sufi Saints in Islam. Popular Poster Art from Pakistan*. Oxford: Oxford University Press.

Gardner, A. 2000. 'Employment and Unemployment Among the Bedouin', *Nomadic Peoples* 4: 21–27.

Geary, P.J. 1994. *Living with the Dead in the Middle Ages*. Ithaca, NY and London: Cornell University Press.

Geertz, C. 1968. *Islam Observed*. New Haven, CT: Yale University Press.

———. 1983. *Local Knowledge*. New York: Basic Books.

Geldermalsen, M. van. 2006. *Married to a Bedouin*. London: Virago.

Gell, A. 1992. The Technology of Enchantment and the Enchantment of Technology, in J. Coote and A. Shelton (eds), *Anthropology, Art and Aesthetics*. Oxford: Clarendon Press, pp. 4–63.

———. 1998. *Art and Agency: An Anthropological Theory*. Oxford: Oxford University Press.

Gellner, E. 1963. 'Saints of the Atlas', in J. Pitt-Rivers (ed.), *Mediterranean Countrymen: Essays in the Social Anthropology of the Mediterranean*. Paris: Mouton & Co., pp. 145–57.

———. 1981. *Muslim Society*. Cambridge: Cambridge University Press.

Gershon, I. and D.S. Raj. 2000. 'Introduction: the Symbolic Capital of Ignorance', *Social Analysis* 44: 3–14.

Gibson, J.J. 1979. *The Ecological Approach to Visual Perception*. Boston, MA: Houghton Mifflin.

Gilsenan, M. 1982. *Recognizing Islam: Religion and Society in the Modern Middle East*. London: I.B. Tauris.

————. 2000. 'Signs of Truth: Enchantment, Modernity and the Dreams of Peasant Women', *Journal of the Royal Anthropological Institute* 6: 597–615.

Di Giovine, M.A. 2009. *The Heritage-Scape: UNESCO, World Heritage, and Tourism*. Lanham, MD: Lexington Books.

Goffman, E. 1974. *Frame Analysis*. Boston, MA: Northeastern University Press.

Goldziher, I. 1967. *Muslim Studies: Vol 1*. Albany, NY: State University of New York Press.

————. 1971. *Muslim Studies: Vol 2*. Chicago: Aldine.

————. 1981. *Introduction to Islamic Theology and Law*. Princeton, NJ: Princeton University Press.

Graham, B., G.J. Ashworth and J.E. Tunbridge. 2000. *A Geography of Heritage: Power, Culture, and Economy*. London: Oxford University Press.

Graham, W. 1987. *Beyond the Written Word*. Cambridge: Cambridge University Press.

Hafstein, V.T. 2009. 'Intangible Heritage as a List: From Masterpieces to Representation', in L. Smith and N. Akagawa (eds), *Intangible Heritage*. London: Routledge, pp. 93–111.

Hageraats, C. 2014. 'Who Says Myths are not Real? Looking at Archaeology and Oral History as Two Complementary Sources of Data'. Unpublished MA thesis, University of Leiden.

Hallam, E. and J. Hockey. 2001. *Death, Memory and Material Culture*. New York: Berg.

Hammoudi, A. 1997. *Master and Disciple: the Cultural Foundations of Moroccan Authoritarianism*. Chicago, IL: University of Chicago Press.

Harfouche, J.K. 1981. 'The Evil Eye and Infant Health in Lebanon', in A. Dundes (ed.), *The Evil Eye: A Casebook*. Madison: University of Wisconsin Press, pp. 86–106.

Harper, S. 2010. 'The Social Agency of Dead Bodies', *Mortality* 15: 308–22.

Harrison, R. 2013. *Heritage Critical Approaches*. London: Routledge.

Hazbun, W. 2004. 'Globalisation, Reterritorialisation and the Political Economy of Tourism Development in the Middle East', *Geopolitics* 9: 310–41.

————. 2008. *Beaches, Ruins, Resorts: The Politics of Tourism in the Arab World*. Minneapolis: University of Minnesota Press.

Hertz, R. 1960 [1907]. 'A Contribution to the Study of the Collective Representation of Death', in R. Needham and C. Needham (eds), *Death and the Right Hand*. London: Cohen & West, pp. 29–86.

Herzfeld, M. 2009. *Evicted from Eternity: The Restructuring of Modern Rome*. Chicago, IL: University of Chicago Press.

Hewinson, R. 1987. *The Heritage Industry: Britain in a Climate of Decline*. London: Methuen.

High, C., A.H. Kelly and J. Mair (eds). 2012. *Anthropology of Ignorance*. New York: Palgrave Macmillian.

Hirschkind, C. 2006. *The Ethical Soundscape: Cassette Sermons and Islamic Counterpublics*. New York: Columbia University Press.

————. 2008. 'Cultures of Death: Media, Religion, Bioethics', *Social Text* 26: 39–58.

Hobsbawn, E. and T. Ranger (eds). 1983. *The Invention of Tradition*. Cambridge: Cambridge University Press.

Hockey, J.L., C. Komaromy and K. Woodthorpe. 2010. *The Matter of Death: Space, Place and Materiality*. Basingstoke: Palgrave Macmillan.

Holes, C. and S.S.A. Athera. 2005. 'Yaa Kundaliizza! Politics and Popular Poetry in Jordan', *CBRL: Newsletter of the Council of British Research in the Levant* (2005): 21–25.

Hood, K. and M. Al-Oun. 2014. 'Changing Performance: Traditions and Bedouin Identity in the North Badiya, Jordan', *Nomadic Peoples* 18: 78–99.

Husban, A.H. Al. 2007. 'The Socio-Anthropological Value of Oral and Intangible Expressions of the Bedu in Southern Jordan', *Dirasat: Human and Social Sciences Journal* 34: 1–20.

Højer, L. and A. Bandak. 2015. 'Introduction: the Power of Example', *Journal of Royal Anthropological Institute* 21: 1–17.

Ihde, D. 1990. *Technology and the Lifeworld*. Bloomington: Indiana University Press.

Ingold, T. 2000. *The Perception of the Environment: Essays in Livelihood, Dwelling and Skill*. London: Routledge.

———. 2007. 'Materials Against Materiality', *Archaeological Dialogues* 14: 1–16.

Jabbur, J. 1995. *The Bedouins and the Desert: Aspects of Nomadic Life in the Arab East*. Albany, NY: SUNY Press.

Jaussen, A. 1908. *Coutumes des Arabes: au pays de Moab*. Paris: Librairie Victor Lecoffre.

Jaussen, A. and R.R.P.P. Savignac. 1914. *Coutumes Des Fuqarâ, Mission Archéologique En Arabie*. Paris: Librairie Paul Geuthner.

JCOICH. 2004a. *Oral Expressions of the Bedu of Al Sharah and Wadi Rum, Southern Jordan*. Amman.

———. 2004b. *The Cultural Space of the Bedu in Petra and Wadi Rum*. Amman.

———. 2004c. *Action Plan for the Safeguarding, Promotion and Development of "The Cultural Space of the Bedu in the Regions of Petra and Wadi Rum": UNESCO Masterpiece of the Oral and Intangible Heritage of Humanity*. Amman.

Joffé, G. 2002. *Jordan in Transition 1990-2000*. London: Hurst & Company.

Johannsen, N. 2012. 'Archaeology and the Inanimate Agency Proposition: a Critique and a Suggestion', in N. Johannsen, M.D. Jessen and H.J. Hensen (eds), *Excavating the Mind: Cross-sections Through Culture, Cognition and Materiality*. Aarhus: Aarhus University Press, pp. 305–47.

Jones, S. 2006. 'Weaving an Ethnography: a Longitudinal Study of the Impact of a Weaving Project on the Lives of the Bani Hamida Bedouin Women in Jordan'. Unpublished PhD thesis, University of London.

Joy, C. 2012. *The Politics of Heritage Management in Mali From UNESCO to Djenné*. Walnut Creek, CA: Left Coast Press.

Katakura, M. 1977. *Bedouin Village: a Study of a Saudi Arabian People in Transition*. Tokyo: University of Tokyo Press.

Katz, K. 1999. 'Jordanian Jerusalem: Postage Stamps and Identity Construction', *Jerusalem Quarterly File* 5: 14–26.

Kirshenblatt-Gimblett, B. 1991. 'Objects of Ethnography', in I. Karp and S.D. Lavine (eds), *Exhibiting Cultures: the Poetics and Politics of Museum Display*. Washington, DC: Smithsonian Institution Press, pp. 386–443.

———. 2004. 'Intangible Heritage as Metacultural Production', *Museum International* 56: 52–64.

———. 2006. 'World Heritage and Cultural Economics', in I. Karp, C.A. Kratz and L. Szwaja (eds), *Museum Friction: Public Cultures/Global Transformations*. Durham, NC: Duke University Press, pp. 161–202.

Knappett, C. 2004. 'The Affordances of Things: a Post-Gibsonian Perspective on the Relationality of Mind and Matter', in E. Demarrais, C. Gosden and C. Renfrew (eds), *Rethinking Materiality: The Engagement of Mind with the Material World*. Cambridge: McDonald Institute for Archaeological Research, pp. 43–51.

Knappett, C. and L. Malafouris. 2008. *Material Agency: Towards a Non-Anthropocentric Approach*. New York: Springer.

Kohl, P.L. and C. Fawcett. 1995. *Nationalism, Politics, and the Practice of Archaeology*. Cambridge: Cambridge University Press.

Kooring, D. and S. Simms. 1996. 'The Bedul Bedouin of Petra, Jordan: Traditions, Tourism and an Uncertain Future', *Cultural Survival Quarterly* 19: 22–25.

Kressel, G., S. Bar-Zvi and A. Abu Rabia. 2014. *The Charm of Graves: Perceptions of Death and After-Death Among the Negev Bedouin*. Brighton: Sussex Academic Press.

Kressel, G.M. 1992. 'Shame and Gender', *Anthropological Quarterly* 65: 34–46.

Kriss, R. and H. Kriss-Heinrich. 1960a. *Volksglaube im Bereich des Islam: Band I*. Wiesbaden: Otto Harrassowitz.

———. 1960b. *Volksglaube im Bereich des Islam: Band II*. Wiesbaden: Otto Harrassowitz.

Kuper, A. 2005. *The Reinvention of Primitive Society: Transformations of a Myth*. London: Routledge.

Kurin, R. 2007. 'Safeguarding Intangible Cultural Heritage: Key Factors in Implementing the 2003 Convention', *International Journal of Intangible Heritage* 2: 9–20.

Laet, M. de and A. Mol. 2000. 'The Zimbabwe Bush Pump: Mechanics of a Fluid Technology', *Social Studies of Science* 30: 225–63.

Lancaster, W. 1997. *The Rwala Bedouin Today* (2nd edition). Cambridge: Cambridge University Press.

Lane, E.W. 1986. *An Account of the Manners and Customs of the Modern Egyptians: Written During the Years 1833-1835*. London: Darf Publishers.

Latour, B. 1992. '"Where Are the Missing Masses?" The Sociology of a Few Mundane Artifacts', in *Shaping Technology/Building Society: Studies in Sociotechnical Change*. Cambridge, MA: MIT Press, pp. 225–58.

———. 1993. *We Have Never Been Modern*. Cambridge, MA.: Harvard University Press.

———. 2005. *Reassembling the Social*. Oxford: Oxford University Press.

Lavie, S. 1990. *The Poetics of Military Occupation: Mzeina Allegories of Bedouin Identity under Israeli and Egyptian Rule*. Berkeley: University of California Press.

Law, J. 1994. *Organizing Modernity*. Oxford: Blackwell.

Law, J. and A. Mol. 2008. 'The Actor-enacted: Cumbrian Sheep in 2001', in C. Knappert and L. Malafouris (eds), *Material Agency: Towards a Non-anthropocentric Approach*. New York: Springer, pp. 57–77.

Layne, L.L. 1987. 'Village-Bedouin: Patterns of Change From Mobility to Sedentism in Jordan', in S. Kent (ed.), *Method and Theory for Activity Area Research: An Ethnoarchaeological Approach*. New York: Columbia University Press, pp. 345–373.

———. 1994. *Home and Homeland*. Princeton: Princeton University Press.

Layton, R., P.G. Stone and J. Thomas (eds). 2001. *Destruction and Conservation of Cultural Property*. London: Routledge.

Lewis, I.M. 1986. *Religion in Context: Cults and Charisma*. Cambridge: Cambridge University Press.

Limbert, M. 2008. 'The Sacred Date: Gifts of God in an Omani Town', *Ethnos* 73: 361–76.

Lindner, M. 2003. *Über Petra Hinaus*. Rahden: Verlag Marie Leidorf GmbH.

Lowenthal, D. 1998. *The Heritage Crusade and the Spoils of History*. Cambridge: Cambridge University Press.

Lukens-Bull, R.A. 1999. 'Between Text and Practice: Considerations in the Anthropological Study of Islam', *Marburg Journal of Religion* 4: 1–10.

MacDonald, S. 2002. 'Museums and Identities: Materializing German Culture', in A. Phipps (ed.), *Contemporary German Cultural Studies*. London: Arnold, pp. 117–31.

———. 2006. *A Companion to Museum Studies*. London: Blackwell.

———. 2009. 'Reassembling Nuremberg, Reassembling Heritage', *Journal of Cultural Economy* 2: 117–34.

Madigan, D. 2001. 'Book', in J.D. McAulifee (ed.), *Encyclopaedia of the Quran*, vol. 1. Leiden and Boston, MA: Brill, pp. 242–51.

Maffi, I. 2002. 'New Museographic Trends in Jordan: the Strengthening of the Nation', *Jordan in Transition 1990–2000* 208–24.

———. 2005. 'La fabrication des frontières nationales dans les manuels scolaires jordaniens', *A contrario* 3: 26–44.

———. 2009. 'The Emergence of Cultural Heritage in Jordan: The Itinerary of a Colonial Invention', *Journal of Social Archaeology* 9: 5–34.

———. 2011. 'The Creation of Jordanian National Identity: a Short Museographic Story of a Complex Process', in M. Ababsa and R. Daher (eds), *Cities, Urban Practices and Nation Building in Jordan*. Beirut: Institut Francais Du Proche-Orient, pp. 143–62.

———. 2014. 'The Intricate Life of Cultural Heritage: Colonial and Postcolonial Processes of Patrimonialisation in Jordan', in R. Daher and I. Maffi (eds), *The Politics and Practices of Cultural Heritage in the Middle East*. London: I.B. Tauris, pp. 66–103.

Mahmood, S. 2005. *Politics of Piety: The Islamic Revival and the Feminist Subject*. Princeton, NJ: Princeton Press.

Makris, G.P. 2006. *Islam in the Middle East: a Living Tradition.* Malden, MA: Blackwell Pub.

Malafouris, L. 2008. 'At the Potter's Wheel: an Argument for Material Agency', in C. Knappert and L. Malafouris (eds), *Material Agency: Towards a Non-Anthropocentric Approach.* New York: Springer, pp. 19–36.

Management Analysis. 1996. *Management Analysis & Recommendations for the Petra World Heritage Site. Task 96-01.* Washington, DC: US/ICOMOS.

Maniura, R. 2009. 'The Absent Saint', *Critical Inquiry* 35: 629–54.

Manning, P. and A. Meneley. 2008. 'Material Objects in Cosmological Worlds: An Introduction', *Ethnos* 73: 285–302.

Marcus, M.A. 1985. '"The Saint Has Been Stolen": Sanctity and Social Change in a Tribe of Eastern Morocco', *American Ethnologist* 12: 455–67.

Marx, E. 1977. 'Communal and Individual Pilgrimage: the Region of Saints' Tombs in South Sinai', in R.P. Werbner (ed.), *Regional Cults.* London and New York: Academic Press, pp. 29–51.

Marx, E. and A. Shmu'eli. 1984. *The Changing Bedouin.* New Brunswick and London: Transaction.

Masalha, N. 2007. 'Jordan: History', in L. Dean (ed), *The Middle East and North Africa 2008. 54th edition.* London: Routledge, pp. 610–639.

Massad, J.A. 2001. *Colonial Effects: The Making of National Identity in Jordan.* New York: Columbia University Press.

Master Plan. 1968. *Master Plan for the Protection & Use of Petra National Park.* Washington, DC: The US National Park Service.

Master Plan 1994. *Petra National Park Management Plan.* Paris: Unesco.

Maurer, B. 2005. 'Does Money Matter? Abstraction and Substitution in Alternative Financial Forms', in D. Miller (ed.), *Materiality.* Durham, NC and London: Duke University Press, pp. 140–64.

McAuliffe, J.D. 2001. 'Preface', in J.D. McAuliffe (ed.), *Encyclopaedia of the Quran*, vol. 1. Leiden and Boston, MA: Brill, pp. i–xiii.

McKenzie, J.S. 1991. 'The Beduin at Petra: the Historical Sources', *Levant* 23: 139–45.

Meir, A. 1997. *As Nomadism Ends: the Israeli Bedouin of the Negev.* Boulder, CO: Westview Press.

Meltzer, F. and J. Elsner. 2009. 'Introduction: Holy by Special Application', *Critical Inquiry* 35: 375–79.

Meneley, A. 2008. 'Oleo-Signs and Quali-Signs: The Qualities of Olive Oil', *Ethnos* 73: 303–26.

Meri, J.W. 2002. *The Cult of Saints among Muslims and Jews in Medieval Syria.* Oxford: Oxford University Press.

Mershen, B. 1987. 'Amulette als Komponenten des Volksschmucks im Jordanland', in G. Völger, K. Helck and K. Hackstein (eds), *Pracht un Geheimnis: Kleidung und Schmuck as Palästina und Jordanien.* Cologne: Druck- und Verlaghaus Wienand, pp. 106–109.

Messick, B. 1989. 'Just Writing: Paradox and Political Economy in Yemeni Legal Documents', *Cultural Anthropology* 4: 26–50.

Meyer, B. and A. Moors (eds). 2006. *Religion, Media, and the Public Sphere.* Bloomington: Indiana University Press.

Miettunen, P. 2013. 'Our Ancestors were Bedouin: Memory, Identity and Change. The Case of Holy Sites in Southern Jordan'. Unpublished PhD thesis, University of Helsinki.

Miller, D. 2005. 'Materiality: An Introduction', in D. Miller (ed.), *Materiality*. Durham, NC: Duke University Press, pp. 1–50.

Mitchell, T. 2001. 'Making the Nation: the Politics of Heritage in Egypt', in N. Alsayyad (ed.), *Consuming Tradition, Manufacturing Heritage: Global Norms and Urban Forms in the Age of Tourism*. London: Routledge, pp. 212–39.

Mittermaier, A. 2008. '(Re)Imagining Space: Dreams and Saint Shrines in Egypt', in G. Stauth and S. Schielke (eds), *Dimensions of Locality: Muslim Saints, Their Place and Space*. Bielefeld: Transcript, pp. 47–66.

———. 2010. *Dreams that Matter*. Los Angeles: University of California Press.

Mol, A. 2002. *The Body Multiple: Ontology in Medical Practice*. Durham, NC and London: Duke University Press.

Moll, Y. 2010. 'Islamic Televangelism: Religion, Media and Visuality in Contemporary Egypt', *Arab Media & Society* 1–27.

Muhammad, G. Bin. 1998. *The Holy Sites of Jordan*. Amman: Turab.

Musil, A. 1928. *The Manners and Customs of the Rwala Bedouins*. New York: American Geographical Society.

Nakamura, C. 2005. 'Mastering Matters: Magical Sense and Apotropaic Figurine Worlds in Neo-Assyria', in L.Meskell (ed.), *Archaeologies of Materiality*. Malden, MA: Blackwell, pp. 18–45.

Nas, P.J.M. 2002. 'Masterpieces of Oral and Intangible Culture', *Current Anthropology* 43: 139–48.

Nasser, S. and H. al-Khairi. 2003. *Diraset ather es-siaHa a'la al-mujtema't al-maHalieh fii aqliim al-betra* [Study of the Effect of Tourism on the Local People in the Petra Region]. Amman.

Nelson, C. 1973. *The Desert and the Sown: Nomads in the Wider Society*. Berkeley: Institute of International Studies, University of California.

Neveu, N. 2010. 'Islamic Tourism as an Ideological Construction: A Jordan Study Case', *Journal of Tourism and Cultural Change* 8: 327–37.

Nielsen, D. 1933. 'The Mountain Sanctuaries in Petra and its Environs', *JPOS* 13: 185–208.

Nippa, A. 2005. 'Art and Generosity: Thoughts on the Aesthetic Perceptions of the 'arab', in D. Chatty (ed.), *Nomads of the Middle East and North Africa: Facing the 21st Century*. Boston, MA: Brill Publishers, pp. 539–72.

O'Connor, K.M. 2004. 'Popular and Talismanic Uses of the Quran', in J.D. McAuliffe (ed.), *Encyclopaedia of the Quran*, vol. 4. Leiden and Boston, MA: Brill, pp. 163–82.

Ohannessian-Charpin, A. 1986. 'L'Utilisation Actuelle par les Bedouins des Grottes Archeologiques de Petra', *ADAJ* 30: 385–95.

———. 1995. 'Strategic Myths: Petra's B'doul', *Middle East Report* 196: 24–25.

———. n.d. Untitled.

Owusu-Ansah, D. 1991. *Islamic Talismanic Tradition in Nineteenth-century Asante*. Lewiston, NY: The Edwin Mellen Press.

Padwick, C.E. 1961. *Muslim Devotion: A Study of the Prayer Manuals in Common Use*. London: S.P.C.K.

Palumbo, G. and L. Cavazza. 2004. Report on Mission to Petra, Jordan, on behalf of UNESCO. 19–24 March 2004.

PAPOP. 2000. Petra Archaeological Park Operating Plan.

Pedersen, M.A. 2011. *Not Quite Shamans: Spirit Worlds and Political Lives in Northern Mongolia*. Ithaca, NY: Cornell University Press.

Pels, P. 1998. 'The Spirit of Matter: On Fetish, Rarity, Fact, and Fancy', in P. Spyer (ed.), *Border Fetish: Material Objects in Unstable Spaces*. London: Routledge, pp. 91–121.

Pendlebury, J. 2012. 'Conservation Values, the Authorised Heritage Discourse and the Conservation-planning Assemblage', *International Journal of Heritage Studies* 1–19.

Peutz, N. 2011. 'Bedouin "Abjection": World Heritage, Worldliness, and Worthiness at the Margins of Arabia', *American Ethnologist* 38: 338–60.

Pietz, W. 1985. 'The Problem of the Fetish, I', *RES: Journal of Anthropology and Aesthetics* 9: 5–17.

Porter, V. 2007. 'Amulets Inscribed With the Names of the "Seven Sleepers" of Ephesus in the British Museum', in F. Suleman (ed.), *Word of God, Art of Man*. Oxford: Oxford University Press, pp. 123–34.

Povinelli, E.A. 2002. *The Cunning of Recognition: Indigenous Alterities and the Making of Australian Multiculturalism*. Durham, NC: Duke University Press.

Prager, L. 2014a. 'Introduction. Reshaping Tribal Identities in the contemporary Arab World: Politics, (Self-)Representation, and the Construction of Bedouin History', *Nomadic Peoples* 18: 10–15.

———. 2014b. 'Bedouinity on Stage: The Rise of The Bedouin Soap Opera (Musalsal Badawi) in Arab Television', *Nomadic Peoples* 18: 53–77.

Proctor, R. and L.L. Schiebinger. 2008. *Agnotology: the Making and Unmaking of Ignorance*. Stanford, CA: Stanford University Press.

Pütt, K. 2005. *Zelte, Kuppeln und Hallenhäuser: Wohnen und Bauen im ländlichen Syrien*. Petersberg: Michael Imhof Verlag .

Qutb, S. 1981. *Milestones*. Delhi: Markazi Maktaba Islami.

Radtke, B. 2007. 'Saint' in J.D. McAuliffe (ed.), *Encyclopaedia of the Quran*. Washington DC: Brill, pp. 520–21.

Rasmussen, S.J. 2006. *Those who Touch: Tuareg Medicine Women in Anthropological Perspective*. Illinois: Northern Illinois University Press.

Raswan, C.R. 1935. *The Black Tents of Arabia: My Life Amongst the Bedouins*. London: Hutchinson & Co.

Rayner, S. 1992. 'Cultural Theory and Risk Analysis' in S. Krimsky and D. Golding (eds), *Social Theories of Risk*. Westport, CT: Praeger, pp. 83–116.

Renard, J. 2008. *Friends of God: Islamic Images of Piety, Commitment and Servanthood*. Berkeley, CA: University of California Press.

Robb, J. 2004. 'The Extended Artefact and the Monumental Economy: a Methodology for Material Agency', in E. Demarrais, C. Gosden and C. Renfrew (eds), *Rethinking Materiality: the Engagement of Mind with the Material World*. Cambridge: MacDonald Institute for Archaeological Research, pp. 131–39.

Roberts, A.F. and M.N. Roberts. 2003. *A Saint in the City: Sufi Arts of Urban Senegal*. Los Angeles: UCLA Fowler Museum of Cultural History.

Robins, P. 2004. *A History of Jordan*. Cambridge: Cambridge University Press.

Rochlin, G.I. 2003. 'Safety as a Social Construct: The Problem(atique) of Agency', *Constructing Risk and Safety in Technological Practice* 123–39.

Rose, M. 2006. 'Gathering "Dreams of Presence": A Project for the Cultural Landscape', *Environment and Planning D: Society and Space* 24: 537–54.

Rowlands, M. 2005. 'A Materialist Approach to Materiality', in D. Miller (ed.), *Materiality*. Durham, NC: Duke University Press, pp. 72–87.

Ruben, I. and A. Disi. 2006. *Field Guide to the Plants and Animals of Petra*. Amman: Petra National Trust.

Ruggles, D.F. and H. Silverman (eds). 2009. *Intangible Heritage Embodied*. New York: Springer.

––––––. 2009. 'From Tangible to Intangible Heritage', in D.F. Ruggles and H. Silverman (eds), *Intangible Heritage Embodied*. New York: Springer, pp. 1–14.

Runia, E. 2006. 'Presence', *History and Theory* 45: 1–29.

Russell, K.W. 1993. 'Ethnohistory of the Bedul Bedouin of Petra', *Annual of the Department of Antiquities of Jordan* 37: 15–35.

––––––. 1995. 'Traditional Bedouin Agriculture at Petra: Ethnoarchaeological Insights into the Evolution of Food Production', *Studies in the History and Archaeology of Jordan* 5: 693–705.

Sajdi, R. 2007. *Land of the Noble Shepherds*. Amman: National Press.

Salamandra, C. 2004. *A New Old Damascus: Authenticity and Distinction in Urban Syria*. Bloomington: Indiana University Press.

Salzman, P.C. and J.G. Galaty. 1990. *Nomads in a Changing World*. Naples: Istituto universitario orientale.

Salzman, P.C. and E. Sadala. 1980. *When Nomads Settle: Processes of Sedentarization as Adaptation and Response*. New York: Praeger.

Schielke, S. 2009. 'Being Good in Ramadan: Ambivalence, Fragmentation and the Moral Self in the Lives of Young Egyptians', *Journal of the Royal Anthropological Institute* 15: S24–S40.

––––––. 2012. *The Perils of Joy: Contesting Mulid Festivals in Contemporary Egypt*. Syracuse, NY: Syracuse University Press.

––––––. 2015. *Egypt in the Future Tense: Ambivalence, Hope and Frustration in Egypt Before and After 2011*. Bloomington: Indiana University Press.

Schielke, S. and G. Stauth. 2008. 'Introduction', in G. Stauth and S. Schielke (eds), *Dimensions of Locality: Muslim Saints, Their Place and Space*. Bielefeld: Transcript, pp. 7–21.

Scholze, M. 2008. 'Arrested Heritage. The Politics of Inscription into the UNESCO World Heritage List: The Case of Agadez in Niger', *Journal of Material Culture* 13: 215–31.

Seeley, N. 2006. 'The Desert Dancers', *JO magazine* (May), 88–93.

Shaer, M. 2008. 'Cultural Heritage Management: the Special Case of the World Heritage Site of Petra', in N. Marchetti and I. Thuesen (eds), *ARCHAIA: Case Studies on Research Planning, Characterisation, Conservation and Management of Archaeological Sites*. Oxford: BAR International Series 1877, pp. 341–45.

Shenoda, A. 2008. *(Re)Producing Holiness: Coptic Christians, Mass Media, and the Miraculous*. Presented at American Anthropological Association, San Francisco, CA (22 November).

Shepard, W.E. 2001. 'Age of Ignorance', in J.D. McAuliffe (ed.), *Encyclopaedia of the Quran*, vol. 1. Leiden and Boston: Brill, pp. 37–40.

Shoup, J. 1985. 'The Impact of Tourism on the Bedouin of Petra', *Middle East Journal* 39: 277–91.

Shryock, A. 1997. *Nationalism and the Genealogical Imagination: Oral History and Textual Authority in Tribal Jordan*. Berkeley: University of California Press.

Silberman, N.A. 1989. *Between Past and Present: Archaeology, Ideology, and Nationalism in the Modern Middle East*. New York: Holt.

Sincich, F. 2002. *Bedouin Traditional Medicine in the Syrian Steppe. Al-Khatib Speaks: an Interview with a Hadidin Traditional Doctor.* Rome: FAO. Fiat Panis.

Smith, L. 2006. *Uses of Heritage*. New York: Routledge.

Smith, L. and N. Akagawa. 2009. *Intangible Heritage*. Abingdon: Routledge.

Soucek, P.P. 2004. 'Material Culture and the Qur'ān', in J.D. McAuliffe (ed.), *Encyclopaedia of the Quran*, vol. 1. Leiden and Boston, MA: Brill, pp. 296–330.

Starrett, G. 1995. 'The Political Economy of Religious Commodities in Cairo', *American Anthropologist* 97: 51–68.

Stauth, G. (ed.). 2004. *On Archaeology of Sainthood and Local Spirituality in Islam: Past and Present Crossroads of Events and Ideas*. Bielefeld: Transcript Verlag.

Steen, D., B. Porter, J. Jacobs and B. Routledge. 2010. 'Exploring Heritage Discourses in Central Jordan', in L.S. Dodd (ed.), *Controlling the Past, Owning the Future: The Political Uses of Archaeology in the Middle East*. Tucson: University of Arizona Press, pp. 159–177.

Stewart, D.J. 2001. 'Blessing', in J.D. McAuliffe (ed.), in *Encyclopaedia of the Quran*, vol. 1. Leiden and Boston, MA: Brill, pp. 236–37.

Strathern, M. 2004. *Partial Connections*. Walnut Creek, CA: AltaMira Press.

Sweetman, J. 2004. 'Nature and Art in Enlightenment Culture', in P.J.M. Fitzpatrick, C. Knellwolf and I. McCalman (eds), *The Enlightenment World*. London: Routledge, pp. 288–306.

Sørensen, T.F. 2009. 'The Presence of the Dead: Cemeteries, Cremation and the Staging of Non-place', *Journal of Social Archaeology* 9: 110–35.

Tambiah, S.J. 1984. *The Buddhist Saints of the Forest and the Cult of Amulets*. Cambridge: Cambridge University Press.

Tamim, S. 2005. *Only Time Will Tell*. Amman: Flower of Life.

Topham, J., A.N. Landreau and W.E. Mulligan. 2005. *Traditional Crafts of Saudi Arabia: Weaving, Jewellery, Costume, Leatherwork, Basketry, Woodwork, Pottery, Metalwork* (rev. edition). Riyadh and London: Al-Turath, Stacey International.

Tunbridge, J.E. and G.J. Ashworth. 1996. *Dissonant Heritage: The Management of the Past as a Resource in Conflict*. Chichester and New York: John Wiley & Sons.

UNESCO. 2003. *Convention for the Safeguarding of the Intangible Cultural Heritage*. Paris: UNESCO.

Verbeek, P.-P. 2008. 'Morality in Design: Design Ethics and the Morality of Technological Artifacts', *Philosophy and Design: From Engineering to Architecture* 7: 91–103.

Vitebsky, P. 1993. 'Is Death the Same Everywhere? Contexts of Knowing and Doubting', in M. Hobart (ed.), *An Anthropological Critique of Development: The Growth of Ignorance*. London: Routledge, pp. 100–15.

Warnier, J.-P. 2006. 'Inside and Outside: Surfaces and Containers', in C. Tilley, W. Keane, S. Küchler, M. Rowlands and P. Spyer (eds), *Handbook of Material Culture*. London: Sage, pp. 186–95.

Wedeen, L. 2008. *Peripheral Visions: Publics, Power, and Performance in Yemen*. Chicago, IL: University of Chicago Press.

Weir, S. 1976. *The Bedouin: Aspects of the Material Culture of the Bedouin of Jordan: World of Islam Festival 1976*. London: World of Islam Festival Publishing Co. Ltd.

Werthmann, K. 2008. 'Islam on Both Sides: Religion and Locality in Western Burkina Faso', in G. Stauth and S. Schielke (eds), *Dimensions of Locality: Muslim Saints, Their Place and Space*. Bielefeld: Transcript, pp. 125–47.

Willerslev, R. 2004. 'Not Animal, Not Not-Animal: Hunting Imitation and Empathetic Knowledge Among the Siberian Yukaghirs', *Journal of Royal Anthropological Institute* 10: 629–52.

Winter, T. 2007. *Post-Conflict Heritage, Postcolonial Tourism: Culture, Politics and Development at Angkor*. London and New York: Routledge.

Wooten, C. 1996. 'From Herds of Goats to Herds of Tourists: Negotiating Bedouin Identity Under Petra's "Romantic Gaze"'. Unpublished MA thesis, The American University in Cairo.

Young, W.C. 1999. '"The Bedouin": Discursive Identity or Sociological Category? A Case Study from Jordan', *Journal of Mediterranean studies* 9: 275–99.

Zayd, N.H.A. 2002. 'Everyday Life', in J.D. McAuliffe (ed.), *Encyclopaedia of the Quran*, vol. 2. Leiden and Boston, MA: Brill, pp. 80–98.

≋ Index

www.ingramcontent.com/pod-product-compliance
Lightning Source LLC
Chambersburg PA
CBHW070622030426
42337CB00020B/3887